INNOVATIVE IMPRESSIONS

Sarah Lees

Richard R. Brettell

Prints by Cassatt, Degas, and Pissarro

Philbrook HIRMER

Lenders to the Exhibition

ART INSTITUTE OF CHICAGO

BALTIMORE MUSEUM OF ART

BROOKLYN MUSEUM

BRYN MAWR COLLEGE, PENNSYLVANIA

CINCINNATI ART MUSEUM

THE CLEVELAND MUSEUM OF ART

DALLAS MUSEUM OF ART

HARVARD ART MUSEUMS, CAMBRIDGE, MASSACHUSETTS

HIGH MUSEUM OF ART, ATLANTA

MEAD ART MUSEUM, AMHERST COLLEGE, MASSACHUSETTS

THE METROPOLITAN MUSEUM OF ART, NEW YORK

MILDRED LANE KEMPER ART MUSEUM, WASHINGTON UNIVERSITY IN SAINT LOUIS

MINNEAPOLIS INSTITUTE OF ART

MUSEUM OF FINE ARTS, BOSTON

NATIONAL GALLERY OF ART, WASHINGTON, DC

THE NELSON-ATKINS MUSEUM OF ART, KANSAS CITY, MISSOURI

NEW YORK PUBLIC LIBRARY

PHILADELPHIA MUSEUM OF ART

PHILBROOK MUSEUM OF ART, TULSA, OKLAHOMA

PRIVATE COLLECTION

PRIVATE COLLECTION, COURTESY OF HARRIS SCHRANK, NEW YORK

RHODE ISLAND SCHOOL OF DESIGN MUSEUM, PROVIDENCE

SCHORR COLLECTION

SMITH COLLEGE MUSEUM OF ART, NORTHAMPTON, MASSACHUSETTS

SPENCER MUSEUM OF ART, UNIVERSITY OF KANSAS, LAWRENCE

STERLING AND FRANCINE CLARK ART INSTITUTE, WILLIAMSTOWN, MASSACHUSETTS

URSULA AND R. STANLEY JOHNSON FAMILY COLLECTION

Director's Foreword

Creativity rarely happens in a vacuum. Artists, artisans, musicians, writers, choreographers—all draw inspiration not just from their own imaginations but from working with and reacting to their colleagues as friends, rivals, or friendly competitors, and responding to the broader society in which they work. In 1879, Mary Cassatt, Edgar Degas, and Camille Pissarro began working together on a publication dedicated to original etchings. All three were members of the group known as Impressionists, artists whose radical paintings redefined many of the rules of the medium. Although the intended publication never came to fruition, this collaborative project had a profound influence on all three artists' printmaking practices. Through their artistic interchanges, which continued for much of their careers, they inspired and challenged each other to develop a new language of printmaking whose visual and expressive potential went well beyond the traditional reproductive purpose of the medium. The complex, beautiful, and groundbreaking prints they created were every bit as innovative as their paintings.

Exhibitions are similarly collaborative efforts. *Innovative Impressions: Prints by Cassatt, Degas, and Pissarro* relied on the contributions of many to realize its vision. The initial conception of the project was prompted by Philbrook's acquisition of its first work by Camille Pissarro, the etching *View of Rouen (Cours-la-Reine)*, a purchase made possible by the Philbrook Patrons of Paper group in 2015. From there, Ruth G. Hardman Curator of European Art Sarah Lees assiduously worked to secure a group of exceptional prints from lenders across much of the country. I offer my sincere thanks to all the lenders for their generous support of this exhibition. The leadership and vision of the Philbrook Board of Trustees, led by Bill Thomas and Howard Barnett, has been invaluable, and the support of the 2017–2019 Philbrook Series Sponsors has made this, and all our exhibitions and related programs, possible. I also wish to extend my thanks to scholar Richard Brettell for his insightful contribution to this publication. And none of this would have happened without the hard work and dedication of the entire Philbrook staff—particularly the Curatorial Department, led by Director of Collections and Exhibitions Rachel Keith and Chief Curator Catherine Whitney. Thanks to their teamwork, and the support of the extended Philbrook community, we are able to present a remarkable group of objects that not only sheds light on the working practices of three extraordinary and influential artists, but also more broadly embodies the creative potential of collaboration.

SCOTT STULEN

Director and President
Philbrook Museum of Art

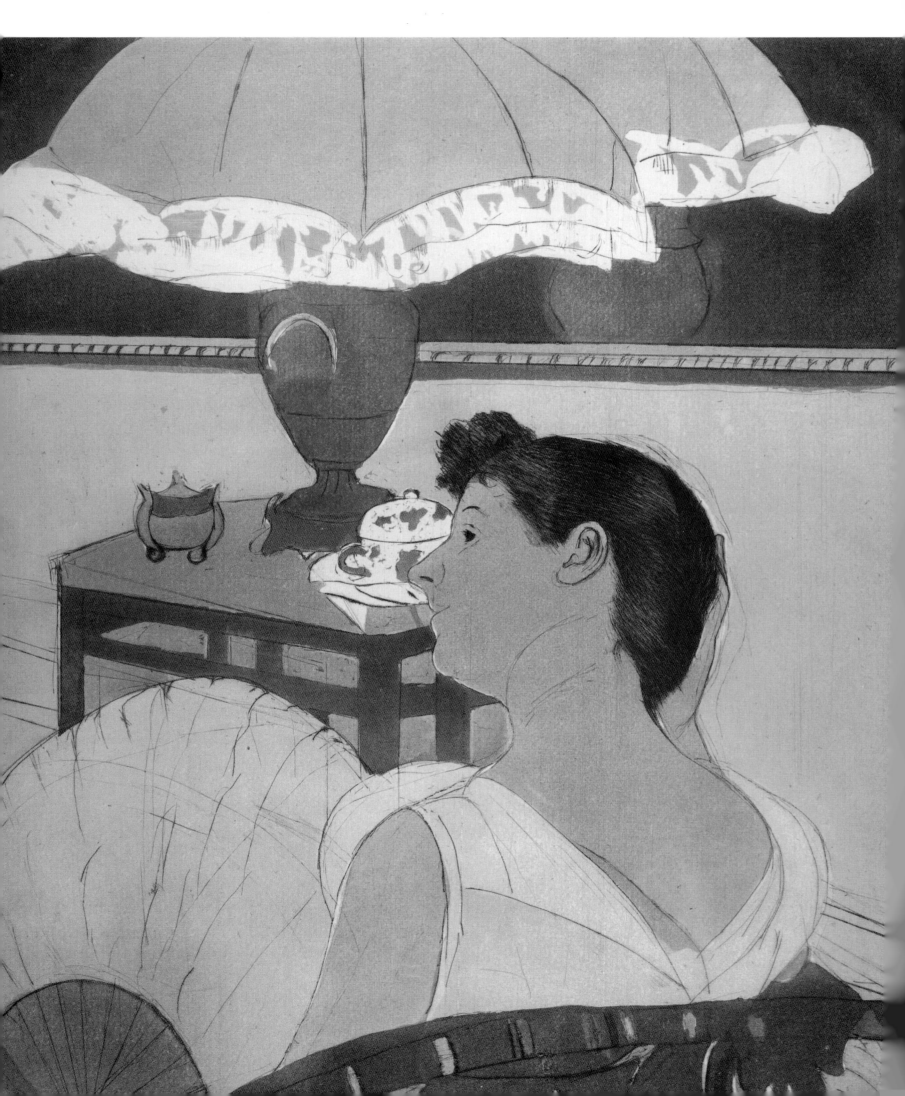

Philbrook Exhibition Series Sponsors 2017–2019

PRESENTING SPONSOR

Mary K. Chapman Foundation

CONTRIBUTING SPONSOR

The Mervin Bovaird Foundation

Herman G. Kaiser Foundation

Ralph and Francis McGill Foundation

Meinig Family Foundation

Sherman E. Smith Family Charitable Foundation

SUPPORTING SPONSOR

Billie and Howard Barnett

George Kaiser Family Foundation

Helmerich Trust

Barbara and Steve Heyman

Matrix Service Company

Susan and Bill Thomas

The Anne and Henry Zarrow Foundation

Judith and Jean Pape Adams Foundation

SPONSOR

Blue Cross Blue Shield

Margo and Kent Dunbar

Pam and Lee Eslicker

Beth and Ben Latham

Mabrey Bank

Oklahoma Arts Council

OneGas

Philbrook Contemporary Consortium

Cheryl Ulmer and Greg Ratliff

SemGroup

Senior Star

Jill and Robert Thomas

The Andy Warhol Foundation for the Visual Arts

Kathleen Patton Westby Foundation

ADDITIONAL SUPPORT

Barbara and Hal Allen

Sam J. and Nona M. Rhoades Foundation

Bank of Oklahoma

Philbrook Board of Trustees

ARTISTIC COLLABORATION

A Brief History

Richard R. Brettell

In our marketing-centered capitalist world, artists have become "brands." Their signatures are printed on T-shirts, banners, and posters; the works of the most famous are gathered in solo exhibitions; and their oeuvres and lives are presented and dissected in books with their names on the spines. All of this reinforces an idea that artists work alone, that their work is about—or all wrapped up in— their individual identity, and that their careers are fundamentally solitary.

That the opposite is more often true will come as a surprise to people who attend monographic exhibitions or read books devoted to artists like Michelangelo, Rembrandt, Vermeer, Delacroix, Manet, or Van Gogh. Like most people, artists rely on their colleagues for both technical and psychological support as they develop their craft. Rarely does an artist invent a "signature style" in isolation. More frequently than not, such a style is created with and against other artists, who become as necessary to the process of self-definition as the artist her- or himself.

This exhibition is focused on the intense artistic interaction of Camille Pissarro, Edgar Degas, and Mary Cassatt. One Dane, one Frenchman, and one American, all three of their careers were based in Paris and its environs in the late nineteenth century. It is a collaboration unlike many others in that the people involved in it were as different from each other—in class, gender, education, and

religious origins—as three people of Euro-American origin could be. Indeed, the very existence of this collaboration among a group with such disparate backgrounds raises larger questions about the nature of joint artistic endeavor.

A broad exploration of the phenomenon of artists working in groups, whether guilds, apprenticeships, schools, academies, or movements, is beyond the scope of this study, but it is worthwhile to place the particular achievement of these three artists within a larger historical context. Before the creation of art academies in sixteenth-century Italy, artists trained as apprentices with a single master for whom they worked for years until attaining their own status as a master. The transfer of this authoritarian system to the academy is roughly equivalent to the shift from small, single-master schools in general education to colleges and universities in the humanities and sciences during the same period. Both of these modes of instruction were by nature hierarchical, and the student was anything but a collaborator with the master, even when she or he worked directly on one of the master's paintings or sculptures.

The stories of painting assistants who began by painting drapery and worked up to landscapes and, eventually, bodies, are well known in the lore surrounding studio apprenticeships from the late Middle Ages to the large shop of Peter Paul Rubens, and even to the current practice of artists like Jeff Koons (who at one time hired as many as sixty painting assistants). Yet this type of artistic relationship has little room for individual invention or what might be called true collaboration. For that, one has to consider artistic interaction among "equals" like that experienced in the Carracci Academy of the late sixteenth century, which included not only students, but multiple masters who worked in various collectives to solve representational or aesthetic problems. Perhaps the best-known case of an oeuvre in which collaborative practice was essential is that of the Le Nain brothers of seventeenth-century Paris (fig. 1). The three brothers worked in the same studio and signed the majority of their work only with their surname, creating problems of attribution for art historians. This kind of attribution quagmire recurs with regularity in the study of late medieval painting practice, as well as in the scholarship around the careers of such legendary Renaissance artists as Giorgione and Titian, who produced work that challenges the very best connoisseurs.

But despite these difficulties, the brand of the artist continues to triumph in art history. From the earliest art-historical rediscovery of the Le Nain brothers in the nineteenth century, scholars have labored to separate the work of the three brothers so that Antoine, Louis, and Mathieu each have their own paintings, and the same is true for undocumented paintings and drawings by one or other of the Carracci brothers in the preceding century.[1] We want to know that a work of art is wholly by an individual artist because it is difficult for us to imagine more than a single person working on something handmade. We yearn to downplay the role of collaboration and competition in the study of art. It is individual artists who matter, not collectives of various types.

The study of "schools" of artists or of artist "colonies," however, works against this overwhelmingly monographic tendency. In both these types of study, the former practiced rigorously in the

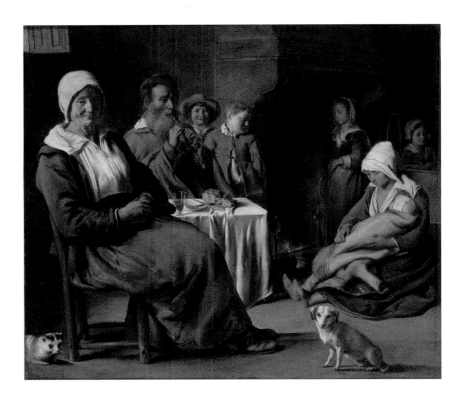

organization of the earliest European art museums and surviving today in institutions from Saint Petersburg to Chicago, artists are considered in groups defined by the place in which they worked. The regional schools of Italy persist in art-historical investigation, and there is still a kind of competition for supremacy among scholars who study artists from the Bolognese or Florentine or Venetian Schools. Which school had the most masters? Which produced the most significant formal or iconological innovations? Which had influence beyond the descriptor city of the school? Yet, in the end, a school is simply the sum of the masters who worked in that city, not a place of collaboration and collective activity. Each artist remains alone with his students in the physical milieu of the school's place.

Similar problems plague the study of colonies of artists who worked together, generally in the summer months, in far flung beach, peasant, or mountain communities throughout Europe and the United States.[2] When we discuss the Pont-Aven School of the late nineteenth century, we see it as dominated by Paul Gauguin, although many of its members were artists whose work has no connection whatsoever to that artist's aesthetic. And, even in the one area in which formal invention seems tied to Pont-Aven—the case of the "invention" of Cloisonnism by either Gauguin or Émile Bernard— the literature is focused on identifying which of the artists was the prime mover (fig. 2).[3] It would be more profitable to analyze the structure of the collaborative working method in which Gauguin, Paul Sérusier, Bernard, and possibly others collectively engaged as they introduced new and innovative practices into their art.

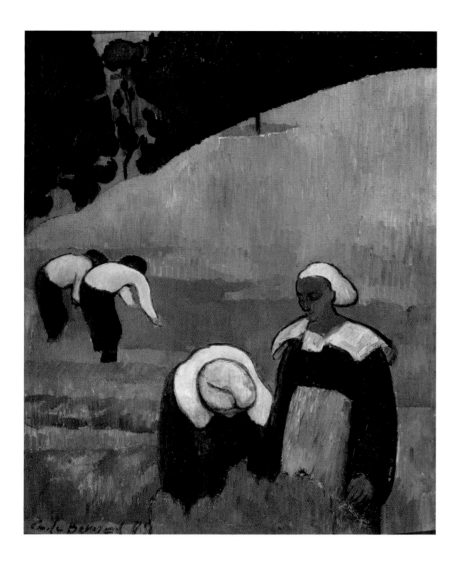

2. **Émile Bernard**
Breton Landscape or *The Harvest*, 1888. Oil on wood,
22 ¼ × 17 ¾ in. (56.5 × 45 cm). Musée d'Orsay, Paris,
RF 1977-42

One tack that scholars have taken to address the issue of artistic collaboration is to focus on pairs of artists, and two groundbreaking studies of artist pairs in the history of modern art deserve special attention. The first is Barbara Ehrlich White's *Impressionists Side by Side*, published in 1996, which includes lengthy and well-illustrated chapters devoted to pairs of artists working in dialogue.[4] White's text is based on letters and documents, and clearly articulates the intensity of these working relationships—some more rivalries than friendships. The author courageously includes women artists in these dialogues, not only in their professional relationship with male artists, but also, in the case of Mary Cassatt and Berthe Morisot, with each other. The persistent flaw of White's important book, however, is evident in its title, which suggests that the artists worked next to each other physically, when this is true in only a minority of the cases she illustrates and discusses. Even so, White's overall argument and image selection reveal that she considers these dialogues in a much more comprehensive manner than her "Side by Side" title suggests.

A decade later, in 2006, Joachim Pissarro's study of two pairs of artists—one from the nineteenth century (Cézanne and Pissarro) and one from the twentieth century (Robert Rauschenberg and

Jasper Johns)—appeared in print.[5] Himself the great-grandson of Camille Pissarro, one of the most persistent collaborators in the history of art, Joachim Pissarro uses the term "dialogical" to describe the relationship within these artist pairs. He calls his book a study in "intersubjectivity," and maintains that all major artists define themselves with and against others in ways so essential that they cannot be subsumed under the category of "influence." Although in no case does he insist that any of the works of art he discusses were made jointly, he does believe that the intersubjective condition of making, talking, seeing, and being together was necessary for either artist to make anything on his own. The study focuses on the way artists in such relationships approach and, alternatively, avoid each other throughout the creative process in order to become themselves. The dialogue between "us" and "me" is as fluid as a conversation or argument, and involves personal as well as technical components. This dialogue is embodied, for Joachim Pissarro, in the works made by each individual artist.

Like White, Pissarro makes use of primary documents like letters and contemporary reviews, although he places all of this material in a context derived fundamentally from philosophy, particularly German philosophy from the eighteenth century to the present. This methodological openness to sources outside the traditional purview of art history allows Pissarro to approach the nature of artistic collaboration in new and exciting ways. Indeed, when reading the passages of Immanuel Kant and Johan Gottlieb Fichte quoted in Pissarro's text, one feels in the presence of thinkers who write precisely about the conditions for both individual and intersubjective action—conditions of real relevance for a new kind of art history.

The problem with both these texts, and many others dealing with pairs of artists, is precisely that too much of their attention is devoted only to pairs, when, in fact, artists often work in groupings of three or more, which results in complexities of method for the modern scholar.[6] Focusing on three extremely innovative artists of the late nineteenth century, this current exhibition is what we might call "triological," and provides the first in-depth exploration of the meaningful and sustained interaction among these artists over the period of more than a decade when they worked together.[7] While the precise nature of that interaction is covered in the other essay in this volume, the issue of multiple artist interactions and the move beyond pairs has larger implications worth investigating.

One of the very few books that attempts to look at this type of larger collaboration is Jeffrey Meyers's *Impressionist Quartet: The Intimate Genius of Manet and Morisot, Degas and Cassatt*.[8] Yet, even here, as the title makes clear, the quartet is really a series of pairs in various combinations— Degas and Manet, Manet and Morisot, Degas and Cassatt, Morisot and Cassatt—without two of the possible permutations of those four artists: Degas and Morisot (though this could have been promising) or Manet and Cassatt. Rather than creating the quartet of his title, Meyers limits himself to duets.

Confining myself only to French art from 1830 to 1900, I can think of several larger interactions involving painting and printmaking. Perhaps the clearest model for the Pissarro-Degas-Cassatt

trio was the group of painters and photographers making clichés-verre in and around Arras in the 1850s. A hybrid of autograph printmaking and photography, the cliché-verre had been developed as early as the 1830s, but its real artistic triumph came two decades later in Arras, a large commercial and administrative town in northeast France.[9] The loci were the home and commercial lithography studio of a painter named Constant Dutilleux, whose friendship with Jean-Baptiste-Camille Corot was to provide a link to the Paris-centered art world. While staying repeatedly with Dutilleux and his family in Arras between 1851 and 1865, Corot worked with a father-son team of photographers named Adalbert and Eugène Cuvelier, a professor of drawing in Arras named Léandre Grandguillaume, and a practitioner of both lithography and photography named Charles Paul Desavary.

This small group of artists brought together a wide range of technical knowledge in both printmaking and photography. To this experience in reproductive technologies, a minor artist, Grandguillaume, and a major one, Corot, contributed skills in autograph art making. Together, they worked toward a production of both lithographs and clichés-verre of varying types. This collaboration resulted in a group of innovative photographic prints destined to play an important role in the history of modern printmaking, photography, and representational art in general (fig. 3). Although each seems mostly to have worked on his own glass plates, the artists used many different transfer methods and played with materials in such an experimental way that their efforts were as much collective as individual. Not even Corot could have accomplished what he wanted without the technical support

3. Jean-Baptiste-Camille Corot
The Dreamer (Le Songeur), 1854. Cliché-verre on paper, 5 ⅞ × 7 ⅞ in. (15 × 19.9 cm). Library of Congress Prints and Photographs Division, Washington, DC

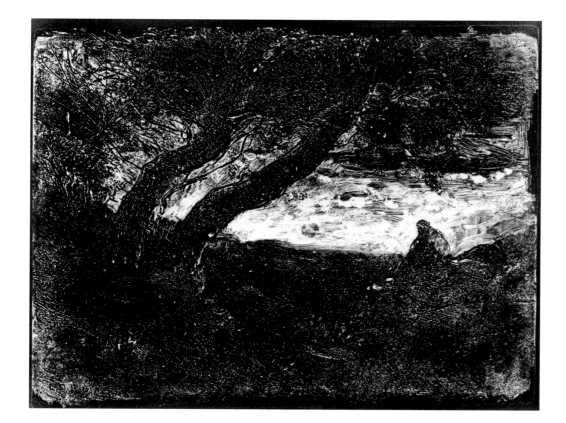

of the others, and it is highly likely that, in many cases, more than one hand was involved in creating the image on the glass plate and in exposing the plate to light.

When one looks at the surviving clichés-verre produced in Arras between 1851 and 1865 (when Dutilleux died), it is difficult to be sure about attributions of uninscribed prints from unsigned glass plates. The connections between certain clichés-verre by Corot and others attributed to Dutilleux are so marked that any reasonable viewer would find it difficult to accept the attribution to one or the other unequivocally. And the possible confusion continues when we take into account the fact that Corot taught the methods he learned at Arras to his friend Charles François Daubigny. Indeed, one would be immediately tempted to attribute an impression formerly in the collection of Huguette Berès entitled *Evening—Fisherman* to Daubigny were it not for an inscription by Dutilleux.[10]

What is fascinating is that, to my knowledge, there has never been a systematic exhibition of lithographs, clichés-verre, and drawings produced by these artists in Arras in the 1850s and 1860s. The Arras paintings by these artists can be seen in Arras itself, but most of the exhibitions devoted to their printmaking have dealt only with the clichés-verre and omitted the lithographs and drawings.[11] It was, in the end, the complex interplay among several media, both reproductive and autograph, that animated the discussions and bouts of collective work in Arras, and exhibitions and books limited to one of the media miss the subtler aspects of the intramedia collaboration.

Another gathering of artists involving collective printmaking is the enterprise of the Société des Aquafortistes founded in Paris by Alfred Cadart and Auguste Delâtre in 1862. While the etching revival was jump-started by artists of the so-called Barbizon School in the 1840s, Cadart's promotional and economic savvy and Delâtre's technical expertise successfully brought a medium that had languished since the eighteenth century into the hands of scores of artists.[12] Cadart's role in publishing editions of etchings has often been justifiably stressed in the literature on the etching revival, but Delâtre's hands-on teaching of the complex chemistry of etching and the numerous techniques within the medium has been underemphasized. There must have been many gatherings of artists in Delâtre's studio to work in small groups (depending on skill and technical difficulty) preparing copper plates, applying soft ground, and using various tools to etch in other harder grounds. These technical exercises had aesthetic as well as strictly mechanical dimensions. For example, the transference of the wrist gestures used in etching to drawing and even painting became increasingly prominent in the experimental art of the late 1860s and 1870s. Notably, the characteristic, almost instinctual, gestures used by the Impressionists as a direct record of their manipulation of paint in their plein-air landscapes of the second half of the 1870s have their most substantial precedents in the graphic arts—lithography and etching as well as drawing.[13] This extended influence on one medium from another made these graphic experimental groupings significant in ways that transcended both the medium and the discrete period of interaction in the studio.

Aside from these earlier complex groupings of artists, the most important context for the three artists whose collaboration is the subject of this exhibition is Impressionism itself. Starting with the Paris views of Claude Monet and Renoir in 1867, gaining momentum when these two artists painted together at La Grenouillère in the summer of 1869, and then fanning out to the various groupings of artists in the 1870s working in Argenteuil (Monet, Renoir, Alfred Sisley, and Gustave Caillebotte) and Pontoise (Pissarro, Armand Guillaumin, Paul Cézanne, and later Gauguin), the artists associated with Impressionism worked in diverse permutations and combinations in the formative years of the movement. When this is considered with the fact that they also exhibited together, selecting their own submissions and working to install them, it becomes clear that the movement was a true collective. Strangely, this is almost never recognized in exhibitions or books, which tend to follow the art-historical trend toward the definition of single-artist brands.[14]

After the initial period of the group's formation, yet another instance of collective effort occurred around the "invention" of the dot as a mode of paint application in the 1880s. While the discovery of the dot method is usually attributed solely to Georges Seurat, from whom it is said to have spread to other artists, the process of dividing the surface of a painting into uniform touches of color (rather than mixing them on a palette) had actually been in practice since the early 1870s, and took a real collaborative turn with Pissarro, Cézanne, and Gauguin in the years 1878–85—well before any of them met Seurat. And both Monet and Sisley, although not part of the collaborative group, made paintings that, when seen by the others, contributed to the development of the "divided" pictorial surface. As in the case of the invention of Cloisonnism, the study of single artists in isolation has again resulted in simplification of the actual art-historical record. Taking note of the current state of scholarship, the pioneering work of John Rewald, who was the first to work intensively in the family archives of the artists, deserves renewed consideration. His 1946 *History of Impressionism* is a collective rather than an individual study, and lays bare the almost heroic joint enterprise of these artists against the prevailing structures of the state art system dominated by the Academy and its Salon.[15]

We can perhaps best understand the nature of the Impressionist enterprise when we think about a particular grouping of artists who gathered for a period of several days in the landscape around Pontoise in 1881. Working from memory in the early twentieth century, George Manzana-Pissarro, Camille's son, recalls this moment in a drawing he called *An Impressionist Picnic* (fig. 4). Depicting four painters—Pissarro, Cézanne, Gauguin, and Guillaumin—just before lunch in the landscape east of Pontoise, waiting for Mme Pissarro to finish cooking over a campfire, the drawing forces us to think about how the group worked collectively on a pictorial project in a single landscape. The artists lounge, chat, paint, and play, clearly hungry after a long morning of work. What we learn from this is that these artists worked together on the same landscape theme, directly comparing their efforts to similar paintings by the others. And there were certainly informal critiques as well as "touch-ups" or specific suggestions about awkward passages or demonstrations of particular paint stroke technique, making these shared work periods important in diverse ways to the artists present.

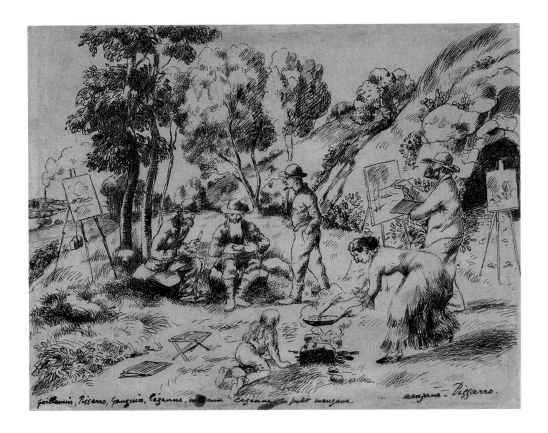

This type of interactive art practice was also bolstered when the artists traded works or lent paintings or drawings to each other for study. Cézanne actually copied a plein-air landscape painting by Pissarro in order to sharpen his techniques of pictorial construction and his control of facture. And this surely also happened with Gauguin, who had the means to purchase paintings by Cézanne, Pissarro, and Guillaumin so that he could look at them obsessively.

We know, of course, that all of this happened earlier in the history of art. The painters of the eighteenth and nineteenth centuries who traveled in the Roman Campagna from the Netherlands, Germany, France, Scandinavia, and the United States worked jointly both in the countryside and in their Roman studios in ways that would have been difficult or even impossible at home. Tracing the effect of these interactions would not only free the oeuvres of these artists from the silo of individual artist narratives, it would also undoubtedly lead to important new insights into the nature of the collective practice of art.[16]

Simply because the study of artistic interaction has taken a backseat to that of individual artists, this exhibition is particularly welcome. It can focus the attention of future scholars on these nodes of collectivity that largely structure invention in the visual arts. That matters of technique and of experimentation with materials were often more effectively dealt with in small collectives than in the privacy of an individual studio is abundantly clear. The wide-ranging impact of these types of collaborations and how they shaped the arc of art's history, however, has yet to be fully appreciated. Let's start the work now.

INNOVATIVE IMPRESSIONS

Cassatt, Degas, and Pissarro as Painter-Printmakers

Sarah Lees

"Today there are two kinds of etchings: those that everyone makes that look the same in subject, facture, color, and especially in the absence of ideas—they rely on the title to say what they want to be—and those that are self-explanatory. The latter are imperfect. Like youth, they have flaws, and it's in their nature to have them. . . . The edges are uneven, certain parts are neglected, others partially made, and others have a finished and charming spirit. You are looking at a true etching, the work of an artist, and the spirit he put into his plate awakens yours and speaks to it. . . . They feel unexpected, they are unfinished and undefined; it is characteristic of etching to be sudden and finished at the same time."[1]

These words, written in 1876 by an artist in the Impressionist circle, Vicomte Ludovic Lepic (1839–1889), describe (with a certain degree of self-importance) a new approach to etching that he was practicing. Other avant-garde artists in France were just beginning to take up this approach at the time, and a few years later their efforts would begin to reach fruition. Perhaps the most striking aspect of this description is that it refers to a printmaking technique, for it would seem otherwise to be an apt assessment of the paintings with which the Impressionists had begun to make their

names in their first exhibition in 1874. That exhibition, in fact, incorporated a considerable number of etchings—including three by Lepic himself—suggesting that prints had a place from the outset in the work of these experimental artists.

Only three of the most prominent members of the Impressionist group—Mary Cassatt (1844–1926), Edgar Degas (1834–1917), and Camille Pissarro (1830–1903)—developed significant bodies of printed work, but these three artists devoted considerable efforts to printmaking, expanding the boundaries of the medium in both form and content much as they did in painting. They were an unlikely trio. The differences among them in nationality (Cassatt was American, Degas was French, and Pissarro was born in the Danish West Indies to French-Jewish parents), gender, age, religious background, and political convictions might have hindered their relationships.[2] Yet in spite of their differences, they were all members of the collective group that formed in the 1870s; they respected each other as colleagues; they socialized with each other for much of their lives; and for a brief period in 1879–80, they worked together directly on a project to publish their etchings. While print-making endeavors are often collaborative to some extent, with the tasks of creating the image, producing the matrix, and printing the image sometimes being divided among several different people, the interactions among Cassatt, Degas, and Pissarro were of a different order. They shared the belief that not only was there value in the artist executing each of these steps, but that doing so allowed them greater freedom to develop unconventional techniques that served their artistic visions, much as Lepic articulated in his essay. They also shared practical advice about these tech-niques with each other, particularly when they first began to collaborate in the late 1870s and Degas, who had previously worked more extensively with etching than his two colleagues, demonstrated or explained his approach to them.

In the following years, these artists expanded their practices to include not only etching, but drypoint, lithography, and monotype—developing new methods to explore the expressive potential of each. This included the incorporation of color into media that had, up to that point, been pre-dominantly black and white. And as prints became a significant portion of their output, these works not only drew inspiration from, but contributed important ideas to, the artists' paintings. Indeed, the small scale and intimate nature of works on paper gave the artists the opportunity to be more radically inventive in their printed work than they were in their paintings. After their initial collabo-ration came to a close, the three artists continued to see each other and to take interest in each other's work, a dynamic that occasionally included a degree of criticality, even competitiveness, as well as mutual support. Certainly, each also had significant relationships with other artists. Notably, the close bond between Pissarro and Paul Cézanne (1839–1906), centered on painting, was more sustained and intensely personal than that among the three printmakers.[3] In the print medium, how-ever, Cassatt, Degas, and Pissarro were the only Impressionists whose shared interest in techniques drew them together through interactions that involved similar reciprocal exchanges intended to develop a new visual language. This complex dynamic of artistic interchange, which they sustained

over most of their careers, was the ground from which their printed work sprang, and highlighting it provides a new perspective on the creative processes each of them followed.

Originality and Experimentation

The three artists' printmaking developed in the context of a renewed interest in original prints, particularly etching, in the mid-nineteenth century. Etching as a technique had gone in and out of favor in Europe over the centuries, and in the earlier part of the nineteenth century it had few adherents. The primary purpose of prints in this period was to reproduce works of art in other media, and the regular, carefully controlled line of engraving was seen as better suited to the task of reproduction than the more fluid and spontaneous line of etching. But artist associations like the Etching Club, which formed in London in 1839, began to reevaluate etching's characteristics and capabilities, and to defend its qualities as a means of artistic expression.[4] In France the revival took shape somewhat later, marked particularly by the formation of the Société des Aquafortistes (Society of Etchers) in 1862, a group led by several figures, including the publisher Alfred Cadart (1828–1875) and the artist Félix Bracquemond (1833–1914). The concept of originality served as one of the primary focal points of the project, and this originality was defined in contrast not only to reproductive engraving, but also to the still-new medium of photography, which served the purpose of reproduction even more faithfully than older media. As journalist and art critic Théophile Gautier explained, in the preface to the first portfolio of etchings published by the Société in 1863, etching could "combat photography, lithography, aquatint, and dot-and-lozenge engraving . . . work that is regular, automatic, lacking in inspiration, work that denatures the artist's idea."[5] In this formulation, etching became a direct expression of artistic inspiration.

Another quality that was understood to define the etching medium was improvisation, even experimentation. This was articulated a few years later by Charles Blanc, a critic, editor, and arts administrator who, in 1867, published his influential treatise on art and architecture, *Grammaire des arts de dessin: architecture, sculpture, peinture*. Soon to be elected head of the Académie des Beaux-Arts, Blanc was a staunch defender of artistic traditions and valued the formal qualities of engraving somewhat higher than those of etching, but he nonetheless delegated an important role to etching. In the section of the *Grammaire* that described etching, he wrote, "just as the [engraving] burin, with its formal air, its planned and methodical elegance, is well suited to solemn compositions and ideal figures and nudes, so etching, with its capricious approach, works well with familiar and pastoral things, with the jumble of rustic landscapes, the picturesque quality of ruins, and the perpetually recurring battles that light and shadow wage before our eyes. . . . In a word, the burin corresponds to the majesty of art and the severe eloquence of design; etching represents improvisation, liberty, and color."[6]

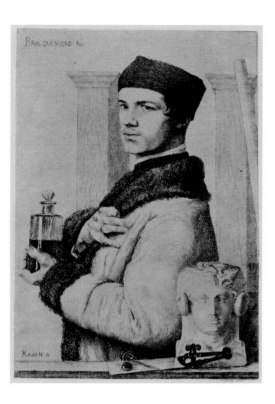

5. Paul-Adolphe Rajon
Félix Bracquemond in 1852, c. 1870. After Félix
Bracquemond (French, 1833–1914). Etching on paper.
Harvard Art Museums/Fogg Museum. Cat. 95

These concepts also informed the meaning of the term *peintre-graveur*, a formulation probably
first used by Adam Bartsch (1757–1821), the Viennese artist and art historian who titled his twenty-
one-volume compendium of Old Master printmakers *Le peintre graveur* (1803–21). Although Bartsch
used the French word *graveur*, which is strictly translated as "engraver," these volumes included all
the print media artists had used up to that time. A more apt translation of the compound term
would render it as "painter-printmaker"—and this broader designation is closer to Bartsch's intended
meaning, which was not to single out engraving as a medium, but rather to indicate artists who
worked in both painting and printmaking, and who, in the latter mode, created images of their own
invention rather than copying from other media. As etching underwent a reevaluation in the nine-
teenth century for its qualities of spontaneity and invention, the term peintre-graveur or painter-
printmaker became closely associated with artists who created original etchings, precisely as a
means of distinguishing them from copyists who most often worked in engraving. Thus, by the time
the Impressionist artists organized their group, the medium of etching had already been defined as
embodying values that they broadly embraced in their work.

Two peintre-graveurs and members of the Société des Aquafortistes played particularly significant
roles in encouraging their avant-garde colleagues. The first was Bracquemond, who had tried his
hand at painting but was primarily an etcher, working both as a copyist and an original printmaker.
He explicitly presented this identity in a self-portrait drawing of 1853 (Harvard Art Museums/Fogg
Museum, Cambridge, MA) that he exhibited at the Salon (and that was later translated in etching
by Paul-Adolphe Rajon [fig. 5]). The drawing is inscribed "F. Bracquemond pictor chalcographus,"

6. Félix Bracquemond
The Winged Door (Le haut d'un battant de porte), 1852,
published 1865. Etching on laid paper, v/v. Spencer
Museum of Art. Cat. 1

or painter-printmaker, and its pose and presentation situate the artist in the lineage of such fore-bears as Titian (1488–1576), Albrecht Dürer (1471–1528), and more directly, Jean-Auguste-Dominique Ingres (1780–1867). Alluding to Ingres's already well-known self-portrait of 1804 (Musée Condé, Chantilly), Bracquemond depicts himself holding a jar of etching acid with an engraver's burin and copper plate beside him, rather than the painter's brush and canvas.[7] He had found early success in his chosen profession the previous year with *The Winged Door* (*Le haut d'un battant de porte*) (fig. 6), an illusionistic image that presents the upper portion of a stone door frame and wooden door to which are nailed three birds and a bat, along with a small wooden plaque inscribed with a moralizing verse. Reportedly based on an actual farmyard scene Bracquemond observed,[8] the etching served as a showcase for the artist's talent, and was soon lauded by critics and colleagues, particularly after its inclusion in the Exposition Universelle of 1855.

As this success suggests, Bracquemond was able to navigate both official and oppositional spheres of the art world, and his work, similarly, could be fairly conventional or more original. His copy work often demonstrated consummate technical skill, as in his 1863 version of Hans Holbein's portrait of Dutch humanist scholar Desiderius Erasmus (c. 1523; Musée du Louvre, Paris), which was commissioned by the French government. Working painstakingly through ten states, Bracquemond achieved an effect comparable to the fine detail and crystalline clarity of his painted source (figs. 7–9).

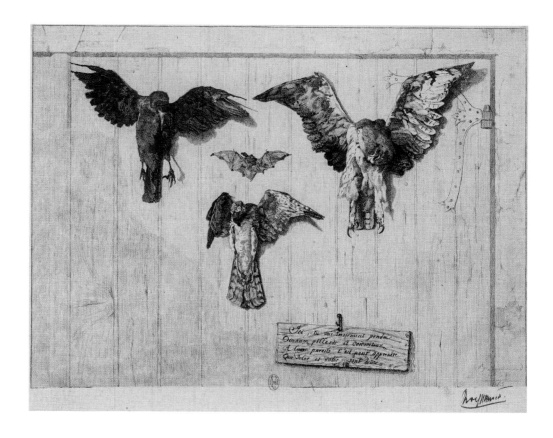

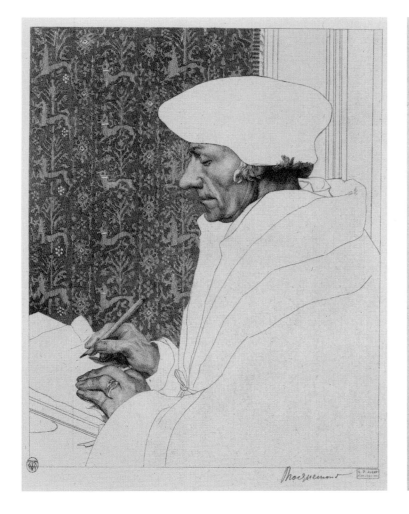

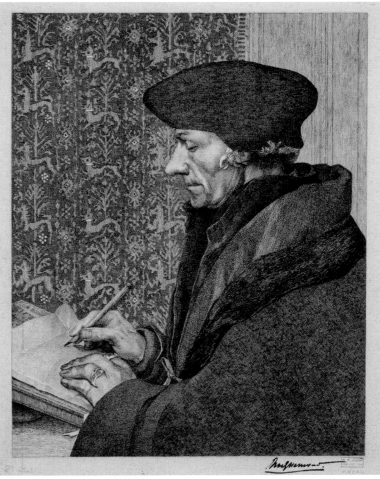

The set serves as a textbook demonstration of the etching process, as the image's development extends over a considerable number of steps, progressing logically from an obviously incomplete state to one of fully worked completion.[9] Despite the commission, as well as the traditional appearance and evident artistic success of the result, the work was rejected by the jury of the 1863 Salon, perhaps as much in response to Bracquemond's liberal political leanings as to any bias against etching as a reproductive medium.[10] Instead, an impression of *Erasmus* appeared in the Salon des Refusés of that year, where it was joined by almost 700 other prints, paintings, and sculptures, including Édouard Manet's (1832–1883) *Déjeuner sur l'herbe* (1863; Musée d'Orsay, Paris).

Bracquemond was friends with Manet, who was a fellow member of the Société des Aquafortistes. His etched portrait of Manet served as the frontispiece for Émile Zola's 1867 *Étude sur Manet* (*Study on Manet*), and presents a bust-length depiction of the dandyish artist, impeccably dressed in a suit and tie and gazing off to the left (fig. 10). Despite the two men's close relationship, the portrait was not made from life but copied after a three-quarters length photograph by Anatole Godet (1839–1887).[11] The print captures the tousled hair, piercing gaze, and slightly furrowed brow recorded in the photograph with remarkable accuracy, demonstrating again Bracquemond's skill as a copyist

7. Félix Bracquemond
Desiderius Erasmus, 1863. After Hans Holbein the Younger (German, c. 1497–1543). Etching on paper, i/x. New York Public Library. Cat. 3

8. Félix Bracquemond
Desiderius Erasmus, 1863. After Hans Holbein the Younger (German, c. 1497–1543). Etching on paper, ii/x. New York Public Library. Cat. 4

9. Félix Bracquemond
Desiderius Erasmus, 1863. After Hans Holbein the Younger (German, c. 1497–1543). Etching on paper, viii/x. New York Public Library. Cat. 5

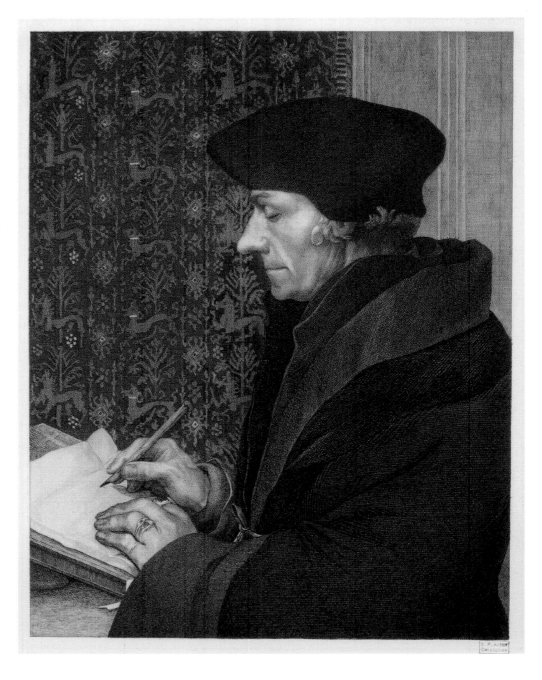

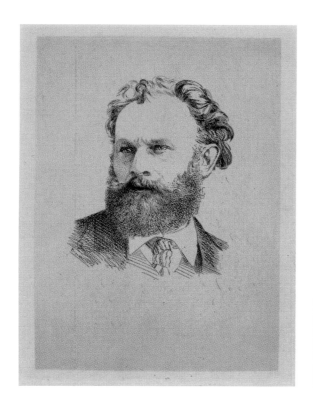

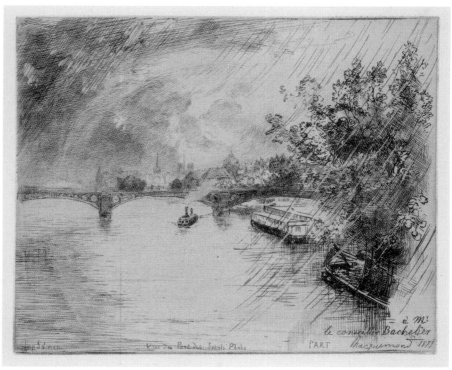

in his chosen medium. In his original work, Bracquemond's handling could be considerably looser and more sketch-like, as in the 1877 *View of Saints-Pères Bridge* (*Vue du Pont des Saints-Pères*) (fig. 11), whose urban subject and atmospheric weather conditions recall a number of paintings of the city center by his Impressionist colleagues, such as Claude Monet's (1840–1926) rainy view of the nearby Pont Neuf (1873; Dallas Museum of Art).

Likely due to his friendships as well as his talent, Bracquemond joined a group of artists calling themselves the Société anonyme des artistes peintres, sculpteurs, graveurs, etc. (Anonymous Society of Painters, Sculptors, Printmakers, etc.), who staged their first exhibition in April 1874, a display that would come to be known as the first Impressionist exhibition. Although it is not often discussed in the extensive literature on Impressionism, Bracquemond contributed thirty-two etchings to the 1874 exhibition, a surprisingly large group of prints in an exhibition generally known for paintings. The broad sampling of his work highlighted the full range of his talent as a portraitist, a copyist, and an original printmaker—the distinctions among the categories being underscored by groupings of multiple prints of each type together in single frames. Bracquemond's submissions consisted of a series of portraits of artists and writers that featured not only the first and the final states of his *Erasmus*, but depictions of Charles Meryon and Charles Baudelaire; copies after notable paintings, including Ingres's *The Spring* (1856; Musée d'Orsay, Paris) (fig. 12) and Manet's *Reclining Young Woman in Spanish Costume* (1862–63; Yale University Art Gallery, New Haven, CT) (fig. 13); and several original, informal landscapes of trees, riverbanks, and farmyards that recall Théodore Rousseau's (1812–1867) casual views of untamed nature.[12]

10. Félix Bracquemond
Manet, 1867. Etching on paper, proof. Baltimore Museum of Art. Cat. 6

11. Félix Bracquemond
View of Saints-Pères Bridge (*Vue du Pont des Saints-Pères*), 1877. Etching and drypoint on paper, iv/v. Baltimore Museum of Art. Cat. 9

12. Félix Bracquemond
The Spring, 1861. After Jean-Auguste-Dominique Ingres (French, 1780–1867). Etching on paper, ii/ii. Baltimore Museum of Art. Cat. 2

13. Félix Bracquemond
Young Woman in Spanish Costume, 1867. After Édouard Manet (French, 1832–1883). Etching and spit bite (?) on paper. Baltimore Museum of Art. Cat. 7

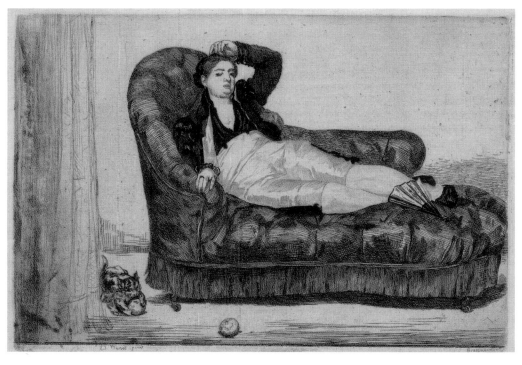

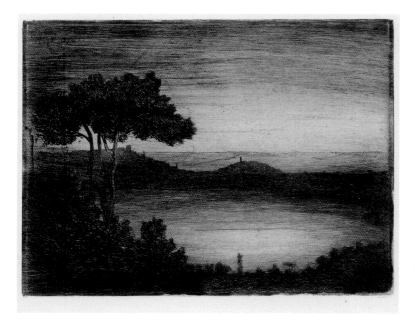

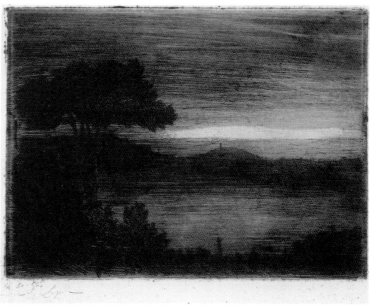

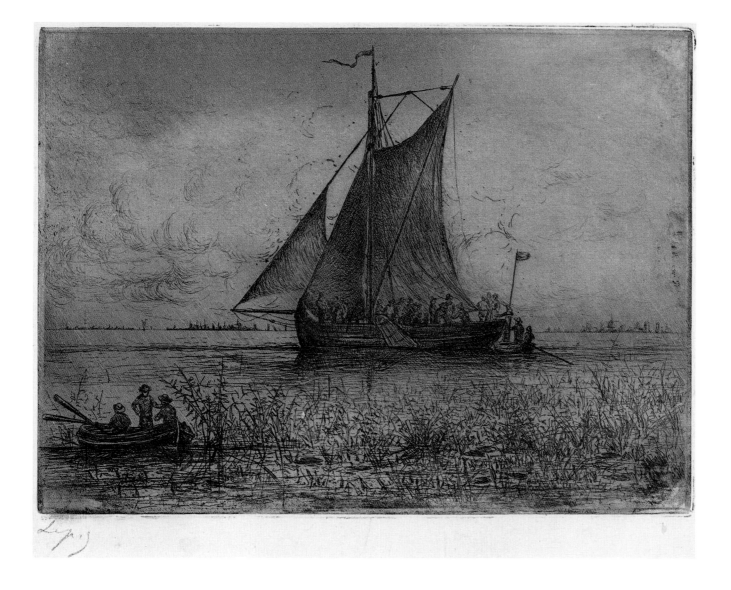

14. Ludovic Lepic
Dusk over Lake Nemi, near Rome, 1870. Etching on cream laid paper. Sterling and Francine Clark Art Institute. Cat. 61

15. Ludovic Lepic
Lake Nemi, 1870. Etching with monoprint inking in black on Chinese paper, plate: 9 7/16 × 12 1/2 in. (24 × 31.7 cm); sheet: 12 3/8 × 16 11/16 in. (31.4 × 42.4 cm). National Gallery of Art, Washington, DC, Ailsa Mellon Bruce Fund, 1997.13.1

16. Ludovic Lepic
Dutch Riverscape, c. 1870. Etching on paper. The Cleveland Museum of Art. Cat. 63

The other noteworthy printmaker who belonged to this artistic circle and contributed to the exhibition was Lepic.[13] Lepic had taken up etching as a profession at an early age despite the disapproval of his aristocratic family, was an original member of the Société des Aquafortistes, and had shown three of his etchings in the official Salon 1863. He and Degas had been friends since about 1860, and it is on this basis, as well as his friendship with several other artists, that Lepic joined the Impressionist group.[14] The three etchings he showed in 1874 had all been made more than ten years earlier and were quite traditional in technique, but Lepic had already begun to experiment with more varied approaches in the 1860s, according to his own account.[15]

Lepic's primary contribution to the renewed interest in etching was his exploration of unconventional methods of inking and handling his plates. In 1867–68, he had traveled in Italy and Holland, sketching numerous landscape subjects that he developed from drawings into etchings on his return. One of these, *Dusk over Lake Nemi, near Rome*, shows standard handling in some impressions (fig. 14), while others include more dramatic effects. The sheet in the National Gallery (fig. 15), for instance, has a layer of ink that obscures many of the linear details and dims the reflections in the lake, while a thin line of light remains in the sky—a line that was either wiped away or left clear in the process of inking. In another example from this group, *Dutch Riverscape* (fig. 16), the etched lines themselves are clear and straightforward, but Lepic added a plate tone that contributes significantly to the overall image. The dark area in the upper left is formed entirely of surface ink, as are the diagonal sweeps of tone visible especially along the distant bank. While he was aware of the historical precedents in the use of plate tone in printmaking, and even praised Rembrandt van Rijn (1606–1669) for his powerful employment of the technique, Lepic's bold experiments incorporate plate tone in new ways that enabled the artist to create dramatic variations in weather conditions or alter his compositions using only surface ink rather than etched lines.[16]

One of the most remarkable examples of this approach is the series of *Views from the Banks of the Scheldt* (c. 1870–76), in which, though the etched composition remains unchanged, conditions vary from day to night and clear to snowy, and significant landscape elements like large trees or smoke from a fire are added and then removed. Lepic noted, presumably with a touch of hyperbole, that he had modified this plate eighty-five times.[17] In another work, *Windmill in the Moonlight (eauforte mobile)* (fig. 17), Lepic's etched lines are distinctly secondary to the surface tones. Here, over an open network of hatched and crosshatched lines sketching out the composition's basic forms, Lepic applied a heavy layer of ink to create a deep black sky and then wiped a circular area of the plate entirely clean, producing a blazing, bright moon against which the figures are silhouetted. While a few other artists had already tried this kind of monotype inking and subtractive mark-making, Lepic was the first to develop his own name for the process, which he called "eau-forte mobile" (mobile etching), a designation that he inscribed in the margin of *Windmill in the Moonlight*. The name suggests the mutability of the resulting image, in contrast to the fixed and unchanging nature of a standard, traditional print—just the kind of unexpected improvisation that Charles Blanc

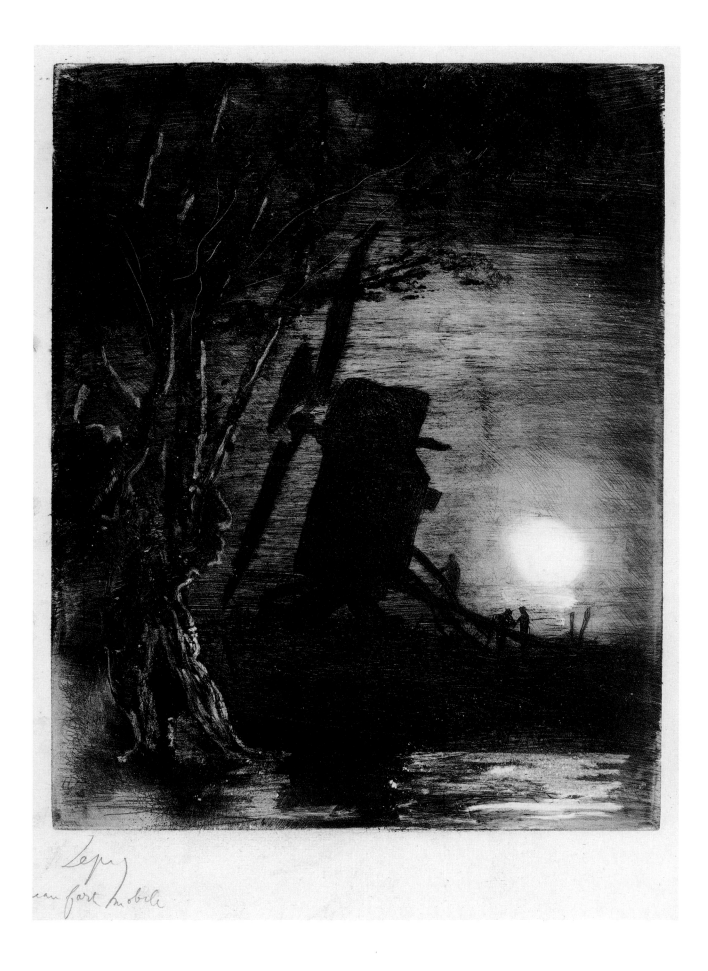

Lepere

eau part mobile

17. Ludovic Lepic
Windmill in the Moonlight (eau–forte mobile), c. 1870.
Etching with monotype inking on paper. Museum of Fine
Arts, Boston. Cat. 62

18. Edgar Degas
Self-Portrait, 1857. Etching and drypoint on paper, iii/iv.
The Cleveland Museum of Art. Cat. 36

19. Edgar Degas
Self-Portrait, probably 1857. Etching on paper, iv/iv,
plate: 9 ⅛ × 5 ¹¹⁄₁₆ in. (23.2 × 14.4 cm); sheet: 14 ⁵⁄₁₆ × 10 ¹³⁄₁₆ in.
(36.3 × 27.5 cm). National Gallery of Art, Washington, DC,
Rosenwald Collection, 1943.3.3360

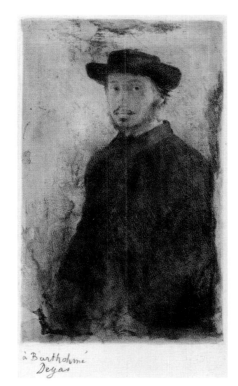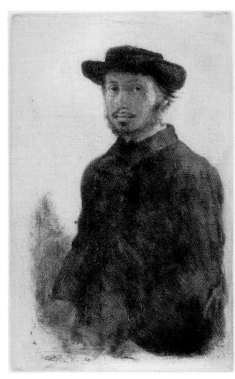

and Lepic himself had defined as characteristic of the medium. It is precisely this kind of innovative work of Lepic's, along with other aesthetic and practical concerns, that began to have a significant impact on Degas's printmaking practice, and in turn on the work of Cassatt and Pissarro.

Degas had already made a considerable number of prints by the mid-1870s. He had first experimented with etching in 1856, using the medium over the next decade to make more than a dozen works, most of them portraits. One of his first significant prints, a self-portrait made during a three-year stay in Italy, was inspired by traditional sources, such as Rembrandt and Ingres, and it relates closely to a painting of the same period (c. 1857–58; Sterling and Francine Clark Art Institute, Williamstown, MA). Degas initially sketched his composition on the plate using light, open lines, creating a uniform tone throughout the image. After reworking the plate for the second state, adding further lines to render his face and figure more solidly, he experienced some difficulty in biting the plate, as some of the acid accidentally etched the lower edge of the image. The third state shows further foul biting, visible as soft, amorphous forms encircling the artist's figure, but rather than burnishing these marks out or abandoning his plate, Degas chose to enhance their atmospheric effect by leaving varying amounts of plate tone on different impressions in addition to the etched forms. The Cleveland version (fig. 18) has a light, uniform tone over much of its surface, so that many of the crosshatched lines modeling the face are still visible, while another third-state impression at the Clark Art Institute displays much heavier inking that obscures much of the linear detail. Finally, in the fourth state, Degas removed most of the unintentional marks in the background and, in the National Gallery sheet (fig. 19), printed the plate relatively cleanly, producing a

Converging Interests and Developing Collaborations

Degas's return to printmaking in 1875–76 was prompted by a variety of impulses that included newly emerging financial challenges and increased exposure to different printmaking techniques, probably thanks to his friendships with printmakers like Bracquemond, Lepic, and Marcellin Desboutin (1823–1902). It was Desboutin who, in 1876, described Degas as "no longer a friend, a man, an artist! He's a zinc or copper plate blackened with printer's ink, and plate and man are flattened together by his printing press whose mechanism has swallowed him completely! The man's crazes are out of this world. He is now in the metallurgic phase of reproducing his drawings with a roller and is running all over Paris, in the heat wave, trying to find the legion of specialists who will realize his obsession."[29] Desboutin's description of a plate with ink on it run through the press, a drawing reproduced with a roller, and no mention of a needle or other implement to create lines, seems especially suggestive of the monotype process, a technique that Degas employed frequently from 1876 through the mid-1880s. This was the most prolific period of Degas's printmaking career—one in which he explored as many techniques as possible, and as feverishly as Desboutin suggests.

The results are evident in a number of ways, not least of which are the works Degas showed in the third Impressionist exhibition of 1877. These include not only a number of pastel over mono-types like the two cited above, but also three untitled works described in the catalogue simply as "drawings made in greasy ink and printed" (dessins faits à l'encre grasse et imprimé), a description that corresponds closely to Desboutin's, and that must indicate monotypes without the addition of any color medium. As well as making monotypes, Degas returned to the increasingly complex blend of etching techniques that he had earlier explored in his Manet portrait. One of the first sub-jects he concentrated on, which also featured prominently in his monotypes and pastels, was that of performers onstage at the ballet or café-concert. A group of related works, each titled *On Stage*, was probably made with the goal of providing an illustration (though not an exact replica) of a pastel to be included in another exhibition in 1877.[30] In *On Stage I*,[31] Degas situated himself roughly eye-level with the stage and with the musicians in the orchestra pit, so that the head of the double bass player and the scrolling head of his instrument cut across the view of two ballet dancers on the stage. This was a motif Degas treated numerous times, perhaps the best-known instance being the painting *The Orchestra of the Opéra* of around 1870 (Musée d'Orsay, Paris).

Degas's second approach to this composition is the most remarkable. In *On Stage II* (fig. 24) the same two dancers appear in similar poses, but they are on the left rather than the right side of the com-position, and they are immersed in a deep, fluid darkness—the result of a heavy application of aquatint. The contrast between the dancers' glowing, ethereal skirts and the surrounding gloom dominates the image, and given that the plate is lacking a level of detail usually found even in first state impressions, it is likely that Degas intended this elemental opposition to be the primary focus of this print. After print-ing one impression, however, he put aside this plate too, and started on a third (fig. 25). Here the two

24. Edgar Degas
On Stage II, 1876. Aquatint over softground etching on paper. Museum of Fine Arts, Boston. Cat. 38

dancers remain on the left side of the sheet, now joined by a third further to the left, and the details of the setting reemerge: a dramatic backdrop that seems to feature twisting tree branches, sketched with both pointed and blunt tools in the softground; two double bass heads again partially obscuring the dancers; a pale line defining the stage's edge; and the tops of several musicians' heads below. This version of the motif must finally have satisfied the artist, because he printed the final state in some quantity. One impression of *On Stage III* (fig. 26) also reveals an instance of Degas's further experimentation with this plate, as he introduced color not through the addition of pastel or gouache, but with a red-brown ink, something he had tried with a few earlier plates.[32]

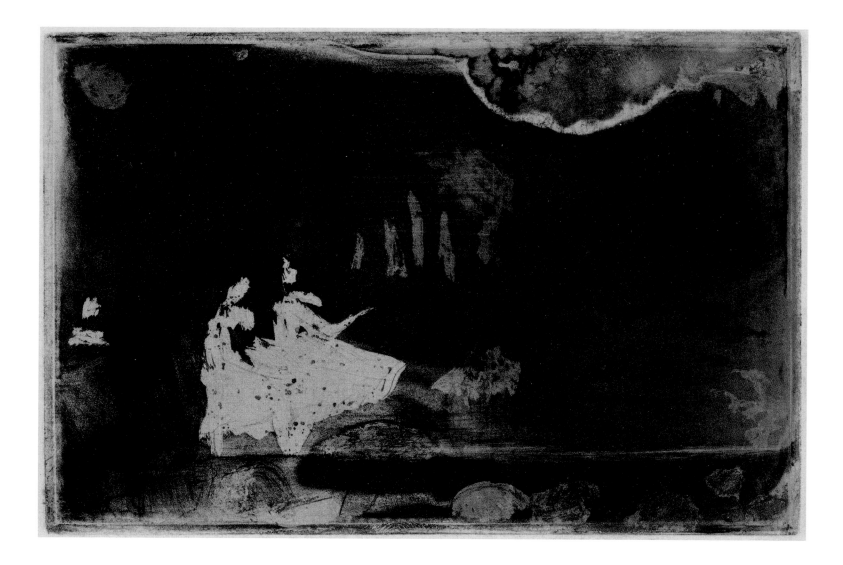

As Degas was devoting considerable time to printmaking, Cassatt and Pissarro were still primarily concentrating their energies on painting. Pissarro, living in Pontoise, produced numerous views of that locale, submitting twelve paintings that explicitly identified the town, or the river Oise, to the Impressionist exhibition in 1877. One type of composition he developed is a view of a group of small white houses seen through a stand of slim, mostly leafless trees, as in *Côte Saint-Denis à Pontoise* (1877; Musée d'Orsay, Paris), and *The Côte des Boeufs at l'Hermitage, near Pontoise* (1877; The National Gallery, London). As well as deriving from a lineage tracing back to Corot, as Joel Isaacson has discussed, these pictures present a uniform distribution of light, shadow, and tone that gives equal emphasis to the screening network of tree branches and to the solid mass of the houses.[33] This, in turn, calls attention to the process of perception and representation, concerns that also preoccupied Degas, if in the very different context of the public performance space. Indeed, an analogy might be drawn between Pissarro's trees and houses and Degas's orchestra musicians and dancers, each element being held in balance with the other as the subject of the image.

Cassatt, for her part, had turned to the subject of the theater, perhaps inspired by Degas's example. Of the eleven works that Cassatt submitted to the 1879 exhibition, four were set in the theater. One of these, *Woman with a Pearl Necklace in a Loge* (fig. 27), depicts a woman seated in a chair, looking out at the hall and other spectators, who are reflected in the mirror just behind her. As much as this painting draws attention to spectatorship and the process of looking, it also embodies Cassatt's fascination with the visual qualities of light and its ability to model form and define color. In this case, the young woman leans back in the loge, away from direct illumination by the brilliant gas chandelier hanging in front of her. Her face and much of the front of her body are slightly shadowed, while the light reflected from the mirror illuminates the right side of her face, the edges of her shoulders and arms, and the sides of her gleaming blonde hair. The complex light conditions and

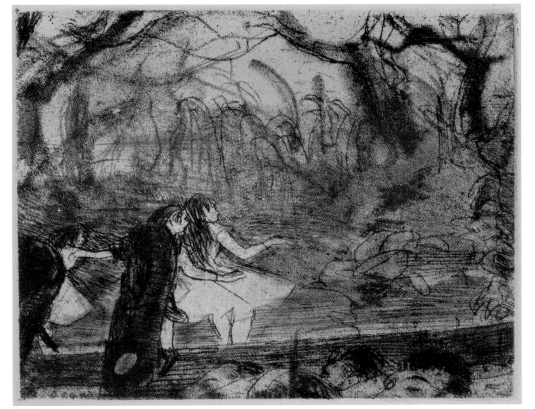

25. Edgar Degas
On Stage III, 1877. Etching on paper, v/v. Mildred Lane Kemper Art Museum. Cat. 40

26. Edgar Degas
On Stage III, 1876–77. Softground etching and drypoint with roulette on paper, printed in red-brown ink, iv/v. Philadelphia Museum of Art. Cat. 39

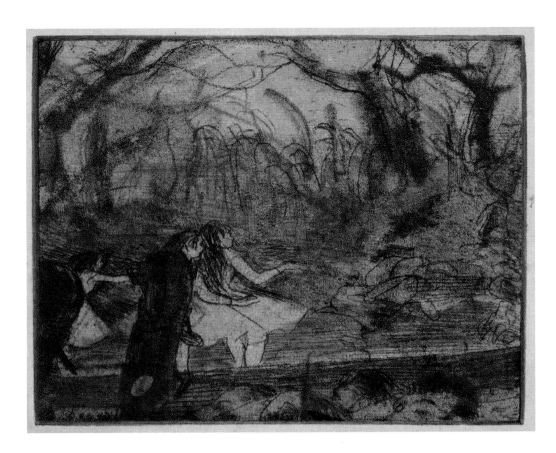

27. Mary Cassatt
Woman with a Pearl Necklace in a Loge, 1879. Oil on

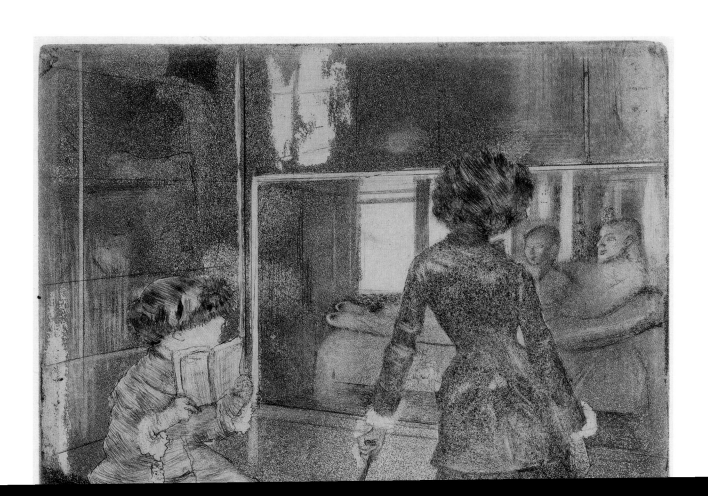

29. Edgar Degas
Mary Cassatt at the Louvre: The Etruscan Gallery,
1879–80. Softground etching, etching, aquatint, and dry-
point printed in black on thin Japan paper, ix/ix. Smith
College Museum of Art. Cat. 50

30. Camille Pissarro
Wooded Landscape at the Hermitage, Pontoise, 1879.
Etching and aquatint on Japan paper, v/v. Spencer
Museum of Art. Cat. 67

31. Camille Pissarro
Wooded Landscape at the Hermitage, Pontoise, 1879.
Oil on canvas. The Nelson-Atkins Museum of Art. Cat. 65

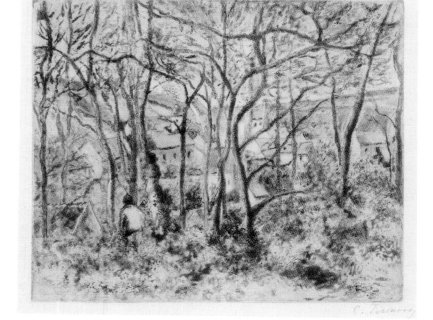

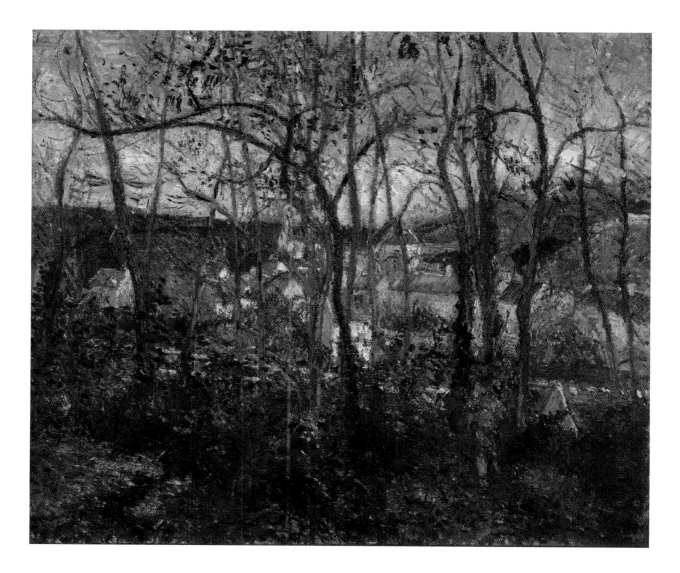

again, adding and removing tones and textures by applying or burnishing out aquatint, and com-
pletely changing for nearly every state the patterning of the marble column or door frame that
slices across the left edge of the image (fig. 37). This restless exploration of the balance between
light and dark and rough and smooth in this print is comparable to his two colleagues' approaches
to their contributions to the journal (if perhaps more obsessive). It also demonstrates that Degas's
intention was not to achieve a single, "finished" state of his print in the traditional manner, but to give
each iteration, several of which are known in single impressions, equal value as complete statements.

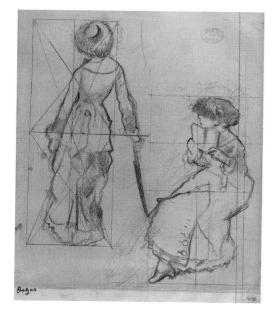

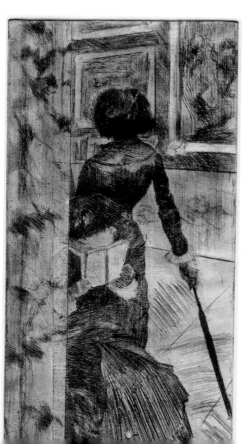

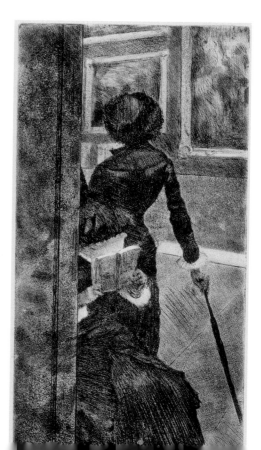

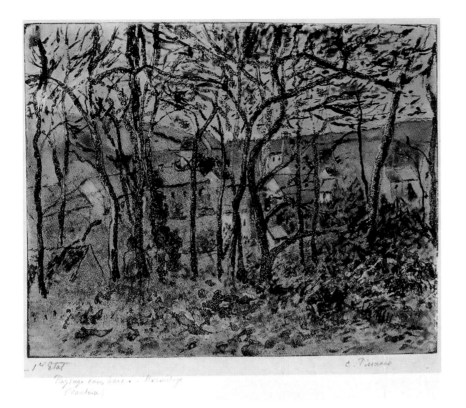

34. Camille Pissarro
Wooded Landscape at the Hermitage, Pontoise, 1879.
Softground etching and aquatint on paper, i/v. Ursula and
R. Stanley Johnson Family Collection. Cat. 66

35. Edgar Degas
Study for *Mary Cassatt at the Louvre* (recto), c. 1879.
Graphite with blind stylus on wove paper, sheet:
12 11/16 × 9 5/8 in. (32.3 × 24.5 cm). National Gallery of Art,
Washington, DC, Ailsa Mellon Bruce Fund, 1995.47.36.a

36. Edgar Degas
Mary Cassatt at the Louvre: The Paintings Gallery,
1879–80. Etching, softground etching, aquatint, and
drypoint on paper, vii/xx. The Cleveland Museum of Art.
Cat. 51

37. Edgar Degas
Mary Cassatt at the Louvre: The Paintings Gallery,
1879–80. Etching, softground etching, aquatint and dry-
point on Blacons wove paper, xx/xx. Brooklyn Museum.
Cat. 52

Degas approached this project in a somewhat different manner. As Kimberly Jones has discussed, he developed a large and complex group of works in various media focused on two women visiting the galleries of the Louvre, with the primary figure modeled by Mary Cassatt.[48] The initial conception for *Mary Cassatt at the Louvre: The Etruscan Gallery* (fig. 29) may have developed from a black chalk drawing of three figures on an otherwise blank sheet (private collection).[49] After further sketches and modifications, Degas settled on the two figures that appear in the early states of the *Etruscan Gallery* composition, one seated holding a book, the other standing, back turned, leaning on an umbrella. By the third state, Degas had added a large case holding an Etruscan sarcophagus— which he had sketched separately—as well as additional shelves and other elements of the shadowy gallery setting using aquatint and fine line work. In some sense this extensive preparatory work might be seen as a more traditional approach than Cassatt's and Pissarro's explorations of tone on their plates; Degas's treatment of each element of his composition as independent and changeable, however, is equally experimental. Even in the initial sheet he used to draw into the softground of the plate (fig. 35), not only are the two figures slightly offset so that the standing figure is higher on

The struggle to produce *Le Jour et la nuit* coincided with preparations for the next Impressionist exhibition, which opened on 1 April 1880. As a result, several of the artists' contributions to the exhibition provide further information about the journal, as well as about the value they placed on the medium of etching. It is likely that impressions of all three of the prints discussed above were shown, but it is perhaps even more revealing that each artist chose to show more than one state of the prints, much as Bracquemond had done in 1874 with his *Erasmus*. In this way they not only highlighted the significance of the creative process, but also undercut notions about the primacy of the finished, final work—an outcome that is often cited as one of the central accomplishments of Impressionist painting, but that is at least as relevant for this printed work. Indeed, printmaking made the working process visible in a way that oil painting could not. While a painting might require innumerable alterations, including scraping off passages of paint and reworking, these changes disappear under the surface of the completed painting. In contrast, any change to an etching plate is recorded and preserved each time a new impression is pulled. Part of these artists' innovative approach was to call attention to this characteristic of their printed output.

38. Edgar Degas
Dancers Backstage, 1876/1883. Oil on canvas. National
Gallery of Art. Cat. 42

39. Edgar Degas
Dancers in the Wings, 1879–80. Etching, aquatint, and
drypoint on wove paper, viii/viii. National Gallery of Art.
Cat. 45

Exhibiting prints for the first time, Cassatt included eight etchings in the 1880 display, among them two described as "*Femme au théâtre*, eau-forte, premier état, dernier état"—that is, the first and the final state of *In the Opera Box (No. 3)*. Degas showed only one etched subject, usually identified as *Mary Cassatt at the Louvre: The Etruscan Gallery,* although it is not clear whether this work was completed in time for inclusion.[51] It is clear from the description in the catalogue, which reads "eaux-fortes. Essais et états de planche" (etchings. Trials and states), that he at least intended to show more than one sheet. Pissarro's contributions were the most extensive and explicit about their purpose. He listed *Wooded Landscape at the Hermitage*, one of eighteen prints he showed at the exhibition, as "four states of the landscape intended for the first issue of *Le Jour et la nuit*." Perhaps even more remarkable than this extended display of the development of a single plate through multiple stages was Pissarro's presentation of some, if not all, of his prints in yellow mats and violet frames, according to the commentary of critic Joris Karl Huysmans.[52] The grouped prints and eye-catching frames were presumably intended to draw greater attention to works that risked being overlooked among the paintings, but they also suggest that Pissarro was already thinking about how to combine color and the black-and-white medium of etching.

As well as sharing an interest in complex processes, the three artists also explored light and its capacity to define—or obscure—form and space, in both paintings and prints. Several of Degas's contemporary images of the ballet, particularly when they are sited in the intermediate spaces off-stage, display an experimental use of light effects. Both *Dancers Backstage* (fig. 38) and *Dancers in the Wings* (fig. 39) picture similar locations, showing performers—and an *abonné* (Opera subscriber) in the painting—standing among roughly defined stage flats. In these ambiguous spaces, neither fully onstage nor off, spatial relations between the figures, and between the figures and the viewer, are difficult to decipher. The white circular forms in the etching that seem to emanate light but are difficult to identify as stage lights only contribute to this disorientation.

Cassatt took up the same concerns in different settings. One of the paintings Cassatt showed at this exhibition was *On a Balcony* (fig. 40). Women reading feature frequently among Cassatt's subjects, but here the location is significant; the figure is in the threshold space of a private balcony, outdoors and yet still in her home. Sunlight catches her right side as she faces inward, illuminating the page and casting her face slightly in shadow—a situation similar to that in *Woman in a Loge*. Just as the 1879 painting is related to the etching *In the Opera Box*, so *On a Balcony* bears numerous parallels with an etching that also appeared in the 1880 exhibition, *Lydia Reading, Turned toward Right* (fig. 41). Here Cassatt's sister, Lydia, sits on the other side of the threshold—that is, indoors, with her back to a large window. A heavy curtain has been pulled aside, leaving only a gauzy white sheer as a thin filter against the light pouring into the room. Although the setting is different in painting and print, the compositional echoes are striking, from the figure's pose and position within the frame to the curving chair that embraces her. Where the lighting conditions are subtle in the painting, however, they are pushed to an extreme in the etching, so that Lydia's

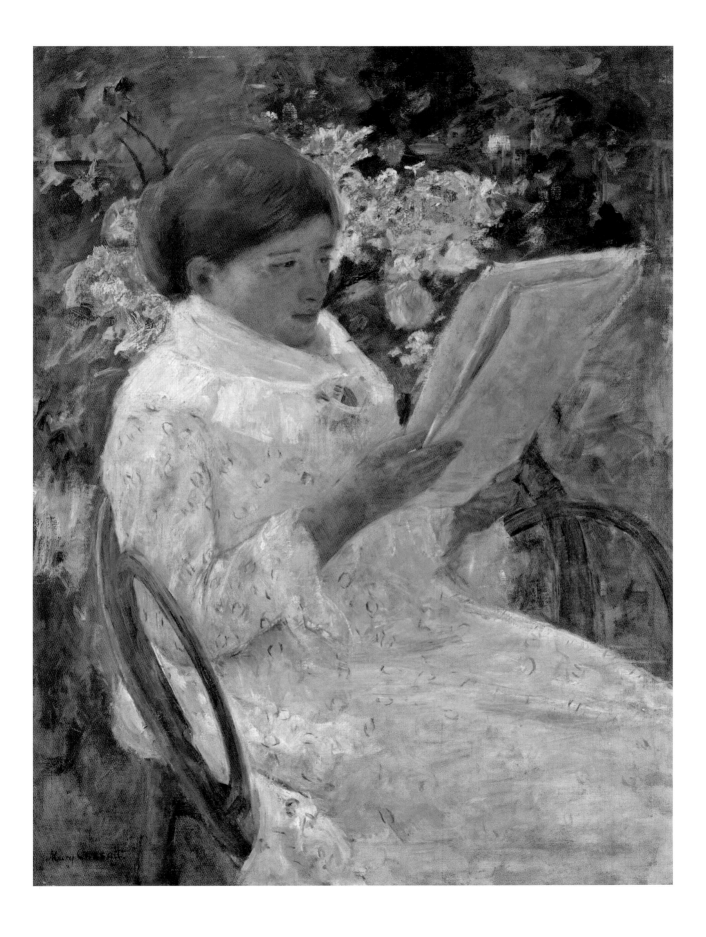

40. Mary Cassatt
On a Balcony, 1878/79. Oil on canvas. Art Institute of Chicago. Cat. 10

41. Mary Cassatt
Lydia Reading, Turned toward Right, c. 1881. Softground etching and aquatint printed in black on off-white laid paper, ii/ii. Smith College Museum of Art. Cat. 16

42. Mary Cassatt
Under the Lamp, c. 1882. Softground etching and aquatint in black on cream wove paper, i/ii. Art Institute of Chicago. Cat. 17

features are cast in such heavy shadow by the light behind her that they are barely discernable.

Another etching that appeared along with these works provides further evidence that Cassatt was preoccupied with investigating a wide range of light effects. *Under the Lamp* (fig. 42), listed in the 1880 catalogue as *Le soir* (*Evening*), depicts two women—probably Cassatt's mother and sister—reading and sewing by the light of a large lamp. While the light fixture has been identified as a regulator oil lamp, whose glass top would have included a chimney to allow heat to escape, Cassatt has cropped the image precisely at the base of the chimney, so that the remaining perfectly spherical form resembles a far more technologically modern gas light, or perhaps even an electric arc light.[53] Electric lights were not widely used in domestic interiors until the early twentieth century, but they had started to proliferate in Parisian public spaces—and gas and electric are just the types of lights that had appeared frequently in Degas's prints of the previous three years depicting café-concerts and other popular entertainment sites. While the quiet domestic interior of *Under the Lamp* could scarcely be more different from the outdoor café-concert exploding with light and sound in Degas's *Mlle Bécat at the Café des Ambassadeurs* (fig. 43), parallels between the lithograph and Cassatt's etching are striking.[54] These include insistent verticals bisecting both compositions, glaring globe-shaped lamps (combined with innumerable other light sources in the Degas), and

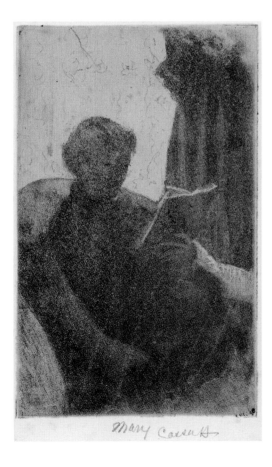

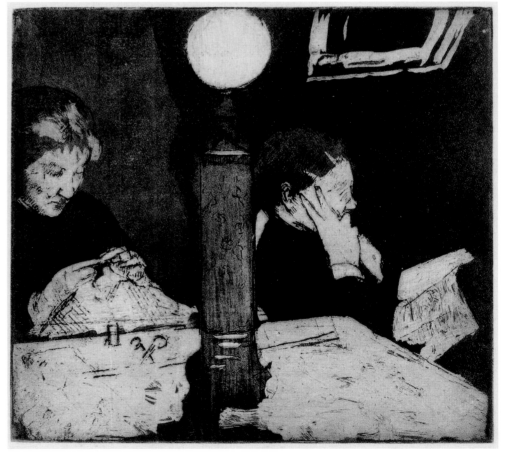

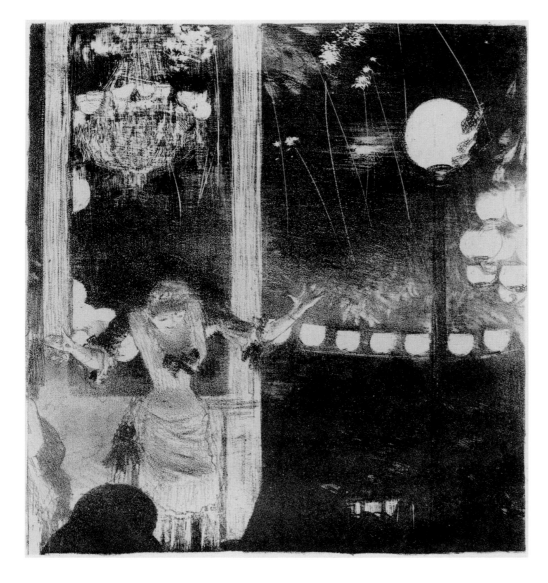

43. Edgar Degas
Mlle Bécat at the Café des Ambassadeurs, 1877–78.
Lithograph on wove Japan paper. Brooklyn Museum.
Cat. 43

women's faces flooded with light. In this context, Cassatt's etching might represent not just a study of the pronounced contrast between light and dark under these conditions, but perhaps also hint at some anxiety regarding the impending advance of too-bright, too-modern light into the home— light so strong that the eyes of the figure on the right are literally effaced.

Cassatt extended the techniques seen in *Under the Lamp* even further in *Knitting in the Library*. In the second state of this print (fig. 44), she covered the initial softground lines with aquatint that obscures much of the composition and then stopped out thick, fluid lines to indicate light entering the room from an unseen window behind the figure, highlighting selective details of the figure's face, shoulder, and the spines of books in the background. One of Cassatt's most fully developed investigations of light, however, used an even more complex combination of techniques. *The Visit* is one of her largest prints up to this point and, as she did with *In the Opera Box*, Cassatt developed it through several states. The overall composition is already largely blocked out in the early states, which show the central figure of a woman supporting herself somewhat tentatively on a chair,

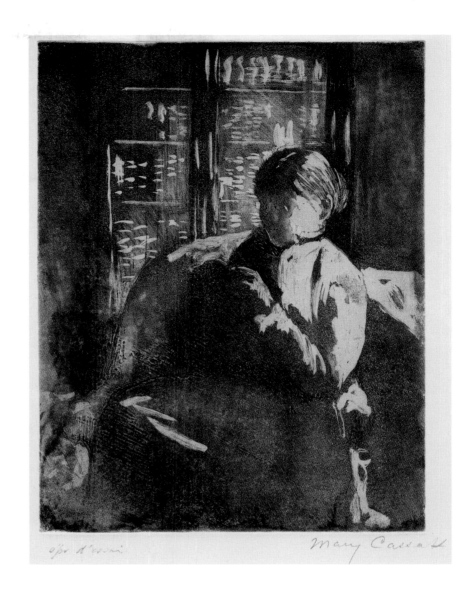

44. Mary Cassatt
Knitting in the Library, c. 1881. Softground etching and aquatint on paper, ii/iii. The Cleveland Museum of Art. Cat. 15

her face and body cast into shadow by bright light from the large, full-length window behind her. While the backlit figure is similar to *Lydia Reading* (and the room itself might well be the same), the variety of marks used to indicate tone and texture is already greater, and would become even more so as Cassatt added a second figure and continued to layer aquatint, drypoint, and burnishing on the plate in successive states. The final state (fig. 45) is a tour de force not only of technical skill, but also of psychological ambiguity resulting from the unresolved nature of the central woman's pose and the relation between her and her seated companion, and enhanced by the atmosphere in a room that seems simultaneously too bright and too dark.

The Visit takes on further significance in the context of Cassatt's collaboration with Degas and Pissarro on *Le Jour et la nuit*. Cassatt's print has been discussed in relation not only to Degas's two prints of Cassatt at the Louvre for their technical and compositional similarities,[55] but also to his monotype *Room in a Brothel* (c. 1879; Stanford University Art Museum, CA).[56] Expressing the concept indicated by the journal's title through their contrasting representations of a daytime versus a

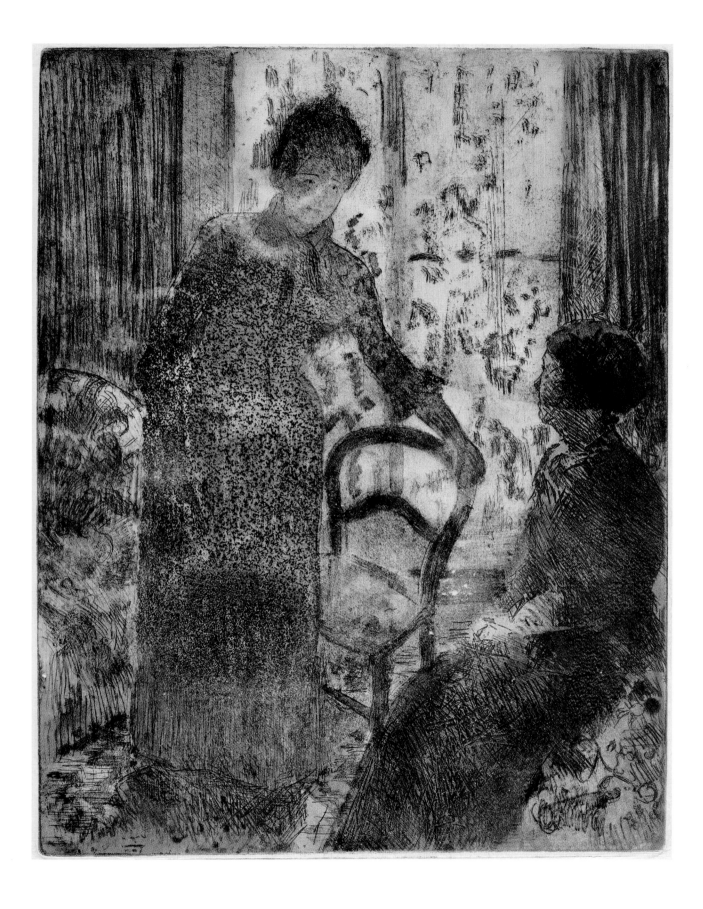

45. Mary Cassatt
The Visit, c. 1881. Softground aquatint, drypoint and etching on paper, vi/vi, plate: 15 ¹³⁄₁₆ × 12 ¼ in. (40.1 × 31.1 cm); sheet: 20 ⁹⁄₁₆ × 15 ¹¹⁄₁₆ in. (52.2 × 39.8 cm). Sterling and Francine Clark Art Institute, Williamstown, Massachusetts, 1967.4

46. Edgar Degas
Two Dancers, c. 1878–79. Aquatint and drypoint on paper. Sterling and Francine Clark Art Institute. Cat. 44

nighttime scene, *The Visit* and *Room in a Brothel* also contrast in representing distinctly female and male social settings.[57] While the formal parallels and contrasting settings of these works are noteworthy, another print Degas made in the same period presents equally suggestive points of comparison. *Two Dancers* (fig. 46), executed on a metal plate intended for use as a daguerreotype, shows Degas experimenting with an unusual reverse technique in which he scratched through the aquatint to produce the white lines that make up much of the composition. As in *The Visit*, the two figures are backlit by a full-length, lightly curtained window, here in a rehearsal studio. The compositional parallels are very close, from the tripartite background to the two women set in a diagonal relationship and inclined to greater or lesser degrees toward each other. These prints also share a similar lighting effect that combines brightness and darkness, as well as a private, behind-the-scenes setting. Most importantly, the parallels among all of these works suggest that the two artists shared a lively interest in exploring such visual effects. Given the experimental nature of *Two Dancers*, it seems logical that it might have held particular interest for Cassatt. Degas clearly appreciated Cassatt's accomplishment, as he owned thirteen impressions of *The Visit*.

Pissarro's print contributions to the 1880 Impressionist exhibition were all landscapes, and thus were less concerned with interior or artificial light effects; instead, they constitute a remarkable exploration of the capacities of the etching medium to create varied forms and textures that describe exterior spaces. In addition to *Wooded Landscape at the Hermitage,* Pissarro included *Horizontal Landscape,*[58] an unusually long, friezelike composition constructed primarily with aquatint, and *The Old Cottage,*[59] of which three of seven states were exhibited. In both of these prints Pissarro initially blocked out the simplest forms and tones in his composition, and gradually added details and intermediate values in each successive state that redefined the space and the respective positions of the elements within it. Another work in the exhibition, however, underwent an even more extensive evolution (although only one impression was shown). The first state of *Rain Effect* (fig. 47) bears the lightest touches of aquatint, which define little more than a horizon line and the form of a large haystack silhouetted against it. By the third state the image emerges more clearly, consisting of a line of wavering, smokelike trees beyond the haystack, and two figures in the field in the foreground, their backs turned. Although the fluid, softly defined forms suggest a damp atmosphere, it was not until the fifth state that Pissarro added diagonal lines to his plate to indicate the rain of the work's title. In the sixth and final state (fig. 48), he burnished a number of additional white lines to render the downpour even more forcefully.

Pissarro's experimentation owed a fair amount to Degas's encouragement, and one impression of *Rain Effect* sheds further light on their collaboration, bearing an inscription (in an unknown hand) noting that it was "printed by E. Degas; aquatint poured by Pissarro; 2nd state modified with metallic brush on softground."[60] This description reflects what must have been their frequent practice at the time: Degas wrote to Pissarro with advice, which Pissarro implemented in his Pontoise studio and then sent the resulting plate back to Degas to print. The fluid landscape and the lines

47. Camille Pissarro
Rain Effect, c. 1879. Aquatint on paper, i/vi. Minneapolis Institute of Art. Cat. 71

48. Camille Pissarro
Rain Effect, 1879. Aquatint and drypoint on paper, vi/vi. New York Public Library. Cat. 72

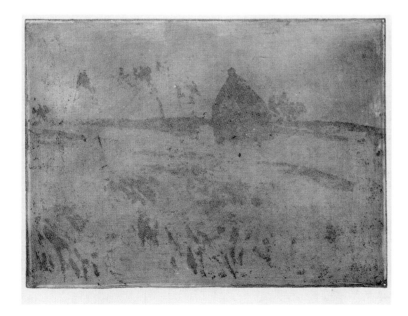

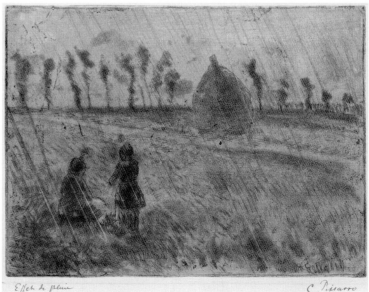

of grass created with a multipointed, possibly brush-like tool surely resulted from these unorthodox approaches, methods that also appear in several other works by both artists.

Another striking example of this kind of technical experimentation is Pissarro's *Woman Emptying a Wheelbarrow*, which was modified dramatically over eleven states. The three initial states were executed in drypoint alone, and it appears that the artist completed that work by 1878, when one impression was exhibited in London.[61] After he began to work with Degas and Cassatt in planning *Le Jour et la nuit* about a year later, however, Pissarro took up the plate again. The fourth state (fig. 49) reveals a fine-grained gray tone over many areas of the composition that was probably produced with a piece of emery or sandpaper formed into a crayon-like point, or with an even more unusual tool for printmaking: a rod of carbon normally used in an electric arc lamp. Both of these tools were mentioned by Degas in a letter of just this period, when he wrote to Alexis Rouart of using a "carbon pencil" that produced a "pretty gray," and commented, "we should have emery pencils." He went on to thank Rouart for sending him a stone that "scratches the copper in a delightful fashion."[62] As Sue Welsh Reed and Barbara Stern Shapiro suggest, Degas and Pissarro probably shared all of these innovative implements in their mutual search for new tones and textures in their etchings, and Pissarro even developed the term *manière grise* (gray manner) to describe the resulting effect.

These new tools were added to a growing arsenal of mark-making implements, which were often used in conjunction to capture a wide variety of tonal and textural effects. In the sixth state of *Woman Emptying a Wheelbarrow*, for instance, Pissarro added aquatint to his plate and began to scrape away certain marks; and by the eighth state (fig. 50), after additional applications of aquatint, nearly all of the initial drypoint lines and much of the manière grise marks have been obscured. The character of the image has also shifted from a spare, wintertime scene with a bare tree to a much lusher, springlike atmosphere, the coarse grains of aquatint along the tree branches suggesting buds. By the tenth state (fig. 51), the touches of aquatint have become further defined so that they now seem to describe a tree in full leaf, and nearly all of the line work has been softened or covered over. With the transformations in both form and content of *Rain Effect* and *Woman Emptying a Wheelbarrow*, the inherently serial nature of successive states of a print takes on a new character, creating not just a numerical series of one print following the next, but a conceptual and temporal series, each sheet standing as a linked but independent image. "One watches the storm approach," as Michel Melot noted of *Rain Effect*, and the seasons change in *Woman Emptying a Wheelbarrow*.[63]

Degas put the same principle into practice in *Leaving the Bath*, a plate he may have been working on while Pissarro was producing *Woman Emptying a Wheelbarrow*. He first drew the composition in drypoint, probably using the rough, abrasive tools he mentioned to Rouart to produce the variety of sharp and blunt lines seen in early states—particularly in the third (fig. 52), which consists largely of parallel hatchings of varying thicknesses. What is perhaps most remarkable about the twenty-two states of this image is the ebb and flow of light and dark as Degas continued to work on his plate,

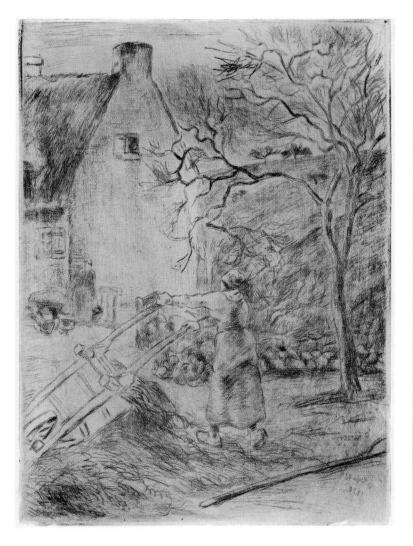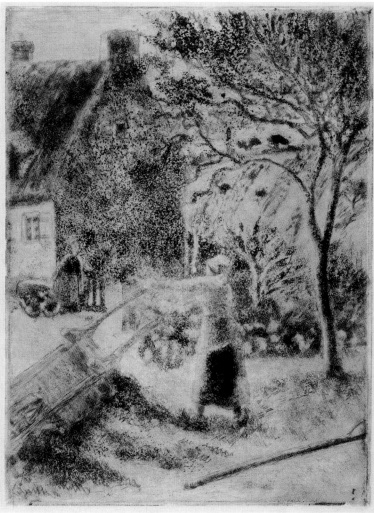

49. Camille Pissarro

Woman Emptying a Wheelbarrow, 1880. Drypoint in black with plate tone on ivory laid paper, iv/xi. Art Institute of Chicago. Cat. 73

50. Camille Pissarro

Woman Emptying a Wheelbarrow, 1880. Drypoint and aquatint on paper, viii/xi. Rhode Island School of Design Museum. Cat. 74

51. Camille Pissarro

Woman Emptying a Wheelbarrow, 1880. Aquatint with drypoint on paper, x/xi. National Gallery of Art. Cat. 75

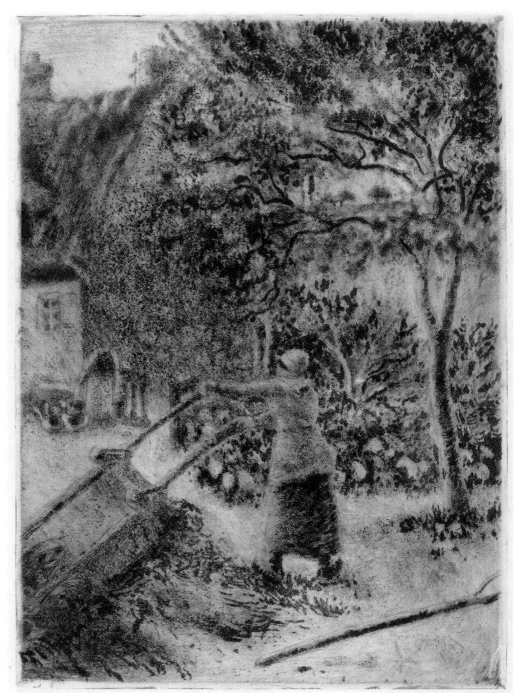

with, "soon I will send you some of my own attempts of this sort," although he seems never to have actually produced such work.[65] He was as good as his word, though, regarding Pissarro's next plate, which must have been *Twilight with Haystacks*. This is because, in addition to a number of impressions printed in black (fig. 56), there are at least six printed in different color inks, including red (fig. 57) and blue (fig. 58), four of them annotated as having been printed by Degas.[66] While this single-color printing is not technically different from Degas's earlier plates printed with red-brown ink, the choice of colors is radically new. The use of different color inks for various impressions of the same plate, moreover, alters the image in a way similar to the changes wrought over several states of works like *Rain Effect* and *Woman Emptying a Wheelbarrow*. The blazing light in the red version in Chicago captures a sense of a landscape alight with the rays of the setting sun, while the deep blues in the Boston sheet more closely resemble a brilliantly moonlit night several hours after twilight, and the saturated, hallucinatory green of the Ottawa sheet suggests an afterimage produced by observing the light-filled scene. The results of this experiment in color, applied to a plate that Pissarro executed using the liquid aquatint technique and a subject that explores a scene of brilliant light and pooling shadows just as complex as Cassatt's curtained interiors or Degas's backstage views, embody the groundbreaking work that these artists produced together.

56. Camille Pissarro
Twilight with Haystacks, 1879. Aquatint, with etching, in black on white wove paper, iii/iii. Art Institute of Chicago. Cat. 68

57. Camille Pissarro
Twilight with Haystacks, 1879. Printed by Edgar Degas. Aquatint, with etching, in orange-red on ivory laid paper, iii/iii. Art Institute of Chicago. Cat. 69

58. Camille Pissarro
Twilight with Haystacks, 1879. Printed by Edgar Degas. Aquatint with drypoint and etching, printed in Prussian blue on beige laid paper, iii/iii. Museum of Fine Arts, Boston. Cat. 70

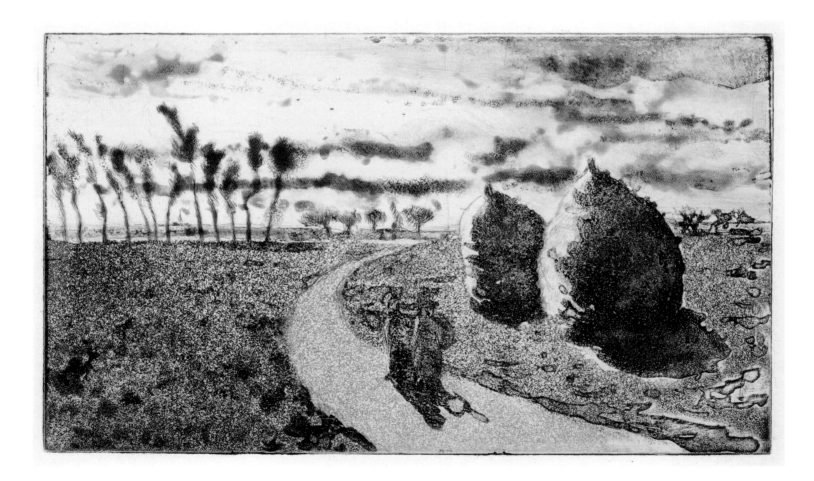

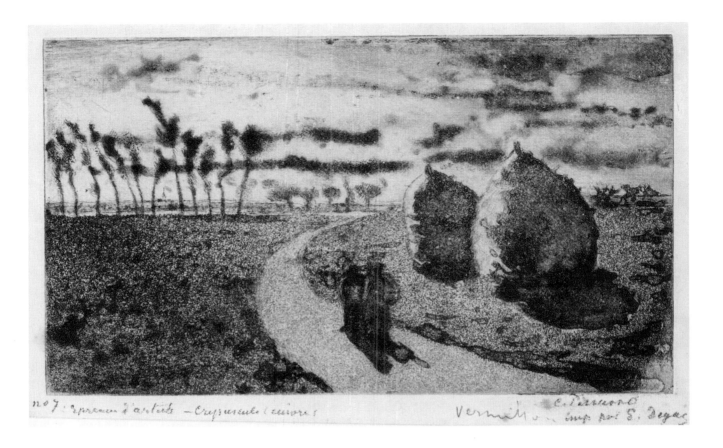

nº7. épreuve d'artiste — Crépuscule (cuivre) C. Pissarro
Vermillon Imp par E. Degas

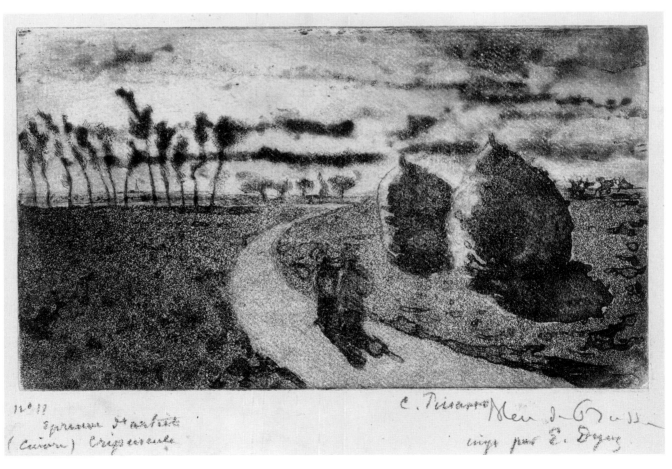

nº11 C. Pissarro Plein de Brume
épreuve d'artiste imp par E. Degas
(cuivre) Crépuscule

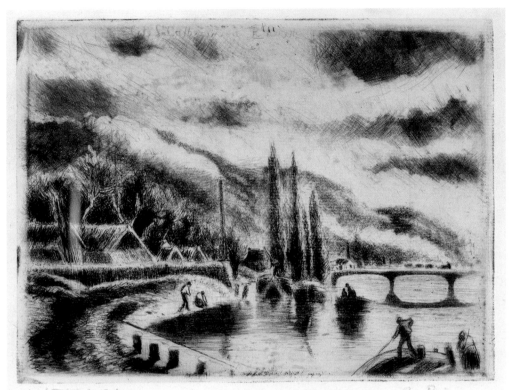

60. **Camille Pissarro**
Riverside at Rouen: Côte Sainte-Catherine, 1883–84.
Etching, drypoint, and aquatint on paper, iv/vii, plate:
5 ¹³⁄₁₆ × 7 ⁹⁄₁₆ in. (14.8 × 19.2 cm); sheet: 9 ⁵⁄₁₆ × 12 ⅛ in.
(23.6 × 30.8 cm). Museum of Fine Arts, Boston, Ellen
Frances Mason Fund, 34.582

61. **Camille Pissarro**
View of Rouen (Cours-la-Reine), 1884. Etching, softground
etching, and drypoint on paper, iii/iii. Philbrook Museum of
Art. Cat. 78

62. **Camille Pissarro**
Quai de Paris, Rouen, 1883. Oil on canvas. Philadelphia
Museum of Art. Cat. 77

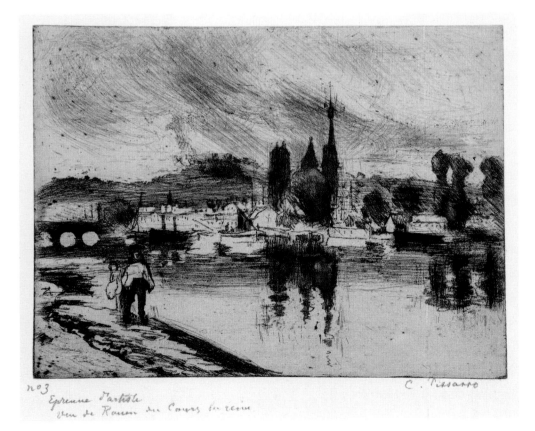

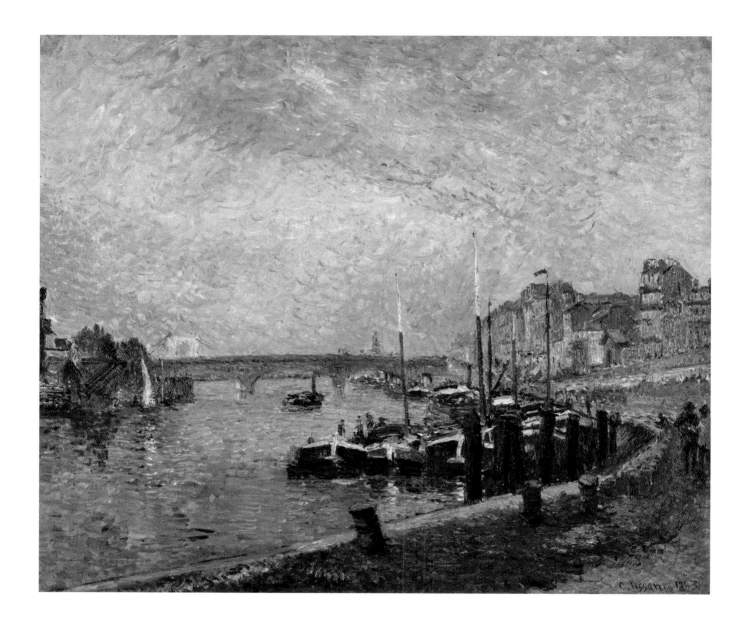

Taken together, these views of Rouen create the sense of watching Pissarro walk around the city as he starts on a new canvas or sheet of paper for each day and each new motif. One can piece together at least a partial image of the city from these works. For the Côte Sainte-Catherine images, Pissarro sat on the Île Lacroix and looked southeast, while on another occasion he sat almost directly across the river on the Quai de Paris and looked northwest toward the Pont Corneille, producing the painting *Quai de Paris, Rouen* (fig. 62). This bridge, which spans the northern tip of the Île Lacroix, links the painting with the etched *View of Rouen*, in which the opposite end of the bridge appears. The iterative process evident in these works recalls the development of earlier etchings like *Rain Effect* and *Woman Emptying a Wheelbarrow*, although here, rather than working hourly or seasonal changes into sequential states of the same print, Pissarro has created a new work for each new idea or moment. While this may suggest a waning interest in exploring the formal possibilities of

etching for its own sake (although he did develop the Côte Sainte-Catherine etching through seven states), it also points the way toward the treatment of city views in series, an approach that came to characterize Pissarro's later work. Several of these prints also served to inspire paintings rather than being derived from them, demonstrating the increasing importance the artist gave to his printmaking. The etching *L'Île Lacroix, Rouen* (fig. 63), for example, belongs to a group of drawings and prints begun in 1883 that all precede the 1888 painting (fig. 64).[74]

Pissarro also continued to explore different print media, including taking up monotype. Indeed, the landscape monotype, explored by both Pissarro and Degas, presents an unexpected area in which the two men's work overlaps. Degas had used monotype since 1876 to depict theater and brothel interiors but rarely landscapes, while Pissarro had not previously tried his hand at the medium, and seems to have done so after his direct collaboration with Degas had begun to wane. While very little is known of the circumstances in which these prints were made, they nonetheless suggest another instance of artistic interchange between the two colleagues. Given the process— in which the image is created on the plate and then immediately put through the press—Pissarro must have had access to a press, possibly working with another artist if not with Degas. By 1891 we know he owned a "bad" press himself, but commented to his son Lucien that he needed something better in order to make his prints.[75] And the medium itself, which Degas had already employed extensively, as well as the compositional approach used by both artists in which natural features are treated as broad, generalized forms rather than as topographically specific sites, point once again to the likely significance of Degas's example for Pissarro.

One of Pissarro's first monotypes is probably *Road by a Field of Cabbages* (fig. 65), since it relates closely to an etching of a similar subject, *The Cabbage Field*, that is generally dated to about 1880.[76] Like the etching, the monotype features a field covered with cabbages filling the foreground,

63. Camille Pissarro
L'Île Lacroix, Rouen, c. 1887. Etching, aquatint, manière grise, drypoint, and burnishing on paper, ii/ii. Private collection, courtesy of Harris Schrank. Cat. 79

64. Camille Pissarro
L'Île Lacroix, Rouen (The Effect of Fog), 1888. Oil on canvas, 18 ⅜ × 22 in. (46.7 × 55.9 cm). Philadelphia Museum of Art, John G. Johnson Collection

65. Camille Pissarro
Road by a Field of Cabbages, c. 1880. Color monotype
on paper. National Gallery of Art. Cat. 76

the vegetables formed in the monotype by thick lines scraped through the ink using a blunt tool. The road alongside the field and the indistinct form along the high horizon appear to have been wiped into the ink, perhaps with a rag, while the rest of the field is textured with small, sharp lines and points suggestive of a wire brush. The motif is characteristic of Pissarro's work—cabbages appear regularly in his images, even prompting Degas to mention "the contour of [his] cabbages" in complimenting him on "the artistic quality of his vegetable gardens." [77] *Road by a Field of Cabbages*, however, also bears striking similarities to one of Degas's monotypes, *The Path up the Hill* (fig. 66). Dated to about 1878–80, this image centers on a steeply rising road wiped onto the plate, a notably

66. Edgar Degas
The Path up the Hill, c. 1878–80. Monotype on paper, plate: 4 ¹¹⁄₁₆ × 6 ⁵⁄₁₆ in. (11.9 × 16.1 cm); sheet: 5 ¹³⁄₁₆ × 7 ⅛ in. (14.8 × 18.1 cm). Museum of Fine Arts, Boston, Fund in memory of Horatio Greenough Curtis, 24.1688

high horizon line, and a grassy field stippled with sharp lines and points. Pissarro's *Herding the Cows at Dusk* (*Vachère le soir*) (fig. 67), currently dated to about 1890, is composed of an even wider variety of marks, from wiping and scraping to thick touches of ink. One passage in the upper left may even reveal traces of the artist's fingerprints, a type of mark that appears regularly in Degas's monotypes. The subject of a field at sunset, with backlit figures set against the intense light of the sky, recalls *Twilight with Haystacks*; in fact, these visual similarities might support an earlier date for the monotype.[78] Compositionally, the print once again also bears comparison with several of Degas's monotypes, including *The Road* (c. 1878/1880; National Gallery of Art, Washington, DC), the remarkably minimal *Moonrise* (c. 1880; Sterling and Francine Clark Art Institute, Williamstown, MA), and the somewhat more finished *The Jockey* (fig. 68). These distinct parallels suggest some mutual influence and ongoing dialogue between the two artists, either directly in the studio, or indirectly as they continued to discuss ideas and techniques. This, in turn, points to the value of such dialogue for generating experimental work, particularly compared to the sometimes more conventional topographical, notational landscape etchings Pissarro produced in approximately the same period.

Cassatt, with one small exception, never worked with monotype. In fact, in the later 1880s, when she once again took up printmaking more actively, her work shifted markedly in a new direction as she began to use drypoint alone and largely set aside the complex, layered technique of softground and aquatint that she had employed in 1879–80. As well as an exploration of a new approach, however, Cassatt's adoption of drypoint—a demanding technique in which lines are scratched directly

67. Camille Pissarro
Herding the Cows at Dusk (*Vachère le soir*), c. 1890.
Monotype on paper. National Gallery of Art. Cat. 80

68. Edgar Degas
The Jockey, c. 1880–85. Monotype on china paper.
Sterling and Francine Clark Art Institute. Cat. 53

into the etching plate and are difficult to correct—might in some sense be seen as a response not just to her own previous work but also to the monotypes of her colleagues. Cassatt is said to have commented that "in drypoint you are down to the bare bones; you can't cheat."[79] It seems possible that this thought emerged in part as a reaction to the soft, tonal, nonlinear images of monotype, images that are produced not through a technically demanding intaglio process but by the simple, direct means of manipulating ink on the plate with anything that comes to hand—a technique Degas and Pissarro had both been employing in the preceding years.

It was in drypoint that Cassatt began to treat a theme that has come to define (and perhaps somewhat overshadow) her work overall: the subject of mothers and children. In an 1890 exhibition put on by a newly formed group called the Société des Peintres-Graveurs at the Durand-Ruel Galleries, she included a series of twelve drypoints, half of which featured mothers and children, while most of the others focused on women alone.[80] While the images of women in interiors in moments of reflection or repose (as two of the drypoints were titled) or prepared to receive a visitor recall some of her earlier prints, those featuring children expanded her printed subject matter into an area for which she had already received some praise, and which appealed to a growing public awareness of, and interest in, childhood as a concept.[81] Several drypoints that she did not include in the exhibition, however, treat a rather different subject, that of women at their toilette. Like the earlier *Standing Nude with a Towel*, these present intimate views of nude or partially clothed figures, and seem to have been printed in very limited numbers. *While Undressing (En Déshabillé)* (fig. 69) shows a seated woman, seen from the back, who appears to be wearing a chemise and corset; the gesture of her right hand suggests she is either dressing or undressing. *Young Girl Fixing Her Hair (No. 1)* (fig. 70) takes a similar figure seen from the front, with only the suggestion of a towel or robe wrapped loosely around her hips. Much as the figure in *Standing Nude with a Towel* is partly obscured by an array of marks ranging from pale gray to black, the form of the *Young Girl Fixing*

69. Mary Cassatt
While Undressing (En Déshabillé), c. 1889. Drypoint on Van Gelder laid paper. Spencer Museum of Art. Cat. 20

70. Mary Cassatt
Young Girl Fixing Her Hair (No. 1), 1889. Drypoint on paper, iii/iii. New York Public Library. Cat 19

71. Mary Cassatt
Two Children on the Grass, c. 1887. Softground etching and aquatint on paper, ii/ii. Minneapolis Institute of Art. Cat. 18

Her Hair is only partially defined, with the spare, simple lines tapering off into the blank surface of the sheet so that this empty space seems to encroach on much of the figure.

Despite her increasing focus on drypoint, Cassatt continued to use aquatint for some of her more experimental images. In *Two Children on the Grass* (fig. 71) she covered the simple softground outline of the first state with an extensive layer of aquatint in the second, obscuring the figures in a manner reminiscent of Degas's *On Stage II*. Moreover, in the same 1890 Durand-Ruel exhibition at

which she showed the set of twelve drypoints, she also included a series of aquatints, though these have been difficult to identify.[82] A small softground and aquatint of this period, *Back View of a Draped Model Arranging Her Hair* (fig. 72) features a woman at her toilette, nude to the waist, combing or tending to her hair.[83] While not as complex in its use of the two media as more ambitious works like *In the Opera Box (No. 3)* or *The Visit*, this sheet successfully combines simple lines like those of her drypoints and the atmospheric tones of her earlier aquatints. As well as adding to the small group of Cassatt's prints that treat this theme, it also brings out the unexpected parallels between this group of works and several by both Degas and, later, Pissarro that present similar subjects.

One of Degas's earliest approaches to the theme of women at their toilette is *Women Combing Their Hair* of about 1875 (fig. 73), an oil painting on paper that depicts a model in three different poses. A decade later he exhibited a group of ten pastels in the 1886 Impressionist exhibition that he described as "a series of nudes of women bathing, washing, drying themselves, wiping, combing

72. Mary Cassatt
Back View of a Draped Model Arranging Her Hair, c. 1889.
Softground etching and aquatint on laid paper, i/ii. Private collection. Cat. 21

73. Edgar Degas
Women Combing Their Hair, c. 1875–76. Oil on paper mounted on canvas, 12 ¾ × 18 ⅛ in. (32.4 × 46 cm). The Phillips Collection, Washington, DC, Acquired 1940

their hair or having it combed." He returned to such intimate views of women bathing or preparing their hair for the rest of his career—indeed, judging by the extensive literature on this subject, it is as significant in defining his work as the mother and child theme is for Cassatt's. Considering only his printed work, the subject of women at their toilette first appears about a year after the Phillips painting in a sheet that exhibits a highly experimental technique. For *Three Subjects: La Toilette; Marcellin Desboutin; Café-Concert* (fig. 74) Degas began by producing three unrelated monotypes, pulling impressions on transfer paper, and then transferring these images to a single lithographic stone.[84] In addition to a small portrait of his printmaking colleague Desboutin, and a characteristically light-filled and surprisingly framed view of a performer, a larger portion of the sheet presents a nude figure standing beside what must be a tub, having her hair combed by a maid. This unexpected juxtaposition of a figure study, a stage scene, and a bather summarizes Degas's primary artistic interests and points to the increasing importance the third subject would come to hold in his output.

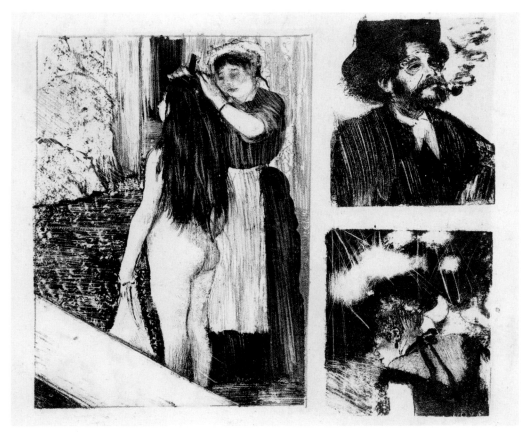

74. Edgar Degas
Three Subjects: La Toilette; Marcellin Desboutin;
Café-Concert, 1876–77. Lithograph transferred from three
monotypes on paper, ii/ii. Mead Art Museum. Cat. 41

The brothel monotypes of about 1877–79, of course, take intimate views of women as their subject, sometimes explicitly depicting the business aspect of these women's activities—as in *The Client* (Musée Picasso, Paris),[85] or *In the Salon* (fig. 75). Other examples, like *Woman Slipping on Her Dress* (private collection, Chicago)[86] and *The Bath* (Statens Museum for Kunst, Copenhagen),[87] however, omit such context and show women alone, absorbed in ordinary tasks. *Leaving the Bath* (figs. 52–55) similarly lacks any explicit context, while another group of monotypes usually dated to about 1880 to 1885 and made in a "dark field" manner again presents women in the most private of moments, nude or mostly so, as they bathe, recline, begin to dress, or climb into bed.[88] *Seated Nude* (fig. 76) is a remarkable and little-known example of this type, in which a woman seems to fold in on herself with her head down. Everything about this image is obscure, from the woman's body, which Degas formed by roughly wiping away and brushing on ink, to her actions and intentions, despite what appears to be a brilliant light source in the lower left corner of the sheet.

Nearly every aspect of Degas's images, from the models that inspired them to the circumstances in which they were made, differs from Cassatt's views of women at their toilette. And yet, in addition to the occasional coincidence of states of undress and gestures of hair-combing, the status of these intimate scenes as subjects for art is nonetheless similar. That is, the nude or seminude women who appear in Cassatt's few prints of the subject were almost certainly paid models, not family

75. Edgar Degas
In the Salon, c. 1880s. Monotype on paper. The Cleveland Museum of Art. Cat. 55

76. Edgar Degas
Seated Nude, c. 1880–85. Monotype on white wove paper. Smith College Museum of Art. Cat. 54

members or friends, whom she ordinarily would not have seen in such poses. Cassatt's images thus suggest both a deliberate desire to craft a representation of a quotidian but rarely observed moment in the life of a contemporary woman, and an awareness that a tradition extending as far back as classical representations of Venus sanctioned such images as constituting art. Degas, too, must have paid for the privilege of observing women in the brothel, also with a desire to represent a rarely acknowledged aspect of contemporary life. His monotypes, however, subvert any of the notions of classical beauty to which Cassatt's prints might allude, instead exposing the commodification of female bodies and images of them.[89] While both Cassatt's unexhibited drypoints and Degas's monotypes were small-scale works that the artists kept largely private, Cassatt would soon incorporate images of women bathing into a group of works intended to have a much higher public profile and wider distribution.

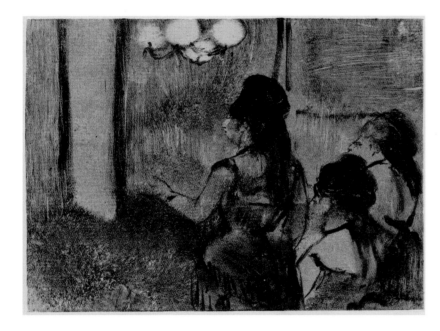

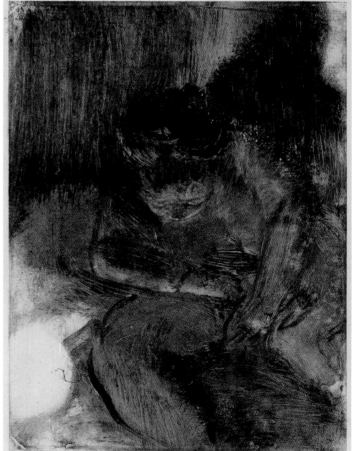

Intimate Views and Returning to Color

In April 1890, a now-famous exhibition of Japanese *ukiyo-e* color woodblock prints went on view at the École des Beaux-Arts in Paris. It attracted widespread attention, prompting visits from a range of artists including Henri Fantin-Latour (1836–1904), Pierre Bonnard (1867–1947), and many others. The prints had an immediate effect on Cassatt; "you must not miss" the exhibition, she wrote to Berthe Morisot (1841–1895), "you who want to make color prints you couldn't dream of anything more beautiful. I dream of it and don't think of anything else but color on copper."[90] Within the next few months, she began a series of prints that would become some of her best-known works in any medium. She conceived of these ten prints as a coherent group, in direct response to the works she had seen in the exhibition. "The set of ten plates," she later acknowledged, "was done with the intention of attempting an imitation of Japanese methods."[91] As has been well analyzed in the Cassatt literature, this set accomplished many things, from emulating Japanese print port-folios both stylistically and in their focus on the daily lives of well-to-do women to providing an accessible and marketable sampling of her work.[92] In the context of her previous work and that of her colleagues, they also stand as a remarkable synthesis of many of the ideas and methods they had been practicing up to this point, and served as a kind of reconciliation of the much-debated elements of line and color—they incorporate both the sharp, rigorous line of her drypoints and the nuanced tonal areas of aquatint, they fully employ printed color, and they foreground the equal value of each unique impression.

Cassatt had seen Degas and Pissarro's joint effort at color aquatint in *Twilight with Haystacks*, as well as Bracquemond's color etching *In the Zoological Garden*. In the late 1880s, color printing seems once more to have been a topic of interest for these artists, as Cassatt's comment to Morisot reveals. Indeed, when the writer Stéphane Mallarmé requested illustrations for a collection of his poems from Morisot, Degas, and Pierre-Auguste Renoir (1841–1919) in 1888, he noted that "Madame Morisot . . . has learned the 'three crayon' [color lithography] technique; Degas himself is also pro-posing color."[93] More broadly, color lithography, practiced in a brilliant and very public manner by artists like Henri de Toulouse-Lautrec (1864–1901), had given color printing a new prominence. For her set of ten prints, however, Cassatt devised a new method that combined drypoint, softground, and aquatint in a manner that appeared visually similar to the Japanese woodblock prints using the general technical approach of color etching.

The first print Cassatt worked on for this set was *The Bath*, which she developed through seventeen different states as she learned to handle the complex techniques. She started by transferring her draw-ing to the plate using softground and then reinforcing the lines in drypoint. Even in the early states, she began experimenting with color, printing some impressions in black ink (fig. 77) and some in black with red-brown around the woman's face and baby's body to indicate the tonality of skin. In the fourth state, she added aquatint to the woman's dress and inked it in yellow, but returned to black ink for the unique

77. Mary Cassatt
The Bath, 1890–91. Drypoint and softground etching on paper, ii/xvii. Philadelphia Museum of Art. Cat. 22

78. Mary Cassatt
The Bath, 1890–91. Drypoint, softground etching, and aquatint on paper, printed in black ink from one plate, v/xvii. The Metropolitan Museum of Art. Cat. 23

impression of the fifth state (fig. 78). In the sixth state, she first attempted to use two separate plates, initially without registration marks to align the two plates precisely. She did, however, use guide marks in the following state, which is lightly printed in black and yellow. Subsequent states add details like aquatint to strengthen the flower pattern on the woman's dress as well as new colors, such as blue on the tub and pink for one or both of the figures' exposed skin. Cassatt seems to have printed most of these proofs herself as she worked, but in order to produce an edition of twenty-five of each of the ten finished works, she turned to a professional printer, Modeste Leroy, who must have helped to insure the strength and clarity of the editioned impressions (fig. 79).

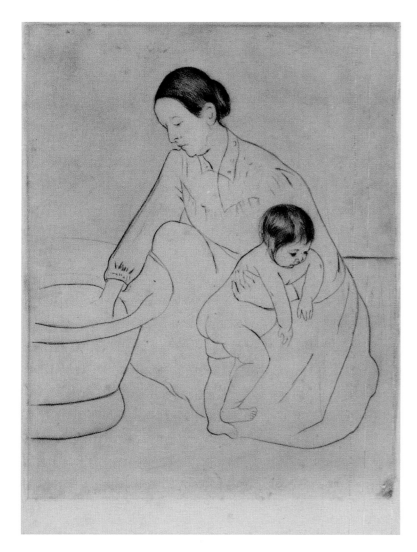

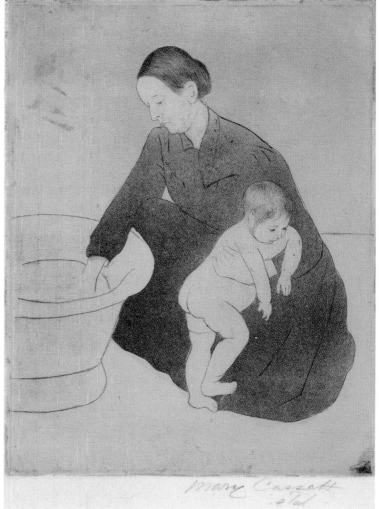

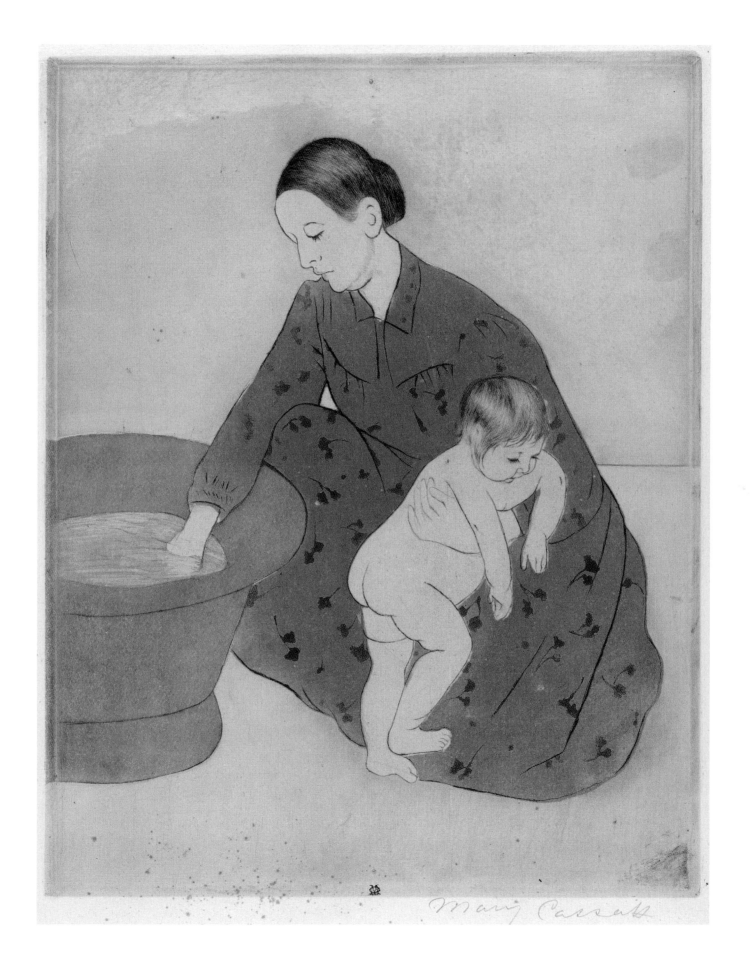

Mary Cassatt

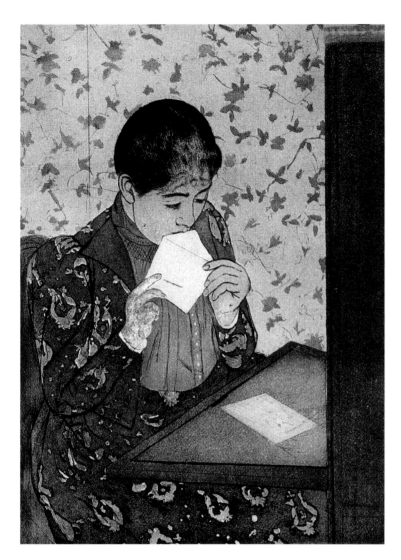

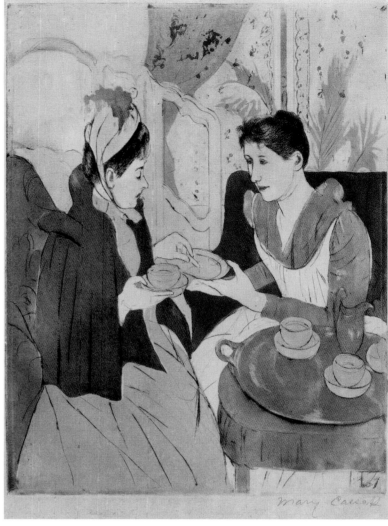

79. Mary Cassatt
The Bath, 1890–91. Drypoint, soft-ground etching and aquatint on paper, xvii/xvii, plate: 12 9/16 × 9 3/4 in. (32 × 24.8 cm); sheet: 17 × 11 13/16 in. (43.2 × 30.1 cm). The Cleveland Museum of Art, Bequest of Charles T. Brooks, 1941.70

80. Mary Cassatt
The Letter, 1890–91. Drypoint and softground etching on paper, iv/iv. Bryn Mawr College. Cat. 27

81. Mary Cassatt
Afternoon Tea Party, 1891. Drypoint and aquatint in color on wove paper, undescribed state between ii and v/v. Brooklyn Museum. Cat. 33

While a professionally printed edition suggests some degree of market-driven motivation, Cassatt had no intention of producing uniformly repeated images. Virtually all of the final states are printed in unique variations and combinations of colors, and she also made alternate versions—some exhibiting remarkably bold and experimental tones—that were not included in the twenty-five sets.[94] As Cassatt honed her technique, she began to achieve her desired effects in as few as four states, and she also produced many preliminary impressions that can stand on their own as completed works. She often introduced small variations, like the water in the tub of *The Bath* being inked in green in some sheets and blue in others, or blue flowered wallpaper in *The Letter* (fig. 80) rather than red. Sometimes, she reenvisioned the overall image. The Brooklyn Museum's *Afternoon Tea Party* (fig. 81), for instance, features subdued shades of gray, yellow, and pink, while other impressions use deep blue for the teacups, green for the plant and screen behind the figures, and on some sheets, touches of gold paint added to the edges of the tea service.[95]

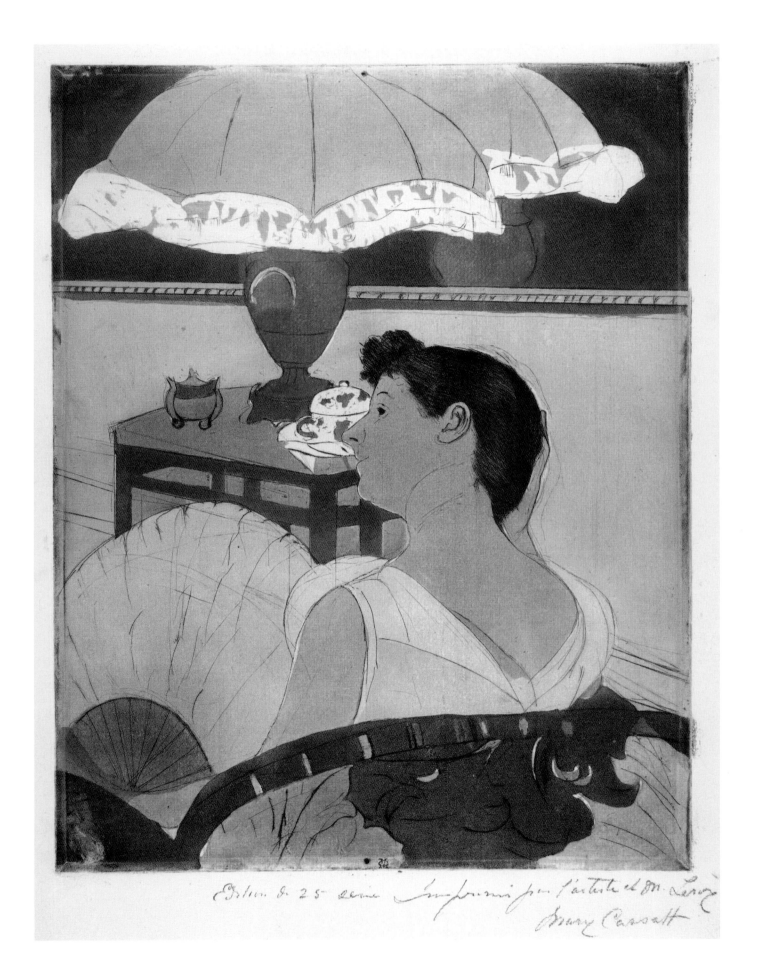

Edition de 25 Imprimé par l'artiste et M. Leroy

Mary Cassatt

82 Mary Cassatt
The Lamp, 1890–91. Drypoint, softground etching, and aquatint on paper, printed in color from three plates, iv/iv. The Metropolitan Museum of Art. Cat. 24

83. Mary Cassatt
After the Bath, 1891. Color drypoint and aquatint on paper, v/v. Sterling and Francine Clark Art Institute. Cat. 31

84. Mary Cassatt
Maternal Caress, 1891. Drypoint with color aquatint and softground etching on paper, vi/vi. Baltimore Museum of Art. Cat. 32

In addition to their innovative technical aspect, these prints are also notable for their considerable range of subjects. Several of them recall her earlier aquatints, with additional nuances emerging due in part to the use of color, while others present new themes. *The Lamp* (fig. 82) echoes both *Under the Lamp* and the fan-holding woman of *In the Opera Box*; although here, with the uniform light of a shaded lamp playing up the scene's subtle colors, the image centers less on the blinding glare of artificial illumination than on the sensuous nature of the woman's body, gesture, and surroundings. *The Bath*, *After the Bath* (fig. 83), and *Maternal Caress* (fig. 84) all present the kinds of intimate interactions between mother and child that Cassatt's earlier drypoint series featured, while *In the Omnibus* (figs. 85, 86), *The Letter*, and *The Fitting* (figs. 87, 88) are new subjects in her oeuvre.

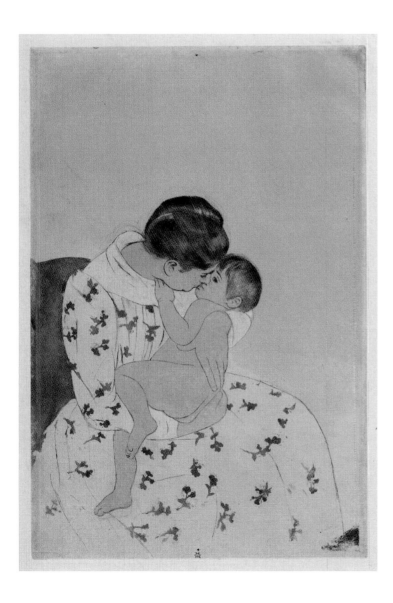

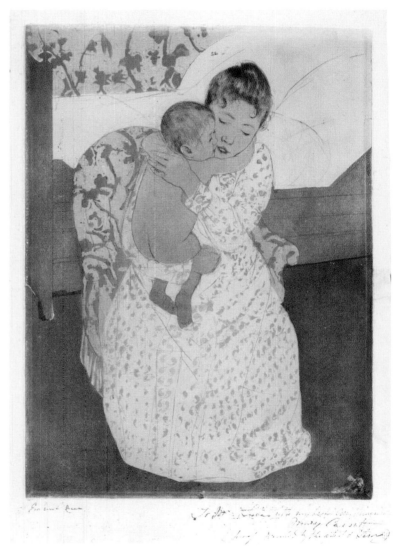

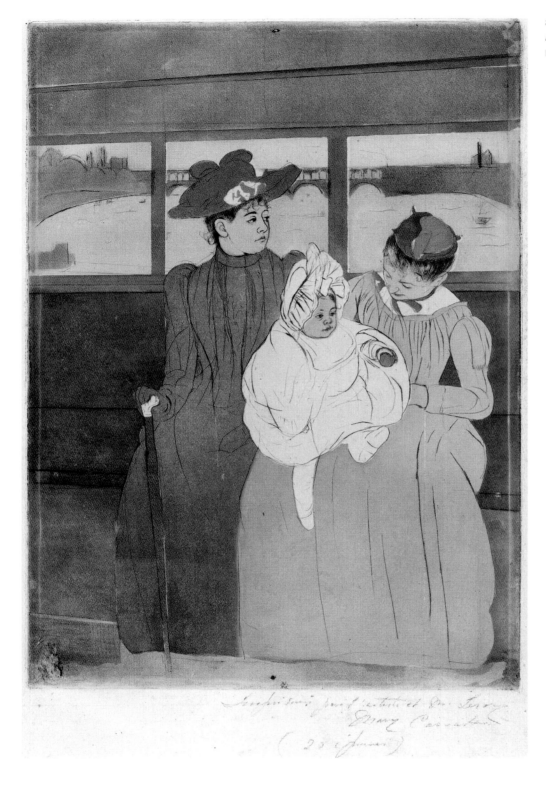

85. Mary Cassatt
In the Omnibus, 1890–91. Color drypoint and aquatint on
paper, vii/vii. The Cleveland Museum of Art. Cat. 25

86. Mary Cassatt
In the Omnibus, 1890–91. Drypoint and softground
etching on paper, vii/vii. Bryn Mawr College. Cat. 26

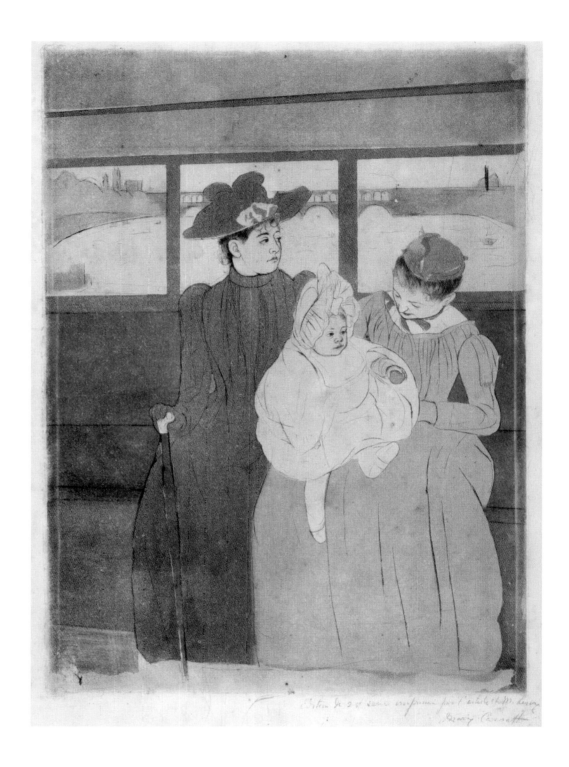

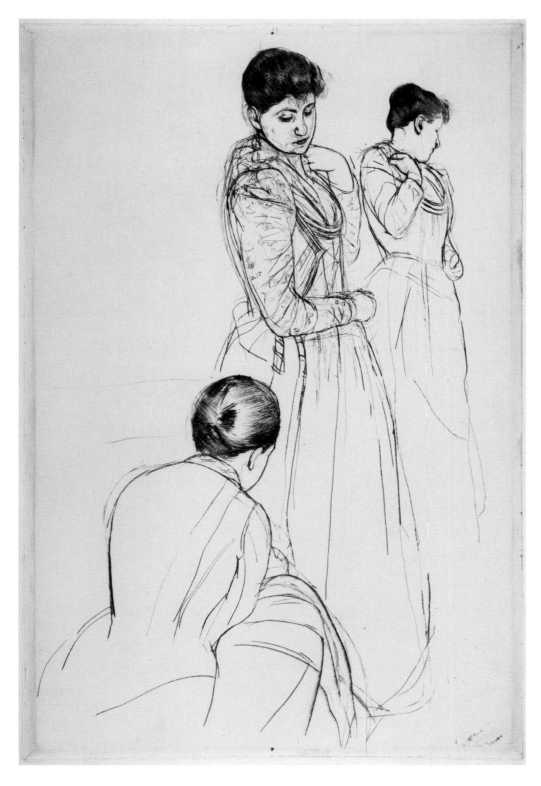

87. Mary Cassatt
The Fitting, 1890–91. Drypoint and softground etching on paper, printed in black ink, ii/vii. The Metropolitan Museum of Art. Cat. 28

88. Mary Cassatt
The Fitting, 1890–91. Drypoint and aquatint on paper,
vii/vii. The Cleveland Museum of Art. Cat. 29

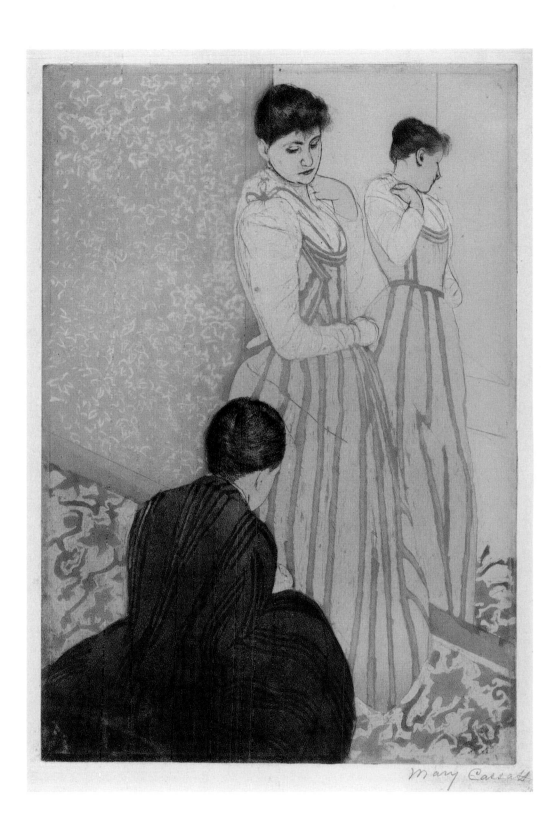

Two of the prints, *Woman Bathing* (*La Toilette*) (fig. 89) and *The Coiffure* (fig. 90) present a woman at her toilette as a more fully developed composition than any of Cassatt's previous works. Her initial conception of *The Coiffure* is closely related to the small 1889 *Back View of a Draped Model Arranging Her Hair* (fig. 72). There are at least two drawings of a model before a mirror with her hands to her hair, nude to the waist (fig. 91 and National Gallery of Art, Washington, DC), that seem to be preliminary sketches for *The Coiffure*, while also distinctly recalling the earlier print. Although the Metropolitan Museum sheet was transferred to a softground plate, it was not directly preparatory to *The Coiffure* but rather seems to have served as a starting point from which the final composition evolved. By placing the figure in the final version within a detailed and specific

89. Mary Cassatt
Woman Bathing (La Toilette), c. 1890–91. Drypoint and aquatint on laid paper, iv/iv. Brooklyn Museum. Cat. 30

90. Mary Cassatt
The Coiffure, 1890–91. Drypoint and aquatint on paper, printed in color from three plates, v/v. The Metropolitan Museum of Art. Cat. 35

91. Mary Cassatt
Study for The Coiffure (No. 2), c. 1891. Graphite on paper with softground on the verso (bled through to the recto). The Metropolitan Museum of Art. Cat. 34

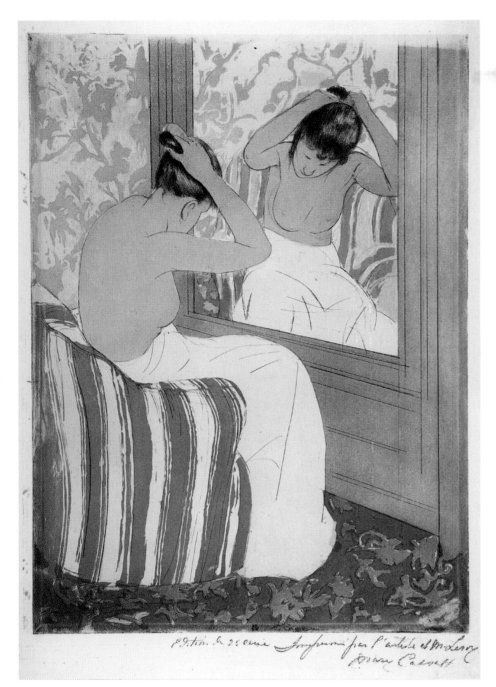

setting, with its striped armchair and richly patterned carpet and wallpaper, Cassatt shifts the image away from depicting a timeless nude toward a representation of a contemporary Parisian woman, seemingly glimpsed in the middle of her daily ritual. The same specificity and immediacy appear in *Woman Bathing*, one of the more widely admired prints in the set, which Cassatt seems to have developed almost entirely on the plate, without any known preparatory drawings.

The set of ten color prints formed the core of Cassatt's first solo exhibition at Durand-Ruel Galleries in April 1891.[96] It was Cassatt's images of women at their toilette, perhaps unsurprisingly, that are said to have caught Degas's attention. According to Achille Segard, Degas responded to *Woman Bathing* by asking Cassatt, "this back, did you draw it?"—the kind of double-edged compliment he seems to have given her more than once.[97] Pissarro, who was exhibiting his own work in an adjacent room, wrote to his son before the show opened of Cassatt's accomplishment in more straightforward terms: "my dear Lucien, I think it is necessary, while my mind is filled with what I saw at Miss Cassatt's, where I went yesterday, to tell you about the color prints she is to show at Durand-Ruel's at the same time as me. . . . You remember the experiments you made at Éragny? Well, Miss Cassatt has realized them admirably: the tone even, subtle, delicate . . . adorable blues, fresh rose, etc. . . . The result is admirable, as beautiful as Japanese work."[98] Five days later Pissarro wrote again of visiting the exhibition with Degas who, he noted, was "charmed by the noble element in this work, although he made minor qualifications which did not touch on their substance."[99] Despite such recognition from her colleagues, Cassatt's set of ten prints did not initially sell very well.

As these accounts make clear, all three artists were still socializing and actively keeping up with each other's output. And color printing seems to have been a subject not just of conversation but of a certain degree of contention among them. Cassatt may have responded rapidly to her experience of the Japanese color prints in the 1890 exhibition, and was the first to exhibit the results of this inspiration; but Degas had been thinking again about color prints at least two years earlier, according to Mallarmé, and his own visit to the École des Beaux-Arts exhibition in 1890 may have prompted an equally significant response. Degas's reaction, however, typical of the artist, was as much against what he had seen as it was inspired by it. In a letter of spring 1890, he wrote, rather cryptically, "dinner Saturday at the Fleury's with Miss Cassatt. The Japanese exhibition at the Beaux-Arts. A fireman's helmet on a frog. Alas, alas, taste everywhere!"[100] Then in September 1890, at a moment when Cassatt was very likely already working on her color aquatints,[101] Degas seemed to be seized by inspiration after a carriage journey from Paris to Burgundy to produce a group of color monotypes that, he is reported to have said, he had been wanting to make for a long time.[102]

As Richard Kendall has discussed, several motivating forces may have prompted Degas to combine the subject of landscape (which he had treated only infrequently), the medium of monotype (which he had not practiced extensively for roughly a decade), and color printing (as he had discussed with Pissarro in 1879–80). These included his experience of traveling through the landscape, his interest in working from memory, his sense of freedom outside his own Paris studio, and perhaps

92. Edgar Degas
Russet Landscape (Paysage Roux), c. 1890. Monotype printed in color ink on cream wove paper, image: 11⅝ × 15¾ in. (29.5 × 40 cm); sheet: 11⅝ × 15¾ in. (29.5 × 40 cm). Detroit Institute of Arts, Founders Society Purchase, Robert H. Tannahill Fund, in honor of Ellen Sharp, 2001.69

the challenge of using the limited materials available to him in his friend Georges Jeanniot's "country studio, installed in the garret."[103] As well as these inward-turning, self-motivated factors, however, another facet of Degas's inspiration may well have been a desire to respond in his own way to his colleagues' renewed interest in color printing prompted by the exhibition of Japanese prints five months earlier. The landscapes he produced in Burgundy, with their radical minimalism, are among the least conventionally "tasteful" works Degas ever made. In a work like *Russet Landscape (Paysage Roux)* (fig. 92), varied shades of brown and a patch of green are dabbed onto the plate and then smeared and wiped away to suggest very roughly the silhouette of a line of hills seen from below, with almost no sense of scale or spatial depth. Even a sheet like *The Road in the Forest* (fig. 93), whose composition recalls the earlier *The Jockey* (fig. 68) and whose shades of green are relatively descriptive, omits the narrative, scale-defining element of the figure to present a dreamlike view of a barely defined site, seen as if floating at the level of the treetops.

93. Edgar Degas
The Road in the Forest, 1890. Monotype in oil,
sheet: 11 13/16 × 15 3/4 in. (30 × 40 cm). Harvard Art
Museums/Fogg Museum, Bequest of Frances L. Hofer,
M19786

94. Edgar Degas
Landscape with Rocks, 1892. Pastel over monotype in oil colors on wove paper. High Museum of Art. Cat. 60

By the time he visited Cassatt's April 1891 exhibition of color aquatints, Degas had completed about thirty monotype landscapes, but had probably kept them largely to himself, as he did with most of his monotypes.[104] If similar forces had prompted both artists to take up color printing, Degas seems to have been more directly spurred by Cassatt's public presentation of her work to follow suit. He continued to make color monotypes in 1892, adding pastel to many of them as he had done with his earlier monotypes of café-concert and ballet performers (fig. 94). These works, along with some of the 1890 monotypes, became the focus of Degas's own first and only solo exhibition, mounted at Durand-Ruel Galleries in October 1892. It has been suggested that, through this show, Degas was staking his claim for artistic prominence in relation not just to Cassatt, but also to the printmakers of the Société des Peintre-Graveurs, and even the landscape painter Monet.[105] After she visited his exhibition, Cassatt, whose relationship with Degas had been difficult for some time, remarked rather briskly on his "series of landscapes in pastel . . . not from nature," noting that she "prefer[red] his landscape when used as a background for his figures."[106] For his part, Pissarro described them somewhat more charitably as "rough sketches in pastel that are like impressions in color, they are very interesting, a little ungainly, though wonderfully delicate in tone."[107]

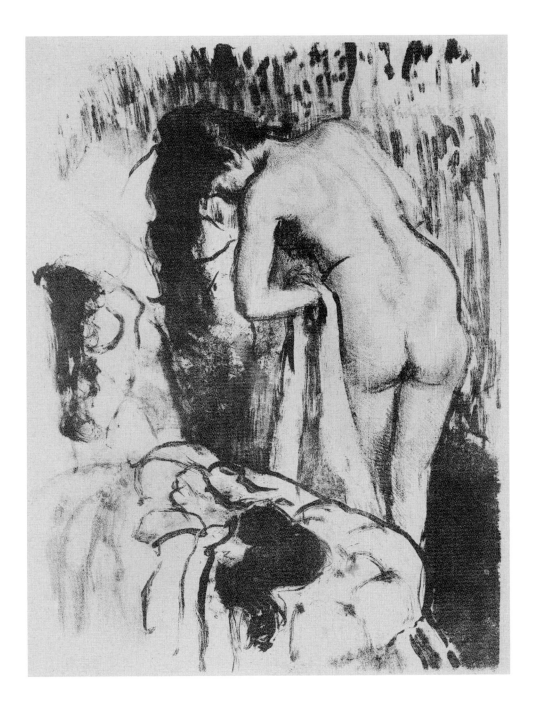

Just as his landscape monotypes should be seen in relation to Cassatt's color prints, Degas's appreciation of the curving line of the back in Cassatt's *Woman Bathing*—which itself may have owed something to Degas's repertoire—perhaps helped inspire his production of a series of lithographs of a nude woman drying herself after a bath. While the subject and composition echo *Woman Bathing*, as well as recalling his earlier etching *Leaving the Bath*, these elements are merely the visual form Degas gave to his exploration of a complex pose and his technical experimentation with the lithography medium. The series appears to have begun as a brush drawing on celluloid, treated essentially as a monotype, which was transferred to a lithographic stone in a process like the one he

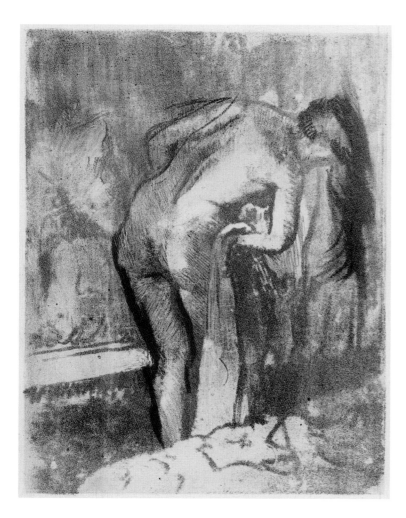
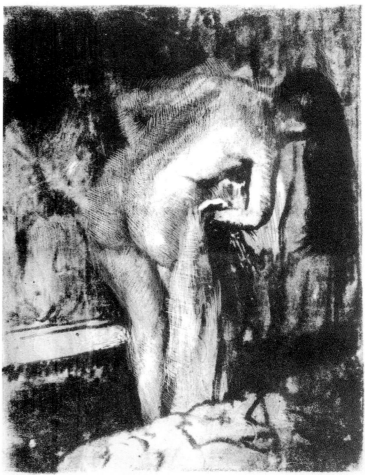

had used for *Three Subjects*.[108] The first state shows the basic, lightly brushed outlines of a figure seen from behind, bending sideways to dry her left hip. Degas then added considerably to the image using lithographic crayon and additional brushwork. By the fourth state (fig. 95), the woman's long hair has become nearly a solid shade of black, as have the rug she stands on and what seems to be a hairpiece on the tufted chaise beside her. In two subsequent states, however, Degas began to lighten certain areas, even entirely removing some of the peripheral elements on the left.

Degas next took essentially the same figure of a woman bending to dry her hip, reversed the orientation so that she bends to the right, and placed her in a similar setting between a tufted seat and a bed, for *After the Bath I*.[109] As Reed and Shapiro have proposed, Degas again made the initial drawing for this composition in ink on celluloid, and then transferred the drawing using a photographic process to the lithographic stone. He used the same photographic transfer process for two additional stones, resulting in impressions that show Degas relentlessly working and reworking the image, using a range of tones and marks that now include soft, slightly blurry passages and stray spots resulting from the photographic process. In the first state of *After the Bath* (*La sortie du bain*), *first plate* (fig. 96) Degas strengthened the transferred outlines of the woman's legs and hair

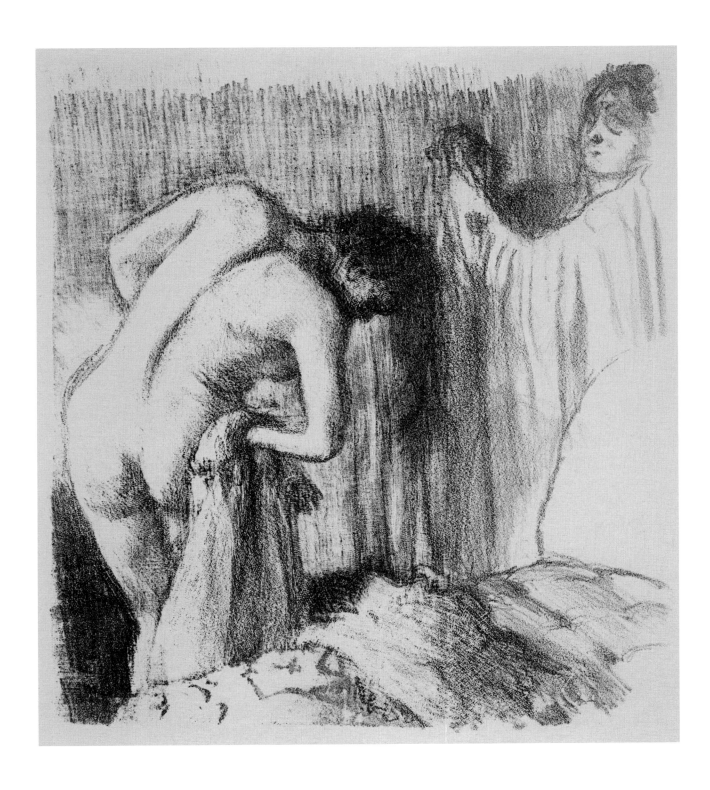

98. Edgar Degas
Leaving the Bath, c. 1891. Lithograph on off-white wove paper, i/ii. Harvard Art Museums/Fogg Museum. Cat. 59

with crayon while leaving much of the rest of the image softly defined and, in the Clark sheet, lightly inked. A second state impression at the Brooklyn Museum (fig. 97) shows further strengthening and heavier inking, but also reveals strong parallel lines scratched into much of the figure to lighten and redefine its contours. By the fifth state Degas had scraped and scratched the figure almost beyond recognition, altering her proportions and her relation to the setting. He then transferred this image to another, larger stone for *Leaving the Bath* (fig. 98). In this sheet the bather is now accompanied by a second figure holding up a towel or robe, but the addition must not have satisfied the artist, as he removed it entirely in the next state. Still not finished with the motif, Degas took up yet another stone that incorporated both bather and attendant, refining this version into a final state in which the maid is reduced to nothing more than a vestigial hand hovering above the bather's head. This series would prove to be Degas's last printmaking project, as if he had finally exhausted the possibilities of a medium that he had played such a central role in expanding.

Even more directly than Degas, Pissarro responded to Cassatt's printmaking innovations by exploring new and unconventional printing practices of his own. Shortly after exhibiting alongside Cassatt in 1891, Pissarro began planning to make his own color prints and reported to his son Lucien that "I have agreed to do some series with Miss Cassatt; I will do some markets, peasant women in the fields, and—this is really wonderful—I will be able to try to put into practice some of the principles of neo-impressionism. . . . If we could make some beautiful prints, that would be really something."[110] Pissarro had been employing Neo-Impressionist color theories in his paintings since 1886, and had been discussing a collaborative printmaking project with his son for just as long, but his experience of the artistic success of Cassatt's color aquatints seems to have renewed his interest in bringing together these ideas to make color prints. He does not seem to have put his plans into effect right away, however, nor did the series with Cassatt seem to have materialized.[111] The main stumbling block may have been that Pissarro still did not have a suitable press. When he finally did acquire one in January 1894, however, Cassatt's efforts—and to some extent Degas's—were still very much on his mind, and the subjects he had mentioned in 1891 did, in fact, appear in his color prints.

Soon after the press that Pissarro had purchased from the printer Auguste Delâtre was installed in the artist's studio at Éragny, he wrote to Lucien that "I am waiting for the printing ink. We tried it with oil color, it will be marvelous. It's going to whet my appetite."[112] The reference to printing with "oil color" using something other than standard printing ink recalls Degas's "drawings made in greasy ink," and suggests that the artist was experimenting with color monotype. Pissarro's color monotypes have been very little studied, and it is difficult to determine which, if any, of some thirty currently known examples might correspond to this first attempt with his new press. The only monotype the artist dated, *A Bather* (fig. 99), was made in 1894, but it is printed primarily with black ink, with only the faintest hint of brownish or pinkish color around the figure. One of the monotypes most fully realized in color, *The Haymakers* (fig. 100), is thought to date to about 1895, though it could have been made the previous year. Featuring a group of three female farm

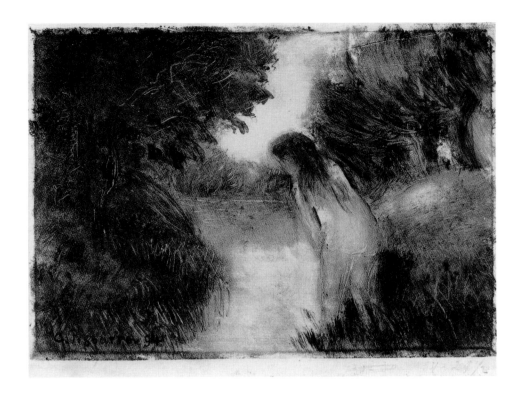

99. Camille Pissarro
A Bather, 1894. Monotype on paper. National Gallery of Art. Cat. 81

100. Camille Pissarro
The Haymakers, c. 1895. Monotype printed in colors on paper, sheet: 7 1/16 × 6 7/8 in. (18 × 17.5 cm). Sterling and Francine Clark Art Institute, Williamstown, Massachusetts, 2005.12

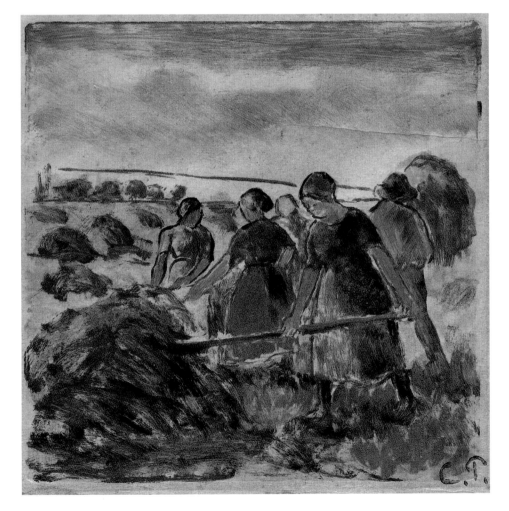

workers, along with one man, at work in a field, it certainly fits into Pissarro's initial vision of making color prints of "peasant women in the fields."[113]

When Pissarro launched seriously into color etching a few months later, he focused on the other subject he had mentioned in 1891: a market scene. And as he started on the long process of developing *The Market at Gisors: Rue Cappeville*, he had Cassatt in mind for more than one reason. First, it seems, she had offered to help him make the registration marks needed to work with the four separate plates he was planning to use. "I've started on color etching," Pissarro wrote to his son, "I'm still waiting for my plates from Miss Cassatt, fifteen days to make the registration marks; I would have already finished my etching if I'd had my plates." He went on to explain that while he was planning to superimpose the four plates as Cassatt had done in her color aquatints, he would proceed somewhat differently in terms of mark-making, using a technique he had perfected with Degas. "I'm going to do them with emery paper, I don't want to use the same method as Miss Cassatt, I'm only going to do highlights; I've begun a *Market*. . . . I want it to be supple, simple, very simple in color, and look strong."[114] As he worked the black-and-white lines of the etching through seven states, Pissarro added watercolor to several sheets, including the Chicago version (fig. 101)—a third state etching lacking registration marks—presumably to experiment with various colors and combinations. In the final state, printed with four plates (fig. 102), the bustling marketplace is colored in warm tones of yellow, red, and green, and the bold shades and somewhat roughly drawn figures, modeled with scratchy shading (presumably made with emery paper), create an image distinctly different from Cassatt's refined, intimate scenes.

Pissarro made a total of five color etchings, gradually gaining confidence with the four-plate process.[115] But the process itself afforded him opportunities for exploration, as in *Church and Farm at Éragny* (fig. 103) which went through a multistage development similar to *The Market at Gisors*. The work has six states, many of which Pissarro seems to have printed in color along the way, as well as additional states made with four color plates. Each impression reveals a different combination of shades and tones. The Harvard sheet, for instance, is printed pale yellow overall, with light touches of rosy red that create a cool, subdued atmosphere. The version in the National Gallery (fig. 104), on the other hand, is filled with a much more intense yellow and accented with larger patches of strong orange-red, evoking the heightened tones of sunset. The various impressions of this etching, in their exploration of light and color—here literally divided and recombined thanks to the four different plates—embody Pissarro's effort to incorporate Neo-Impressionist principles into his printed work.[116]

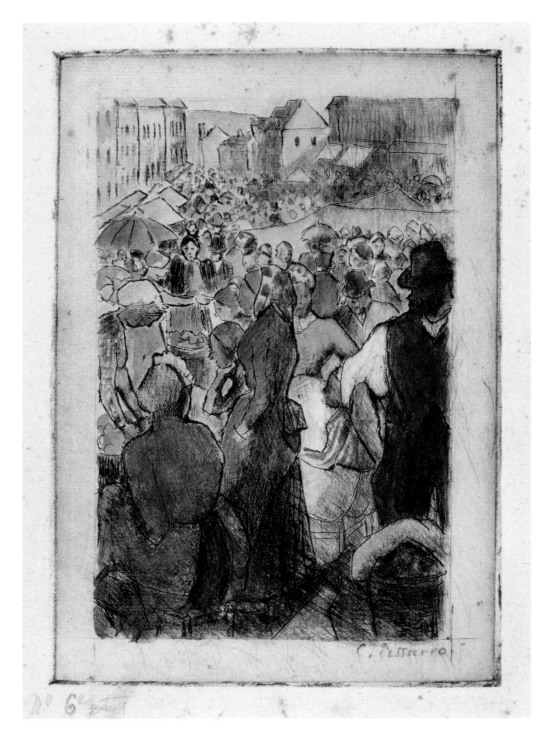

101. Camille Pissarro
The Market at Gisors; Rue Cappeville, c. 1894. Etching in black, with watercolor, on ivory laid paper, iii/vii. Art Institute of Chicago. Cat. 87

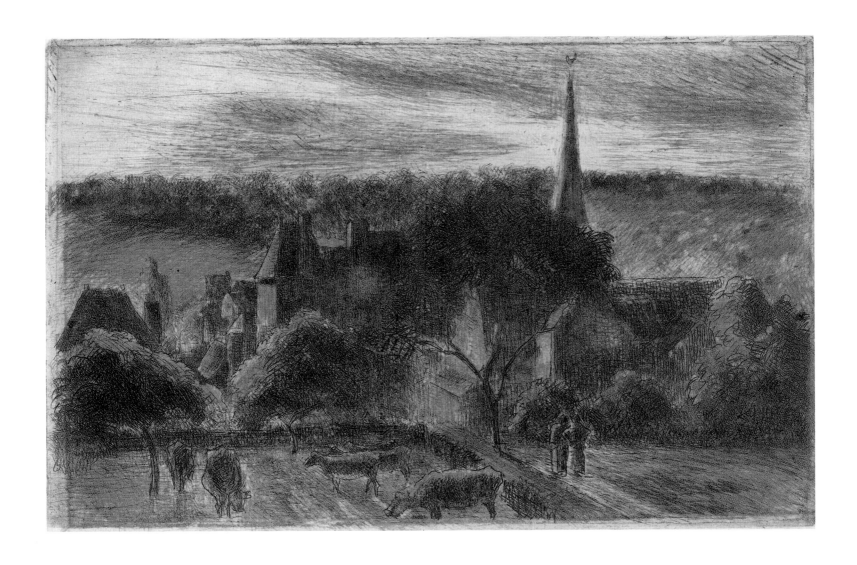

104. Camille Pissarro
Church and Farm at Éragny, 1895. Color etching and drypoint with aquatint on paper, iii/vi, plate: 6 ¼ × 9 ¹³⁄₁₆ in. (15.8 × 25 cm); sheet: 7 ⅝ × 12 ⅛ in. (19.4 × 30.8 cm). National Gallery of Art, Washington, Rosenwald Collection, 1943.3.7310

105. Camille Pissarro
Woman Combing Her Hair, 1894. Color monotype on paper. Museum of Fine Arts, Boston. Cat. 83

106. Camille Pissarro
Woman Arranging Her Hair, 1894. Monotype in black and red ink on wove paper. The Metropolitan Museum of Art. Cat. 82

Much as Pissarro's introduction of color into his printmaking was inspired in part by his colleagues' recent work, the increasing focus on the subject of the bather in his prints of the 1890s seems similarly attuned to their earlier collective efforts. While other factors likely also informed Pissarro's interest, not least his old friend and colleague Cézanne's own ongoing exploration of the bathers theme in rural settings, the links with Degas's and Cassatt's recent printed work are suggestive. Within the first few weeks of owning his new press, Pissarro wrote that he had "decided to make prints of *Bathers*," starting with "two etchings of *Bathers*, amazing, you'll see, perhaps they are too naturalistic, they are peasant women in the flesh . . . but I think it's the best thing I've done."[117] A few months later he continued with the theme, but now in monotype, describing his work on these bather images simply as a way to fill time when he couldn't work outdoors. "I have done a whole series of printed drawings in romantic style which seemed to me to have a rather amusing side: Quantities of *Bathers*, in all sorts of poses and landscape paradises. Interiors, too, *Peasant Women at Their Toilette*, etc. These are the motifs I paint when I can't go outdoors. It's very amusing because of the values—the blacks and whites—that give the tone for paintings. I have heightened some of them with color."[118]

The casual, rather fanciful nature of these works implied by the artist's description is reflected in the relatively large number and variety of the known monotypes. Many are, just as Pissarro described, largely black-and-white images heightened in certain areas with touches of color on the plate, although a smaller number, like the Clark *Haymakers*, are more fully worked up in color. Some allude almost directly to Degas's and Cassatt's work, particularly the interior scenes of peasant women at their toilette. *Woman Combing Her Hair* (fig. 105) and *Woman Arranging Her Hair* (fig. 106) recall works like Degas's painting *Women Combing Their Hair* (fig. 73) and his monotype *Combing the Hair* (Musée du Louvre, Paris),[119] while also echoing Cassatt's drypoints *Young Girl Fixing Her Hair* (fig. 70) and *While Undressing* (fig. 69). Some of Pissarro's bather monotypes seem to be stand-alone sketches, like the loosely brushed and beautifully atmospheric *Bather* (fig. 99); the more linear, and indeed rather amusing, *Bathers* (fig. 107); and *Woman at Her Toilette* (Musée d'Art et d'Histoire Neuchâtel), the only other interior scene.[120] And a few of them relate directly to Pissarro's own paintings, like *Young Woman Washing Her Feet at the Edge of a Stream* (fig. 108), which belongs to a group of works, including a variant monotype, that explore the same composition.[121] The sheet at the Metropolitan Museum is closest to the small, sketch-like painting *The Foot Bath* (Indianapolis Museum of Art),[122] although Pissarro subsequently made two larger painted versions, one with the figure clothed, the other showing her nude (Art Institute of Chicago; and The Metropolitan Museum of Art, New York).[123] *Bathers* (fig. 109)—which also has a variant monotype (fig. 110)—relates in a similar manner to the small painting *Standing and Kneeling Bathers*.[124]

107. Camille Pissarro
Bathers, c. 1894. Color monotype on paper. Museum of Fine Arts, Boston. Cat. 86

108. Camille Pissarro
A Young Woman Washing Her Feet at the Edge of a Stream, c. 1894–95. Monotype on wove paper. The Metropolitan Museum of Art. Cat. 89

109. Camille Pissarro
Bathers, 1895–96. Monotype, pencil, and gouache on laid paper. Dallas Museum of Art. Cat. 91

110. Camille Pissarro
A Bather Standing and a Bather Kneeling, c. 1895–96. Monotype printed in colors, image: 4 15/16 × 7 in. (12.5 × 7.8 cm); sheet: 6 11/16 × 8 7/8 in. (17 × 22.5 cm). Joel R. Bergquist Fine Arts

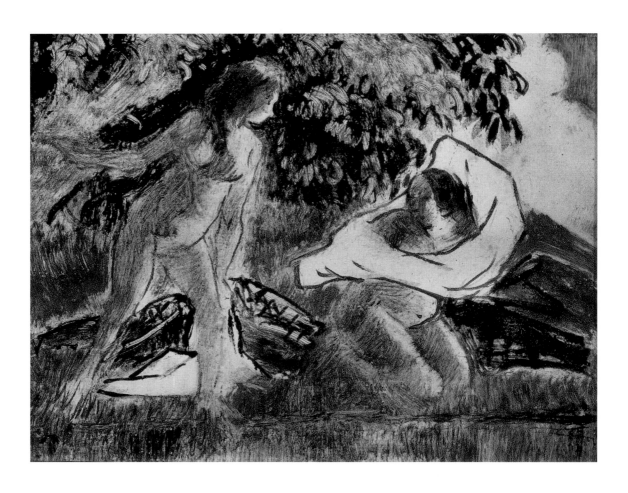

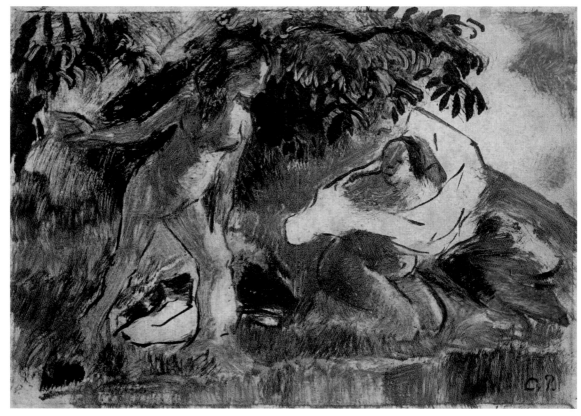

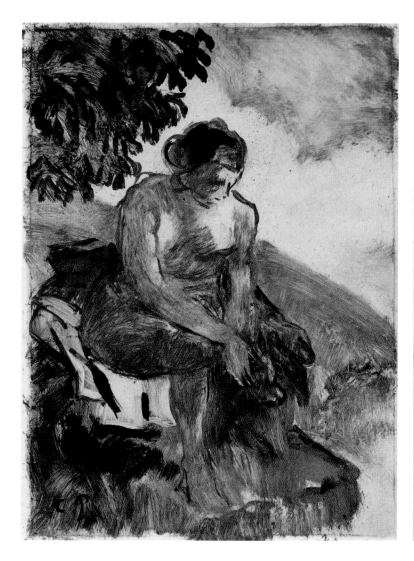
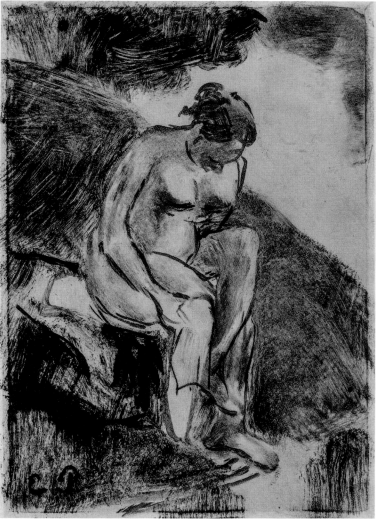

111. Camille Pissarro
Nude Seated on a Bank, c. 1894. Color monotype on paper. Museum of Fine Arts, Boston. Cat. 84

112. Camille Pissarro
Bather, c. 1894. Color monotype on paper. Schorr Collection, Courtesy Museum of Fine Arts, Boston. Cat. 85

113. Camille Pissarro
Line of Women Bathing, 1897. Lithograph on blue-gray paper. Minneapolis Institute of Art. Cat. 94

One of the curious aspects of several monotypes is the existence of these variants.[125] For the pair of *Nude Seated on a Bank* (fig. 111) and *Bather* (fig. 112), Pissarro made two closely related compositions—in this instance, of a figure seated on a sharply sloping bank under an overhanging tree, with one foot drawn up over her knee—but they are not a first and second impression of the same plate, as many of Degas's related monotypes were. Among other discrepancies, the opposite foot is crossed over the figure's knee in the two versions. Yet the basic outlines are close enough in both sheets that some connection might be posited; if he did not redraw the same composition on the clean plate, perhaps he reworked and added to what ink remained on the plate after the first printing. This revisiting or reworking of a composition also extends to Pissarro's treatment of individual figures, which seem to reappear in different prints, including in the group of bather lithographs Pissarro made in the 1890s. The standing figure in the Dallas *Bathers* (fig. 109), for example, holds a pose very similar to that of the *Peasant Woman Chasing Geese* in the lithograph of that subject,[126] and the solitary bather in the Washington monotype (fig. 99) seems to join several companions in one of Pissarro's last lithographs, *Line of Women Bathing* (fig. 113). This kind of repetition recalls the artist's approach to landscape motifs and in some sense also parallels Degas's radical reworking of his *After the Bath* lithographs, if in a more lighthearted manner. These monotypes, although supposedly casually made, seem to have served as the starting point for both prints and paintings, an idea corroborated by Pissarro's comment that the light and dark values he created in monotype would "give the tone" for subsequent paintings.

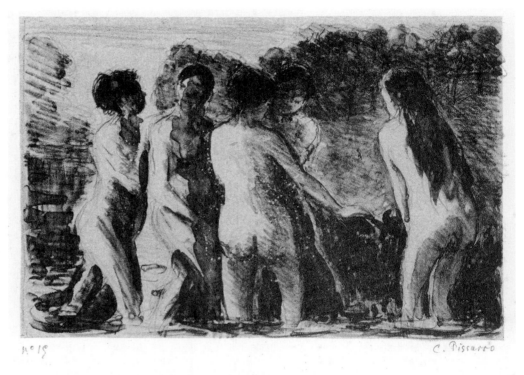

As one looks at the printed work of Cassatt, Degas, and Pissarro, the artistic interactions from which it developed emerge as a central characteristic. These interactions, both collaborative and competitive, played a crucial, generative role in each artist's process, resulting in some of the most innovative works of their careers. Prints served for all three as a field for experimentation, exploration, and for giving form to ideas; a form that was more fully realized than a sketch made for personal reference, but less public and ambitious than a full-scale painting. Indeed, it may be this intermediate status that made prints particularly well suited to a collective practice. And while prints, and portfolios like *Le Jour et la nuit*, were intended to disseminate the artists' work widely, since more collectors are able to acquire a print than a painting, these three artists' prints—particularly the works discussed here, which were sometimes made in only one or two impressions of each state—were often intended for only a small community of artist peers and knowledgeable connoisseurs. Cassatt, Degas, and Pissarro's experimentation took place within this circle of initiates, and embodies their artistic exchanges. To study these work is to be let in on the conversations that happened in the studios in which they were made. Finally, considering these artists' works as part of a collaborative effort also forces us to rethink the standard narratives of artistic creation, posing a challenge to the concept of the singular, solitary—and usually male—artistic genius. This, too, is part of what makes these prints so innovative.

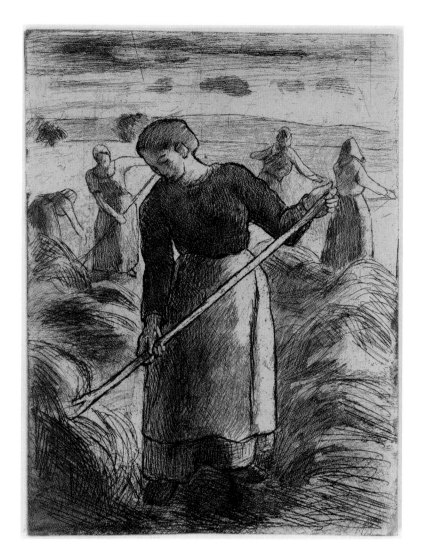

By the late 1890s, all three artists had achieved some measure of success on their own terms. While Degas never returned to printmaking, Pissarro and Cassatt both continued to make prints in the later part of their careers. After her series of ten color aquatints, Cassatt produced nine more color prints, including one related to her ambitious mural project for the World's Columbian Exposition of 1893 (*Gathering Fruit*),[127] and her sole attempt at monotype (*The Album*),[128] a work likely to have been inspired by Pissarro's production of color monotypes in the same period. Many of her later color aquatints have broader, simpler compositions and somewhat less linear detail than the 1890–91 set, but as one impression of the 1896–97 *Barefooted Child*,[129] printed with a brilliant orange background (private collection), demonstrates, she continued at times to take a boldly experimental approach. Alongside these aquatints she also produced numerous drypoints into the early twentieth century, most of them portraits of mothers and children. Pissarro treated most of his favored sub-

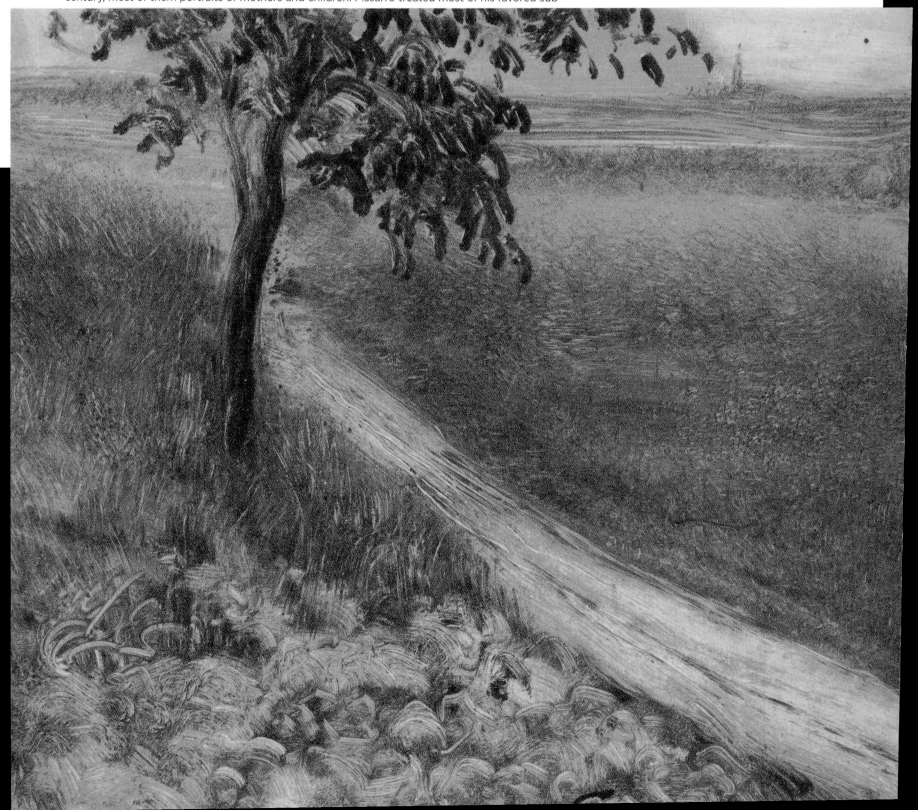

FÉLIX BRACQUEMOND
French, 1833–1914

1. *The Winged Door* (*Le haut d'un battant de porte*), 1852, published 1865

Etching on laid paper, v/v

Image: 12¾ × 19⅝ in. (32.5 × 49.8 cm)

Spencer Museum of Art, University of Kansas, Lawrence, Museum purchase, 1995.0068

Provenance:
Purchased by Spencer Museum of Art, 1995.

Selected References:
Béraldi 1885, no. 110, v/v; Bouillon 1987, no. Ac 1, 8th printing of 10.

Fig. 6

2. *The Spring*, 1861

After Jean-Auguste-Dominique Ingres (French, 1780–1867)

Etching on paper, ii/ii

Plate: 14⁷⁄₁₆ × 8⅞ in. (36.7 × 22.6 cm); sheet: 14¾ × 9³⁄₁₆ in. (37.5 × 23.3 cm)

Baltimore Museum of Art, The George A. Lucas Collection, purchased with funds from the State of Maryland, Laurence and Stella Bendann Fund, and contributions from individuals, foundations, and corporations throughout the Baltimore community, 1996.48.14738

Provenance:
George A. Lucas, Paris (d. 1909, bequeathed to Henry Walters); The Maryland Institute College of Art, through Henry Walters (1909–96); purchased by Baltimore Museum of Art, 1996.

Selected References:
Béraldi 1885, no. 275, ii/ii.

Fig. 12

3. *Desiderius Erasmus*, 1863

After Hans Holbein the Younger (German, c. 1497–1543)

Etching on paper, i/x

Image: 9¾ × 7¾ in. (24.8 × 19.7 cm); sheet: 12½ × 9⁷⁄₁₆ in. (31.7 × 24 cm)

New York Public Library, Astor, Lenox, and Tilden Foundations, Samuel Putnam Avery Collection, Print Collection, Miriam and Ira D. Wallach Division of Art, Prints and Photographs

Provenance:
Samuel P. Avery, New York, given to New York Public Library, 1900.

Selected References
Béraldi 1885, no. 39, i/x.

Fig. 7

4. *Desiderius Erasmus*, 1863

After Hans Holbein the Younger (German, c. 1497–1543)

Etching on paper, ii/x

Image: 9¾ × 7¾ in. (24.8 × 19.7 cm); sheet: 10⅝ × 8½ in. (27 × 21.6 cm)

New York Public Library, Astor, Lenox, and Tilden Foundations, Samuel Putnam Avery Collection, Print Collection, Miriam and Ira D. Wallach Division of Art, Prints and Photographs

Provenance:
Samuel P. Avery, New York, given to New York Public Library, 1900.

Selected References:
Béraldi 1885, no. 39, ii/x.

Fig. 8

5. *Desiderius Erasmus*, 1863

After Hans Holbein the Younger (German, c. 1497–1543)

Etching on paper, viii/x

Image: 9¹³⁄₁₆ × 7¾ in. (25 × 19.7 cm); sheet: 19⅛ × 13⁹⁄₁₆ in. (48.5 × 34.5 cm)

New York Public Library, Astor, Lenox, and Tilden Foundations, Samuel Putnam Avery Collection, Print Collection, Miriam and Ira D. Wallach Division of Art, Prints and Photographs

Provenance:
Samuel P. Avery, New York, given to New York Public Library, 1900.

Selected References:
Béraldi 1885, no. 39, viii/x.

Fig. 9

6. *Manet*, 1867

Etching on paper, proof

Plate: 6¼ × 4¹¹⁄₁₆ in. (15.9 × 11.9 cm); sheet: 12 × 9⅝⁄₁₆ in. (30.5 × 23.7 cm)

Baltimore Museum of Art, The George A. Lucas Collection, purchased with funds from the State of Maryland, Laurence and Stella Bendann Fund, and contributions from individuals, foundations, and corporations throughout the Baltimore community, 1996.48.4596

Provenance:
George A. Lucas, Paris (d. 1909, bequeathed to Henry Walters); The Maryland Institute College of Art, through Henry Walters (1909–96); purchased by Baltimore Museum of Art, 1996.

Selected References:
Béraldi 1885, no. 75.

Fig. 10

7. *Young Woman in Spanish Costume*, 1867

After Édouard Manet (French, 1832–1883)

Etching and spit bite (?) on paper

Plate: 8 9/16 × 12 7/16 in. (21.7 × 31.6 cm); sheet: 12 3/8 × 16 in.
(31.4 × 40.6 cm)

Baltimore Museum of Art, The George A. Lucas Collection,
purchased with funds from the State of Maryland, Laurence
and Stella Bendann Fund, and contributions from individuals,
foundations, and corporations throughout the Baltimore
community, 1996.48.14732

Provenance:
George A. Lucas, Paris (d. 1909, bequeathed to Henry
Walters); The Maryland Institute College of Art, through
Henry Walters (1909–1996); purchased by Baltimore
Museum of Art, 1996.

Selected References:
Béraldi 1885, no. 279.

Fig. 13

8. *At the Zoological Gardens*, 1873

Color etching and aquatint with drypoint on paper, vii/vii

Plate: 8 5/16 × 8 1/2 in. (21.1 × 21.6 cm); sheet: 11 9/16 × 11 3/8 in.
(29.4 × 28.9 cm)

Baltimore Museum of Art, The George A. Lucas Collection,
purchased with funds from the State of Maryland, Laurence
and Stella Bendann Fund, and contributions from individuals,
foundations, and corporations throughout the Baltimore
community, 1996.48.14777

Provenance:
George A. Lucas, Paris (d. 1909, bequeathed to Henry
Walters); The Maryland Institute College of Art, through
Henry Walters (1909–96); purchased by Baltimore
Museum of Art, 1996.

Selected References:
Béraldi 1885, no. 214, vii/vii.

Fig. 59

9. *View of Saints-Pères Bridge (Vue du Pont des
Saints-Pères)*, 1877

Etching and drypoint on paper, iv/iv

Plate: 7 3/4 × 9 3/4 in. (19.7 × 24.7 cm); sheet: 10 5/16 × 12 7/16 in.
(26.2 × 31.6 cm)

Baltimore Museum of Art, The George A. Lucas Collection,
purchased with funds from the State of Maryland, Laurence
and Stella Bendann Fund, and contributions from individuals,
foundations, and corporations throughout the Baltimore
community, 1996.48.4661

Provenance:
George A. Lucas, Paris (d. 1909, bequeathed to Henry
Walters); The Maryland Institute College of Art, through
Henry Walters (1909–96); purchased by Baltimore
Museum of Art, 1996.

Selected References:
Béraldi 1885, no. 217, iv/iv.

Fig. 11

MARY CASSATT
American, 1844–1926

10. *On a Balcony*, 1878/79

Oil on canvas

35 1/2 × 25 5/8 in. (89.9 × 65.2 cm)

Art Institute of Chicago, Gift of Mrs. Albert J. Beveridge in
memory of her aunt, Delia Spencer Field, 1938.18

Provenance:
The artist, to Durand-Ruel by 1901; Durand-Ruel Galleries,
Paris and New York (1901–22, sold to Beveridge); Mrs. Albert J.
Beveridge, Chicago (1922–38, given to Art Institute of
Chicago, 1938).

Selected References:
Paris 1880, cat. 20; Breeskin 1970, no. 94; Barter 1998, cat. 13.

Fig. 40

11. *Standing Nude with a Towel*, c. 1879

Softground etching and aquatint on laid paper, ii/iv

Sheet: 14 1/4 × 10 3/8 in. (36.2 × 26.4 cm)

Rhode Island School of Design Museum, Providence, Mary B.
Jackson Fund, 2008.88.3

Provenance:
Edgar Degas, Paris (d. 1917; his sale, Hôtel Drouot, Paris,
6–7 Nov. 1918, lot 32 [one of three states], as *Femme nue à
sa toilette*, sold to Durand-Ruel); Durand-Ruel, Paris and New
York (from 1918); Robert Hartshorne, New York (d. 1927);
descendants of Hartshorne (1927–2007; sale, Christie's,
New York, 30 Oct. 2007, lot 4 [one of two states], sold to
Schulman); Susan Schulman Printseller (2007–8, sold to
Rhode Island School of Design Museum).

Selected References:
Breeskin 1979, no. 9, ii/iv.

Fig. 22

12. *In the Opera Box*, c. 1880

Drawing on paper for softground transfer

Sheet: 5 13/16 × 4 7/16 in. (14.8 × 11.3 cm)

The Metropolitan Museum of Art, New York, Rogers Fund,
1920, 20.14.2

Provenance:
Durand-Ruel Gallery, New York; purchased by The
Metropolitan Museum of Art, 1920.

Selected References:
Breeskin 1970, no. 716; Breeskin 1979, supplement no. I.

Fig. 32

13. *In the Opera Box (No. 3)*, c. 1880

Softground etching, etching, and aquatint on paper, iii/iv

Plate: 8 1/16 × 7 5/16 in. (20.5 × 18.6 cm); sheet: 14 3/16 × 10 7/16 in.
(36 × 26.5 cm)

Museum of Fine Arts, Boston, Gift of Henri M. Petiet,
confirmed by his estate, 2001.689

Provenance:
Edgar Degas, Paris (d. 1917; his sale, Hôtel Drouot, Paris,
6–7 Nov. 1918, lot 21 [one of four states], as *Au Théâtre
[Jeune femme à l'éventail]*); Henri M. Petiet, Paris (d. 1980);
estate of Petiet, given to Museum of Fine Arts, Boston, 2001.

Selected References:
Breeskin 1979, no. 22, iii/iv.

Fig. 33

14. *In the Opera Box (No. 3)*, c. 1880

Softground etching and aquatint on laid Japan paper, iv/iv

Plate: 8 1/8 × 7 3/8 in. (20.6 × 18.7 cm); sheet: 13 15/16 × 10 7/16 in.
(35.4 × 26.5 cm)

Sterling and Francine Clark Art Institute, Williamstown,
Massachusetts, 1971.45

Provenance:
Acquired by Sterling and Francine Clark Art Institute, 1971.

Selected References:
Breeskin 1979, no. 22, iv/iv.

Fig. 28

15. *Knitting in the Library*, c. 1881

Softground etching and aquatint on paper, ii/iii

Plate: 10 7/8 × 8 5/8 in. (27.7 × 21.8 cm); sheet: 14 3/8 × 11 in.
(36.4 × 27.8 cm)

The Cleveland Museum of Art, Dudley P. Allen Fund, 1988.36

Provenance:
Henri M. Petiet, Paris (d. 1980); Alice Adams, Chicago; Ivo von
Kirschen, Chicago; K. C. Mosier, Dayton, OH; David Tunick,
Inc., New York, sold to The Cleveland Museum of Art, 1988.

Selected References:
Breeskin 1979, no. 30, ii/iii.

Fig. 44

16. *Lydia Reading, Turned toward Right*, c. 1881

Softground etching and aquatint printed in black on off-
white laid paper, ii/ii

Plate: 7 × 4 3/4 in. (17.8 × 12.1 cm); sheet: 13 13/16 × 8 1/4 in.
(35.1 × 21 cm)

Smith College Museum of Art, Northampton, Massachusetts,
Gift of Selma Erving, class of 1927, SC 1972:50-7

Provenance:
Selma Erving, given to Smith College Museum of Art, 1972.

Selected References:
Breeskin 1979, no. 63, ii/ii.

Fig. 41

17. *Under the Lamp*, c. 1882

Softground etching and aquatint in black on cream wove paper, i/ii

Plate: 7 9/16 × 8 5/8 in. (19.2 × 21.8 cm); sheet: 9 1/3 × 12 5/8 in. (23.7 × 32.1) cm

Art Institute of Chicago, Albert H. Wolf Memorial Collection, 1938.33

Provenance:
Alexis Hubert Rouart, Paris (d. 1911); Marcel Guiot, Paris, sold to Art Institute of Chicago, 1938.

Selected References:
Breeskin 1979, no. 71, i/ii.

Fig. 42

18. *Two Children on the Grass*, c. 1887

Softground etching and aquatint on paper, ii/ii

Plate: 9 1/2 × 6 11/16 in. (24.1 × 17 cm); sheet: 15 × 10 7/8 in. (38.1 × 27.6 cm)

Minneapolis Institute of Art, The William M. Ladd Collection Gift of Herschel V. Jones, 1916, P.4,962

Provenance:
Herschel V. Jones, given to Minneapolis Institute of Art, 1916.

Selected References:
Breeskin 1979, no. 90, ii/ii.

Fig. 71

19. *Young Girl Fixing Her Hair (No. 1)*, 1889

Drypoint on paper, iii/iii

Image: 8 3/8 × 6 1/4 in. (21.3 × 15.9 cm); sheet: 13 7/8 × 8 1/4 in. (35.2 × 21 cm)

New York Public Library, Astor, Lenox, and Tilden Foundations, Samuel Putnam Avery Collection, Print Collection, Miriam and Ira D. Wallach Division of Art, Prints and Photographs

Provenance:
Samuel P. Avery, New York, given to New York Public Library, 1900.

Selected References:
Breeskin 1979, no. 99, iii/iii.

Fig. 70

20. *While Undressing (En Déshabillé)*, c. 1889

Drypoint on Van Gelder laid paper

Image: 7 1/4 × 5 3/8 in. (18.4 × 13.7 cm); sheet: 10 3/8 × 7 15/16 in. (26.5 × 20.2 cm)

Spencer Museum of Art, University of Kansas, Lawrence, Bequest of George and Annette Cross Murphy, 1989.0177

Provenance:
Roger Marx, Paris (d. 1913); George and Annette Cross Murphy, bequeathed to Spencer Museum of Art, 1989.

Selected References:
Breeskin 1979, no. 95.

Fig. 69

21. *Back View of a Draped Model Arranging Her Hair*, c. 1889

Softground etching and aquatint on laid paper, i/ii

Plate: 5 3/4 × 4 1/4 in. (14.5 × 11 cm); sheet: 8 × 4 7/8 in. (20.2 × 12.7 cm)

Private collection

Provenance
Ambroise Vollard, Paris (by 1926–d. 1939); estate of Vollard, sold to Petiet, 1940; Henri M. Petiet, Paris (1940–d. 1980); estate of Petiet, sold to Rosen, 1980; Marc Rosen, New York (1980–2008, sold to a private collection).

Selected References:
Breeskin 1979, no. 96, i/ii.

Fig. 72

22. *The Bath*, 1890–91

Drypoint and softground etching on paper, ii/xvii

Plate: 12 1/2 × 9 7/8 in. (31.8 × 25.1 cm); sheet: 17 1/8 × 11 3/4 in. (43.5 × 29.8 cm)

Philadelphia Museum of Art, Gift of Mrs. Horace Binney Hare, 1956, 1956-113-13

Provenance:
Mrs. Horace Binney Hare, given to Philadelphia Museum of Art, 1956.

Selected References:
Breeskin 1979, no. 143, ii/xi; Mathews and Shapiro 1989, no. 5, v/xvii.

Fig. 77

23. *The Bath*, 1890–91

Drypoint, softground etching, and aquatint on paper, printed in black ink from one plate, v/xvii

Plate: 12 9/16 × 9 3/4 in. (31.9 × 24.8 cm); sheet: 16 1/16 × 11 3/4 in. (40.8 × 29.8 cm)

The Metropolitan Museum of Art, New York, Gift of Arthur Sachs, 1916, 16.3.1

Provenance:
Arthur Sachs, New York, given to The Metropolitan Museum of Art, 1916.

Selected References:
Breeskin 1979, no. 143, v/xi; Mathews and Shapiro 1989, no. 5, v/xvii.

Fig. 78

24. *The Lamp*, 1890–91

Drypoint, softground etching, and aquatint on paper, printed in color from three plates, iv/iv

Plate: 12 11/13 × 9 15/16 in. (32.2 × 25.3 cm); sheet: 17 3/16 × 11 5/8 in. (43.7 × 29.5 cm)

The Metropolitan Museum of Art, New York, Gift of Paul J. Sachs, 1916, 16.2.6

Provenance:
Paul J. Sachs, New York, given to The Metropolitan Museum of Art, 1916.

Selected References:
Breeskin 1979, no. 144, iii/iii; Mathews and Shapiro 1989, no. 6, iv/iv.

Fig. 82

25. *In the Omnibus*, 1890–91

Color drypoint and aquatint on paper, vii/vii

Plate: 14 3/8 × 10 1/2 in. (36.6 × 26.8 cm)

The Cleveland Museum of Art, Bequest of Charles T. Brooks, 1941.71

Provenance:
Charles T. Brooks, bequeathed to The Cleveland Museum of Art, 1941.

Selected References:
Breeskin 1979, no. 145, iv/iv; Mathews and Shapiro 1989, no. 7, vii/vii.

Fig. 85

26. *In the Omnibus*, 1890–91

Drypoint and softground etching on paper, vii/vii

Plate: 14 3/8 × 10 1/2 in. (36.6 × 26.8 cm)

Bryn Mawr College, Pennsylvania, Gift of Edith Finch, Class of 1922, from the Collection of Lucy Martin Donnelly, Class of 1893, 1949.17

Provenance:
Lucy Martin Donnelly; Edith Finch, given to Bryn Mawr College, 1949.

Selected References:
Breeskin 1979, no. 145, iv/iv; Mathews and Shapiro 1989, no. 7, vii/vii.

Fig. 86

27. *The Letter*, 1890–91

Drypoint and softground etching on paper, iv/iv

Plate: 13 3/4 × 8 15/16 in. (34.9 × 22.7 cm)

Bryn Mawr College, Pennsylvania, Gift of Edith Finch, Class of 1922, from the Collection of Lucy Martin Donnelly, Class of 1893, 1972.1

Provenance:
Lucy Martin Donnelly; Edith Finch, given to Bryn Mawr College, 1949.

Selected References:
Breeskin 1979, no. 146, iii/iii; Mathews and Shapiro 1989, no. 8, iv/iv.

Fig. 80

28. *The Fitting*, 1890–91

Drypoint and softground etching on paper, printed in black ink, ii/vii

Plate: 14 7/8 × 10 1/16 in. (37.8 × 25.6 cm); sheet: 16 3/16 × 12 1/2 in. (41.1 × 31.8 cm)

The Metropolitan Museum of Art, New York, Gift of Arthur Sachs, 1916, 16.3.3

Provenance:
Arthur Sachs, New York, given to The Metropolitan Museum of Art, 1916.

Selected References:
Breeskin 1979, no. 147, ii/vi; Mathews and Shapiro 1989, no. 9, ii/vii.

Fig. 87

29. *The Fitting*, 1890–91

Drypoint and aquatint on paper, vii/vii

Plate: 14 ¾ × 10 in. (37.6 × 25.5 cm); sheet: 16 ¾ × 12 ⁵⁄₁₆ in. (42.7 × 31.4 cm)

The Cleveland Museum of Art, Bequest of Charles T. Brooks, 1941.72

Provenance:
Charles T. Brooks, bequeathed to The Cleveland Museum of Art, 1941.

Selected References:
Breeskin 1979, no. 147, vi/vi; Mathews and Shapiro 1989, no. 9, vii/vii.
Fig. 88

30. *Woman Bathing (La Toilette)*, c. 1890–91

Drypoint and aquatint on laid paper, iv/iv

Image: 10 ¹⁄₁₆ × 14 ¹⁵⁄₁₆ in. (25.6 × 37.9 cm); sheet: 17 ¹⁄₁₆ × 11 ⅞ in. (43.3 × 30.2 cm)

Brooklyn Museum, Museum Collection Fund, 39.107

Provenance:
Purchased by Brooklyn Museum, 1939.

Selected References:
Breeskin 1979, no. 148, iv/iv; Mathews and Shapiro 1989, no. 10, iv/iv.
Fig. 89

31. *After the Bath*, 1891

Color drypoint and aquatint on paper, v/v

Plate: 11 ¹³⁄₁₆ × 9 in. (30 × 22.9 cm)

Sterling and Francine Clark Art Institute, Williamstown, Massachusetts, 1955.1409

Provenance:
Acquired by Sterling and Francine Clark before 1955; given to Sterling and Francine Clark Art Institute, 1955.

Selected References:
Breeskin 1979, no. 149, iv/iv; Mathews and Shapiro 1989, no. 11, v/v.
Fig. 83

32. *Maternal Caress*, 1891

Drypoint with color aquatint and softground etching on paper, vi/vi

Plate: 14 ½ × 10 ⁹⁄₁₆ in. (36.8 × 26.8 cm); sheet: 17 ¹⁄₁₆ × 11 ⅞ in. (43.3 × 30.1 cm)

Baltimore Museum of Art, The George A. Lucas Collection, purchased with funds from the State of Maryland, Laurence and Stella Bendann Fund, and contributions from individuals, foundations, and corporations throughout the Baltimore community, 1996.48.14788

Provenance:
George A. Lucas, Paris (d. 1909, bequeathed to Henry Walters); The Maryland Institute College of Art, through Henry Walters (1909–96); purchased by Baltimore Museum of Art, 1996.

Selected References:
Breeskin 1979, no. 150, iii/iii; Mathews and Shapiro 1989, no. 12, vi/vi.
Fig. 84

33. *Afternoon Tea Party*, 1891

Drypoint and aquatint in color on wove paper, undescribed state between ii and v/v

Image: 13 ⅝ × 10 ⅜ in. (34.6 × 26.4 cm); sheet: 18 ¾ × 12 in. (47.6 × 30.5 cm)

Brooklyn Museum, Frank L. Babbott Fund and Bristol-Myers Fund, 72.7

Provenance:
Purchased by Brooklyn Museum, 1972.

Selected References:
Breeskin 1979, no. 151, iv/iv; Mathews and Shapiro 1989, no. 13, v/v.
Fig. 81

34. *Study for The Coiffure (No. 2)*, c. 1891

Graphite on paper with softground on the verso (bled through to the recto)

Sheet: 5 ¹³⁄₁₆ × 4 ⁷⁄₁₆ in. (14.8 × 11.3 cm)

The Metropolitan Museum of Art, New York, Rogers Fund, 1920, 20.14.1

Provenance:
Durand-Ruel Gallery, New York; purchased by The Metropolitan Museum of Art, 1920.

Selected References:
Breeskin 1970, no. 814; Breeskin 1979, supplement no. VI.
Fig. 91

35. *The Coiffure*, 1890–91

Drypoint and aquatint on paper, printed in color from three plates, v/v

Plate: 14 ¼ × 10 ½ in. (36.2 × 26.7 cm); sheet: 17 ⅛ × 11 ⅝ in. (43.5 × 29.5 cm)

The Metropolitan Museum of Art, New York, Gift of Paul J. Sachs, 1916, 16.2.3

Provenance:
Paul J. Sachs, New York, given to The Metropolitan Museum of Art, 1916.

Selected References:
Breeskin 1979, no. 152, iv/iv; Mathews and Shapiro 1989, no. 14, v/v.
Fig. 90

EDGAR DEGAS

French, 1834–1917

36. *Self-Portrait*, 1857

Etching and drypoint on paper, iii/iv

Plate: 9 × 5 ¹¹⁄₁₆ in. (23 × 14.5 cm); sheet: 12 ⅜ × 8 ⅞ in. (31.5 × 22.6 cm)

The Cleveland Museum of Art, John L. Severance Fund, 2004.87

Provenance:
Paul-Albert Bartolomé, Paris (d. 1928); César M. de Hauke (New York and Paris, d. 1965); Kimbell Art Foundation, Fort Worth (until 1987; sale, Sotheby's, New York, 13 May 1987, lot 304, sold to Light); Robert M. Light, Boston (from 1987); Samuel Josefowitz, Lausanne, Switzerland; R. M. Light and Co., Inc., Santa Barbara, CA, sold to The Cleveland Museum of Art, 2004.

Selected References:
Delteil 1919, no. 1, iii/v; Reed and Shapiro 1984, no. 8, iii/iv; Amic et al. 2007, pp. 150–51.
Fig. 18

37. *Portrait of Édouard Manet*, 1864

Etching and aquatint on paper, iv/iv

Image: 3 ¼ × 2 ³⁄₁₆ in. (8.3 × 5.6 cm)

Cincinnati Art Museum, Gift of Herbert Greer French, 1940.182

Provenance:
Herbert Greer French, given to Cincinnati Art Museum, 1940.

Selected References:
Delteil 1919, no. 14, iv/v; Reed and Shapiro 1984, no. 19, iv/iv.
Fig. 20

38. *On Stage II*, 1876

Aquatint over softground etching on paper

Plate: 3 ⅛ × 4 ¾ in. (8 × 12 cm); sheet: 7 × 10 ⅜ in. (17.8 × 26.4 cm)

Museum of Fine Arts, Boston, Katherine E. Bullard Fund in memory of Francis Bullard, by exchange, 1983.318

Provenance:
Robert M. Light, Boston; purchased by Museum of Fine Arts, Boston, 1983.

Selected References:
Delteil 1919, no. 31; Reed and Shapiro 1984, no. 23.
Fig. 24

39. *On Stage III*, 1876–77

Softground etching and drypoint with roulette on paper, printed in red-brown ink, iv/v

Plate: 4 × 4 15/16 in. (10.2 × 12.5 cm); sheet: 5 3/4 × 6 3/4 in. (14.6 × 17.1 cm)

Philadelphia Museum of Art, Purchased with the John D. McIlhenny Fund, 1941, 1941-8-33

Provenance:
Purchased by Philadelphia Museum of Art, 1941.

Selected References:
Delteil 1919, no. 32, iv/v; Reed and Shapiro 1984, no. 24, iv/v.
Fig. 26

40. *On Stage III*, 1877

Etching on paper, v/v

Plate: 3 15/16 × 4 15/16 in. (10 × 12.5 cm); sheet: 5 3/16 × 8 3/16 in. (13.2 × 20.8 cm)

Mildred Lane Kemper Art Museum, Washington University in Saint Louis, University purchase, Yalem Fund, 2005, WU 2005.0006

Provenance:
James Bergquist, Newton, MA, sold to Mildred Lane Kemper Art Museum, 2005.

Selected References:
Delteil 1919, no. 32, v/v; Reed and Shapiro 1984, no. 24, v/v; Childs 2017, pp. 60–62, cat. 13.
Fig. 25

41. *Three Subjects: La Toilette; Marcellin Desboutin; Café-Concert*, 1876–77

Lithograph transferred from three monotypes on paper, ii/ii

Plate: 9 1/8 × 7 11/16 in. (23.2 × 19.5 cm); sheet: 10 3/4 × 13 5/8 in. (27.3 × 34.6 cm)

Mead Art Museum, Amherst College, Massachusetts, Gift of Edward C. Crossett (Class of 1905), AC 1951.951

Provenance:
The artist (d. 1917; his studio sale, Galerie Manzi-Joyant, Paris, 22–23 Nov. 1918, lot 176); Edward C. Crossett, given to Mead Art Museum, 1951.

Selected References:
Delteil 1919, no. 55, ii/ii; Reed and Shapiro 1984, no. 28, ii/ii.
Fig. 74

42. *Dancers Backstage*, 1876/1883

Oil on canvas

9 1/2 × 7 3/8 in. (24.2 × 18.8 cm)

National Gallery of Art, Washington, DC, Ailsa Mellon Bruce Collection, 1970.17.25

Provenance:
Théodore Duret, Paris (his sale, Galerie Georges Petit, Paris, 19 March 1894, lot 12, sold to Durand-Ruel); Durand-Ruel, Paris (1894–95, transferred to Durand-Ruel, New York, 27 Feb. 1895); Durand-Ruel, New York (1895–1928, sold 31 Dec. 1928 to Reid & Lefèvre); Alex Reid & Lefèvre, Glasgow and London (from 1928, possibly sold 1929 to D. W. T. Cargill, Glasgow [d. 1939]); Carroll Carstairs Gallery, New York, sold to Bruce, 3 June 1948; Ailsa Mellon Bruce, New York (1948–d. 1969, bequeathed to National Gallery of Art, 1970).

Selected References:
Lemoisne 1946–49, vol. 3, p. 596, no. 1024.
Fig. 38

43. *Mlle Bécat at the Café des Ambassadeurs*, 1877–78

Lithograph on wove Japan paper

Image: 8 1/4 × 7 3/8 in. (21 × 18.7 cm); sheet: 13 1/2 × 10 3/4 in. (34.3 × 27.3 cm)

Brooklyn Museum, Ella C. Woodward Memorial Fund, 52.90.2

Provenance:
Purchased by Brooklyn Museum, 1952.

Selected References:
Delteil 1919, no. 49; Reed and Shapiro 1984, no. 31.
Fig. 43

44. *Two Dancers*, c. 1878–79

Aquatint and drypoint on paper

Image: 6 1/4 × 4 5/8 in. (15.9 × 11.8 cm); sheet: 11 13/16 × 8 3/8 in. (30 × 21.2 cm)

Sterling and Francine Clark Art Institute, Williamstown, Massachusetts, 1968.16

Provenance:
Acquired by Sterling and Francine Clark Art Institute, 1968.

Selected References:
Delteil 1919, no. 22; Reed and Shapiro 1984, no. 33.
Fig. 46

45. *Dancers in the Wings*, 1879–80

Etching, aquatint, and drypoint on wove paper, viii/viii

Plate: 5 1/2 × 4 1/16 in. (13.9 × 10.3 cm); sheet: 12 × 8 9/16 in. (30.5 × 21.8 cm)

National Gallery of Art, Washington, DC, Rosenwald Collection, 1943.3.3365

Provenance:
Lessing J. Rosenwald, Jenkintown, PA, given to National Gallery of Art, 1943.

Selected References:
Delteil 1919, no. 26, viii/viii; Reed and Shapiro 1984, no. 47, viii/viii.
Fig. 39

46. *Leaving the Bath*, 1879–80

Drypoint and aquatint on cream laid paper, iii/xxii

Plate: 5 × 5 in. (12.7 × 12.7 cm); sheet: 8 1/2 × 11 5/8 in. (21.5 × 29.6 cm)

Art Institute of Chicago, Clarence Buckingham Collection, 1962.82

Provenance:
The artist (d. 1917); estate of the artist, from 1917; private collection, Germany; Gutekunst and Klipstein, Berne, sold to Art Institute of Chicago, 1962.

Selected References:
Delteil 1919, no. 39, iv/xvii; Reed and Shapiro 1984, no. 42, iii/xxii.
Fig. 52

47. *Leaving the Bath*, 1879–80

Drypoint and aquatint printed in black on buff wove paper, xiii/xxii

Plate: 5 1/16 × 5 1/16 in. (12.9 × 12.9 cm); sheet: 8 1/4 × 6 7/8 in. (21 × 17.5 cm)

Smith College Museum of Art, Northampton, Massachusetts, Gift of Selma Erving, class of 1927, SC 1972:50-19

Provenance:
Selma Erving, given to Smith College Museum of Art, 1972.

Selected References:
Delteil 1919, no. 39, viii/xvii; Reed and Shapiro 1984, no. 42, xiii/xxii.
Fig. 53

48. *Leaving the Bath*, 1879–80

Drypoint and aquatint on wove paper, xv/xxii

Plate: 5 × 5 1/16 in. (12.7 × 12.8 cm); sheet: 9 1/4 × 7 1/8 in. (23.5 × 18.1 cm)

The Metropolitan Museum of Art, New York, Harris Brisbane Dick Fund, Rogers Fund, The Elisha Whittelsey Collection, The Elisha Whittelsey Fund, 1972, by exchange, 1972.659

Provenance:
The artist (d. 1917; his studio sale, Galerie Manzi-Joyant, Paris, 22–23 Nov. 1918, lot 97 or 99, as *Femme à sa toilette [La sortie du bain]*, one of numerous impressions); purchased by The Metropolitan Museum of Art, 1972.

Selected References:
Delteil 1919, no. 39, xv/xvii; Reed and Shapiro 1984, no. 42, xv/xxii; Kahng 2007, cat. 45, fig. 40.
Fig. 54

49. *Leaving the Bath*, 1879–80

Drypoint and aquatint on paper, undescribed state between xv and xvi/xxii

Plate: 5 × 5 in. (12.7 × 12.7 cm); sheet: 8 × 7 ¼ in. (20.3 × 18.4 cm)

Minneapolis Institute of Art, The John R. Van Derlip Fund, P.90.1

Provenance:
Passed down through unidentified family members to Ami Ladd Vitko, Long Lake, MN, sold to Minneapolis Institute of Art , 1990.

Selected References:
Delteil 1919, no. 39, undescribed state/xvii; Reed and Shapiro 1984, no. 42, undescribed state between xv and xvi/xxii.

Fig. 55

50. *Mary Cassatt at the Louvre: The Etruscan Gallery*, 1879–80

Softground etching, etching, aquatint, and drypoint printed in black on thin Japan paper, ix/ix

Plate: 10 ⅝ × 9 ⁵⁄₁₆ in. (27 × 23.7 cm); sheet: 14 × 10 ⅝ in. (35.6 × 27 cm)

Smith College Museum of Art, Northampton, Massachusetts, Gift of Selma Erving, class of 1927, SC 1972:50-17

Provenance:
Selma Erving, given to Smith College Museum of Art, 1972.

Selected References:
Delteil 1919, no. 30, vi/vi; Reed and Shapiro 1984, no. 51, ix/ix.

Fig. 29

51. *Mary Cassatt at the Louvre: The Paintings Gallery*, 1879–80

Etching, softground etching, aquatint, and drypoint on paper, vii/xx

Plate: 11 ⅞ × 4 ¹⁵⁄₁₆ in. (30.2 × 12.6 cm); sheet: 14 ¼ × 10 ⁷⁄₁₆ in. (36.3 × 26.6 cm)

The Cleveland Museum of Art, Gift of Leonard C. Hanna Jr., 1947.459

Provenance:
Leonard C. Hanna Jr., given to The Cleveland Museum of Art, 1947.

Selected References:
Delteil 1919, no. 29, vii/xx; Reed and Shapiro 1984, no. 52, vii/xx; Amic et al. 2007, pp. 154–55.

Fig. 36

52. *Mary Cassatt at the Louvre: The Paintings Gallery*, 1879–80

Etching, softground etching, aquatint and drypoint on Blacons wove paper, xx/xx

Image: 11 ¹⁵⁄₁₆ × 5 in. (30.3 × 12.7 cm); sheet: 14 ½ × 8 ¹⁄₁₆ in. (36.8 × 20.5 cm)

Brooklyn Museum, Museum Collection Fund, 36.955

Provenance:
Purchased by Brooklyn Museum, 1936.

Selected References:
Delteil 1919, no. 30, xx/xx; Reed and Shapiro 1984, no. 52, xx/xx.

Fig. 37

53. *The Jockey*, c. 1880–85

Monotype on china paper

Image: 4 ¾ × 6 ⁵⁄₁₆ in. (12 × 16.1 cm); sheet: 5 ¹⁄₁₆ × 6 ¹¹⁄₁₆ in. (12.8 × 17 cm)

Sterling and Francine Clark Art Institute, Williamstown, Massachusetts, 1962.40

Provenance:
Acquired by Sterling and Francine Clark Art Institute, 1962.

Selected References:
Janis 1968, cat. 60, no. 261; Adhémar and Cachin 1975, no. 170.

Fig. 68

54. *Seated Nude*, c. 1880–85

Monotype on white wove paper

Image: 8 ⅜ × 6 ¼ in. (21.3 × 15.9 cm); sheet: 9 ³⁄₁₆ × 7 ¾ in. (23.3 × 19.7 cm)

Smith College Museum of Art, Northampton, Massachusetts, Purchased, SC 1979:24

Provenance:
Sale, Sotheby's, New York, 6–8 May 1975, lot 184, as *Femme à sa toilette*, sold to Tunick; David Tunick, New York (1975–79, sold to Smith College Museum of Art, 1979).

Selected References:
None.

Fig. 76

55. *In the Salon*, c. 1880s

Monotype on paper

Image: 4 ⅝ × 6 ¼ in. (11.9 × 16 cm); sheet: 9 ⅝ × 7 ⅜ in. (24 × 18.8 cm)

The Cleveland Museum of Art, Andrew R. and Martha Holden Jennings Fund, 1977.44

Provenance:
William H. Schab Gallery, New York, sold to The Cleveland Museum of Art, 1977.

Selected References:
None.

Fig. 75

56. *Nude Woman Standing, Drying Herself*, 1891–92

Lithograph on paper, iv/vi

Image: 13 × 9 ⅝ in. (33 × 24.5 cm)

Minneapolis Institute of Art, The Francisca S. Winston Fund, 1956, P.12,481

Provenance:
Purchased by Minneapolis Institute of Art, 1956.

Selected References:
Delteil 1919, no. 65, iii/vi; Reed and Shapiro 1984, no. 61, iv/vi.

Fig. 95

57. *After the Bath (La sortie du bain), first plate*, 1891–92

Lithograph in black on wove paper, i/v

Image: 7 ½ × 5 ¹³⁄₁₆ in. (19 × 14.7 cm); sheet: 11 ¹⁵⁄₁₆ × 8 ⁹⁄₁₆ in. (30.3 × 21.8 cm)

Sterling and Francine Clark Art Institute, Williamstown, Massachusetts, 1962.34

Provenance:
The artist (d. 1917; his studio sale, Galerie Manzi-Joyant, Paris, 22–23 Nov. 1918, possibly lot 149, as *Le Lever, 1re planche*); Abby Aldrich Rockefeller, New York (d. 1948); acquired by Sterling and Francine Clark Art Institute, 1962.

Selected References:
Delteil 1919, no. 60, i/vi; Reed and Shapiro 1984, no. 64, i/v.

Fig. 96

58. *After the Bath II*, 1891–92

Lithograph and crayon on stiff wove paper, ii/v

Sheet: 11 ⅞ × 8 ¾ in. (30.2 × 22.2 cm)

Brooklyn Museum, Brooklyn Museum Collection, 36.259

Provenance:
The artist (d. 1917; his studio sale, Galerie Manzi-Joyant, Paris, 22–23 Nov. 1918, possibly lot 152, as *Le Lever, 1re planche*); Marcel Guérin, Paris; purchased by Brooklyn Museum, 1936.

Selected References:
Delteil 1919, no. 60, ii/vi; Reed and Shapiro 1984, no. 64, ii/v.

Fig. 97

59. *Leaving the Bath*, c. 1891

Lithograph on off-white wove paper, i/ii

Image: 9 ¹¹⁄₁₆ × 9 ¹⁄₁₆ in. (24.6 × 23 cm)

Harvard Art Museums/Fogg Museum, Cambridge, Massachusetts, Loan from the Collection of Edouard Sandoz, 5.1965

Provenance:
Edouard Sandoz, Paris.

Selected References:
Delteil 1919, no. 63; Reed and Shapiro 1984, no. 65, i/ii; Cohn and Boggs 2005, p. 123, no. 66, fig. 78.

Fig. 98

60. *Landscape with Rocks*, 1892

Pastel over monotype in oil colors on wove paper

Plate: 9 ¾ × 13 ⅜ in. (24.8 × 34 cm)

High Museum of Art, Atlanta, Purchase with High Museum of Art Enhancement Fund, 2000.200

Provenance:
Durand-Ruel, Paris; Charles H. Senff, Paris (sale, Anderson Galleries, New York, 28 Mar. 1928, lot 37); Knoedler, Paris and New York; purchased by the High Museum of Art, 2000.

Selected References:
Lemoisne 1946–49, vol. 3, p. 608, no. 1040; Hauptman 2016, pp. 195, 234, cat. 143.

Fig. 94

LUDOVIC LEPIC

French, 1839–1889

61. *Dusk over Lake Nemi, near Rome*, 1870

Etching on cream laid paper

Image: 9 ⅜ × 12 ½ in. (23.8 × 31.7 cm); sheet:
12 ¹⁵⁄₁₆ × 19 ¹⁄₁₆ in. (32.8 × 48.4 cm)

Sterling and Francine Clark Art Institute, Williamstown,
Massachusetts, 1978.50

Provenance:
Acquired by Sterling and Francine Clark Art Institute, 1978.

Selected References:
None.

Fig. 14

62. *Windmill in the Moonlight (eau–forte mobile)*,
c. 1870

Etching with monotype inking on paper

Plate: 13 ⅛ × 10 ⅜ in. (33.4 × 26.4 cm); sheet: 19 ⅝ × 12 ⅝ in.
(49.8 × 32 cm)

Museum of Fine Arts, Boston, Fund in memory of Horatio
Greenough Curtis, 2005.295

Provenance:
French art trade; Hill-Stone, New York, sold to Museum of
Fine Arts, Boston, 22 June 2005.

Selected References:
None.

Fig. 17

63. *Dutch Riverscape*, c. 1870

Etching on paper

Plate: 9 ¼ × 12 ½ in. (23.6 × 31.8 cm); sheet: 11 ¹⁵⁄₁₆ × 17 ¹³⁄₁₆ in.
(30.4 × 45.3 cm)

The Cleveland Museum of Art, Carole W. and Charles B.
Rosenblatt Endowment Fund, 2004.228

Provenance:
Susan Schulman Printseller, New York, sold to The Cleveland
Museum of Art, 2004.

Selected References:
None.

Fig. 16

CAMILLE PISSARRO

French, 1830–1903

64. *Paul Cézanne*, 1874, printed 1920

Etching on paper, i/i

Plate: 10 ⅝ × 8 ⅜ in. (27 × 21.4 cm); sheet: 18 ⅜ × 11 ½ in.
(46.8 × 29.3 cm)

The Cleveland Museum of Art, Mr. and Mrs. Lewis B.
Williams Collection, 1956.645

Provenance:
Mr. and Mrs. Lewis B. Williams, given to The Cleveland
Museum of Art, 1956.

Selected References:
Delteil 1999, no. 13.

Fig. 21

65. *Wooded Landscape at the Hermitage, Pontoise*,
1879

Oil on canvas

18 ⁵⁄₁₆ × 22 ¹⁄₁₆ in. (46.5 × 56 cm)

The Nelson-Atkins Museum of Art, Kansas City, Missouri,
Gift of Dr. and Mrs. Nicholas S. Pickard, F84-90

Provenance:
Georges de Bellio, Paris (d. 1894); his daughter, Victorine
de Bellio Donop de Monchy, Paris, by descent (1894–until
at least 1904); Emil and Alma Staub-Terlinden, Männedorf,
Switzerland, as *Village, ou à travers les arbres* (by 1917–
Emil d. 1929); Alma Staub-Terlinden, Männedorf, Switzerland
(1929–42, sold to Wildenstein); Wildenstein and Co., New
York (1942–45, sold to Kostelanetz); Andre Kostelanetz,
New York (1945–76, sold to Pickard); Dr. Nicholas S. and
Mrs. Eva Ann Pickard, Kansas City, MO (1976–84, given to
The Nelson-Atkins Museum of Art).

Selected References:
Shapiro 1973, checklist no. 8; Isaacson 1979, pp. 150–51,
153, cat. 37; Pissarro and Venturi 1939, no. 444; Brettell
1990, pp. 59, 192, 209; Isaacson 1994, pp. 442–43, fig. 9;
Pissarro and Durand-Ruel Snollaerts 2005, vol. 1, pp. 366,
371, 381, 384, 396, 405, 408, 411, 413, vol. 2, pp. 413–14,
no. 614, as *View of L'Hermitage through Trees, Pontoise*.

Fig. 31

66. *Wooded Landscape at the Hermitage, Pontoise*,
1879

Softground etching and aquatint on paper, i/v

Plate: 8 ⅝ × 10 ⅝ in. (21.9 × 26.9 cm)

Ursula and R. Stanley Johnson Family Collection

Provenance
Claude Roger-Marx, Paris (d. 1977); Ursula and R. Stanley
Johnson Family Collection.

Selected References:
Delteil 1999, no. 16, i/v.

Fig. 34

67. *Wooded Landscape at the Hermitage, Pontoise*,
1879

Etching and aquatint on Japan paper, v/v

Plate: 8 ⅝ × 10 ½ in. (22 × 26.8 cm); sheet: 10 ½ × 14 ⅛ in.
(26.8 × 35.8 cm)

Spencer Museum of Art, University of Kansas, Lawrence,
Gift of the Max Kade Foundation, 1969.0129

Provenance:
Edwin Alfred Seasongood, New York (probably sale,
Parke-Bernet, New York, 5–6 Nov. 1951 or 27 Feb. 1952);
Max Kade, New York (d. 1967); Max Kade Foundation,
given to Spencer Museum of Art, 1969.

Selected References:
Delteil 1999, no. 16, v/v.

Fig. 30

68. *Twilight with Haystacks*, 1879

Aquatint, with etching, in black on white wove paper, iii/iii

Plate: 4 ¹⁄₁₆ × 7 ⅛ in. (10.3 × 18.1 cm); sheet: 6 ¹¹⁄₁₆ × 9 ¾ in.
(17.0 × 24.7 cm)

Art Institute of Chicago, Berthold Loewenthal Fund,
1921.217

Provenance:
Edgar Degas (d. 1917; his sale, Paris, Hôtel Drouot, 6–7 Nov.
1918, lot 303, as *Les meules*, one of two impressions, sold
to Le Garrec); Maurice Le Garrec, Paris (from 1918); pur-
chased by Art Institute of Chicago, 1921.

Selected References:
Ives et al. 1997, p. 106, no. 932; Delteil 1999, no. 23, iii/iii.

Fig. 56

69. *Twilight with Haystacks*, 1879

Printed by Edgar Degas

Aquatint, with etching, in orange-red on ivory laid paper,
iii/iii

Plate: 4 ¹⁄₁₆ × 7 ⅛ in. (10.3 × 18.1 cm); sheet: 5 × 8 in.
(12.7 × 20.3 cm)

Art Institute of Chicago, Clarence Buckingham Collection,
1979.650

Provenance:
Kornfeld and Klipstein, Bern, sale, 20–22 June 1979,
lot 1092; C. G. Boerner, Düsseldorf, sold to Art Institute of
Chicago, 1979.

Selected References:
Pissarro 1980, p. 205, cat. 165; Delteil 1999, no. 23, iii/iii.

Fig. 57

70. *Twilight with Haystacks*, 1879

Printed by Edgar Degas

Aquatint with drypoint and etching, printed in Prussian blue on beige laid paper, iii/iii

Plate: 4 ⅛ × 7 ⅛ in. (10.5 × 18.1 cm); sheet: 7 ¼ × 7 ⅞ in. (18.4 × 20.0 cm)

Museum of Fine Arts, Boston, Lee M. Friedman Fund, 1983.220

Provenance:
Kate Ganz, Ltd., London, sold to Museum of Fine Arts, Boston, 1983.

Selected References:
Delteil 1999, no. 23, iii/iii.

Fig. 58

71. *Rain Effect*, c. 1879

Aquatint on paper, i/vi

Plate: 6 ⁵⁄₁₆ × 8 ½ in. (16 × 21.6 cm); sheet: 8 ³⁄₁₆ × 12 ¹⁄₁₆ in. (20.8 × 30.6 cm)

Minneapolis Institute of Art, Gift of Ruth and Bruce Dayton, 2008.9.1

Provenance:
The artist (d. 1903; possibly his studio sale, Hôtel Drouot, Paris, 6 Dec. 1928, lot 31, or 12 April 1929, lot 30, possibly sold to Petiet); Henri M. Petiet, Paris (d. 1980); sale, Piasa, Paris, 13 June 2002, sold to Boerner; C. G. Boerner, New York (2002–8, sold to Minneapolis Institute of Art).

Selected References:
Delteil 1999, no. 24, i/vi.

Fig. 47

72. *Rain Effect*, 1879

Aquatint and drypoint on paper, vi/vi

Plate: 6 ¼ × 8 ½ in. (16 × 21.4 cm)

New York Public Library, Astor, Lenox, and Tilden Foundations, Samuel Putnam Avery Collection, Print Collection, Miriam and Ira D. Wallach Division of Art, Prints and Photographs

Provenance:
Samuel P. Avery, New York, given to New York Public Library, 1900.

Selected References:
Pissarro 1980, p. 207, cat. 170; Delteil 1999, no. 24, vi/vi.

Fig. 48

73. *Woman Emptying a Wheelbarrow*, 1880

Drypoint in black with plate tone on ivory laid paper, iv/xi

Plate: 12 ½ × 9 ⅛ in. (31.8 × 23.3 cm); sheet: 14 ⅜ × 10 ¾ in. (36.5 × 27.2 cm)

Art Institute of Chicago, Joseph Brooks Fair Collection, 1957.329

Provenance:
Edgar Degas (d. 1917; his sale, Hôtel Drouot, Paris, 6–7 Nov. 1918, lot 304, as *La Paysanne à la brouette*, one of eight impressions, sold to Le Garrec); Maurice Le Garrec, Paris (from 1918); Richard Zinser, New York, sold to Art Institute of Chicago, 1957.

Selected References:
Shapiro 1973, cat. 21, checklist no. 29; Ives et al. 1997, p. 106, no. 934; Delteil 1999, no. 31, iv/xi.

Fig. 49

74. *Woman Emptying a Wheelbarrow*, 1880

Drypoint and aquatint on paper, viii/xi

Plate: 12 ½ × 9 ⅛ in. (31.8 × 23.2 cm)

Rhode Island School of Design Museum, Providence, Rhode Island, Museum Works of Art Fund, 48.249

Provenance:
Edgar Degas (d. 1917; his sale, Hôtel Drouot, Paris, 6–7 Nov. 1918, lot 304, as *La Paysanne à la brouette*, one of eight impressions, sold to Le Garrec); Maurice Le Garrec, Paris (from 1918); purchased by Rhode Island School of Design Museum, 1948.

Selected References:
Shapiro 1973, cat. 22, checklist no. 31; Ives et al. 1997, p. 107, no. 936; Delteil 1999, no. 31, viii/xi.

Fig. 50

75. *Woman Emptying a Wheelbarrow*, 1880

Aquatint with drypoint on paper, x/xi

Plate: 12 ½ × 9 ¹⁄₁₆ in. (31.8 × 23 cm); sheet: 20 ¼ × 14 ¹⁄₁₆ in. (51.5 × 35.7 cm)

National Gallery of Art, Washington, DC, Rosenwald Collection, 1943.3.7311

Provenance:
Lessing J. Rosenwald, Jenkintown, PA, given to National Gallery of Art, 1943.

Selected References:
Delteil 1999, no. 31, x/xi.

Fig. 51

76. *Road by a Field of Cabbages*, c. 1880

Color monotype on paper

Image: 7 ⅞ × 6 ¹⁄₁₆ in. (20 × 15.4 cm); sheet: 9 ¹⁄₁₆ × 7 ¹⁄₁₆ in. (23 × 18 cm)

National Gallery of Art, Washington, DC, Print Purchase Fund (Rosenwald Collection), 1976.34.1

Provenance:
Purchased by National Gallery of Art, 1976.

Selected References:
Shapiro and Melot 1975, no. 13.

Fig. 65

77. *Quai de Paris, Rouen*, 1883

Oil on canvas

21 ⅜ × 25 ⅜ in. (54.3 × 64.5 cm)

Philadelphia Museum of Art, Bequest of Charlotte Dorrance Wright, 1978, 1978–1–25

Provenance:
The artist, sold to Durand-Ruel, 22 Dec. 1883; Durand-Ruel, Paris and New York (1883–1933, sold to Nelson Gallery, 10 Feb. 1933); William Rockhill Nelson Gallery of Art, Kansas City, MO (1933–deaccessioned after 1943); Schoneman Galleries, New York; Charles E. Kahr, Long Island, NY (until 1959, sale Parke-Bernet, New York, 15 Apr. 1959, lot 66, sold to Wright); Mr. and Mrs. William Coxe Wright, St. Davids, PA (1959–William d. 1970); his wife, Charlotte Dorrance Wright (1970–1978, bequeathed to Philadelphia Museum of Art, 1978).

Selected References:
Pissarro and Venturi 1939, no. 606; Bailly-Herzberg 1980–91, vol. 1, pp. 238, 270, nos. 180, 205; Thomson 1990, cat. 31; Pissarro and Durand-Ruel Snollaerts 2005, vol. 2, p. 485, no. 727, as *Quai de Paris and the Pont Corneille, Rouen, Sunshine*.

Fig. 62

78. *View of Rouen (Cours-la-Reine)*, 1884

Etching, softground etching, and drypoint on paper, iii/iii

Image: 5 ⅞ × 7 ⅞ in. (14.9 × 20 cm); sheet: 11 × 14 ¼ in. (27.9 × 36.2 cm)

Philbrook Museum of Art, Tulsa, Oklahoma, Museum purchase, 2015.10

Provenance:
Sale, Galerie Kornfeld, Bern, 11 June 2009, lot 628; Harris Schrank, New York, sold to Philbrook Museum of Art , 2015.

Selected References:
Delteil 1999, no. 50, iii/iii.

Fig. 61

79. *L'Île Lacroix, Rouen*, c. 1887

Etching, aquatint, manière grise, drypoint, and burnishing on paper, ii/ii

Plate: 4 ½ × 6 ¼ in. (11.4 × 15.9 cm); sheet: 10 ¾ × 13 in. (27.3 × 33 cm)

Private collection, courtesy of Harris Schrank, New York

Provenance:
Sale, Bonhams, San Francisco, 20 Oct. 2015, lot 155; Harris Schrank, New York; private collection.

Selected References:
Delteil 1999, no. 69, ii/ii.

Fig. 63

80. *Herding the Cows at Dusk* (*Vachère le soir*), c. 1890

Monotype on paper

Plate: 5 × 9 ¼ in. (12.7 × 23.5 cm); sheet: 6 ⅛ × 9 ¼ in. (15.5 × 23.5 cm)

National Gallery of Art, Washington, DC, Print Purchase Fund (Rosenwald Collection), 1967.19.1

Provenance:
Purchased by National Gallery of Art, 1967.

Selected References:
Shapiro 1973, checklist no. 92, as *Vacherie le soir*; Shapiro and Melot 1975, no. 11.

Fig. 67

81. *A Bather*, 1894

Monotype on paper

Plate: 5 1/16 × 7 in. (12.8 × 17.8 cm); sheet: 6 ⅛ × 7 15/16 in. (15.6 × 20.2 cm)

National Gallery of Art, Washington, DC, Ruth and Jacob Kainen Collection, 1977.70.2

Provenance:
Ruth and Jacob Kainen, Chevy Chase, MD, given to National Gallery of Art, 1977.

Selected References:
Shapiro and Melot 1975, no. 1.

Fig. 99

82. *Woman Arranging Her Hair*, 1894

Monotype in black and red ink on wove paper

Plate: 7 × 4 15/16 in. (17.8 × 12.5 cm); sheet: 8 1/16 × 6 ⅛ in. (20.4 × 15.5 cm)

The Metropolitan Museum of Art, New York, Harris Brisbane Dick Fund, 1947, 47.90.4

Provenance:
John Rewald; purchased by The Metropolitan Museum of Art, 1947.

Selected References:
Shapiro 1973, checklist no. 91; Shapiro and Melot 1975, no. 10; *Pissarro 1980*, pp. 229–30, cat. 202.

Fig. 106

83. *Woman Combing Her Hair*, 1894

Color monotype on paper

Image: 4 15/16 × 6 ⅞ in. (12.5 × 17.5 cm); sheet: 8 1/16 × 11 7/16 in. (20.5 × 29.1 cm)

Museum of Fine Arts, Boston, Lee M. Friedman Fund, 60.793

Provenance:
Purchased by Museum of Fine Arts, Boston, 1960.

Selected References:
Shapiro 1973, cat. 43, checklist no. 88; Shapiro and Melot 1975, no. 9.

Fig. 105

84. *Nude Seated on a Bank*, c. 1894

Color monotype on paper

Plate: 6 ⅞ × 4 15/16 in. (17.5 × 12.5 cm); sheet: 9 ⅛ × 7 ¼ in. (23.2 × 18.4 cm)

Museum of Fine Arts, Boston, Gift of Mr. and Mrs. Benjamin A. Trustman, 60.644

Provenance:
Mr. and Mrs. Benjamin A. Trustman, given to Museum of Fine Arts, Boston, 11 May 1960.

Selected References:
Shapiro 1973, checklist no. 87; Shapiro and Melot 1975, no. 6.

Fig. 111

85. *Bather*, c. 1894

Color monotype on paper

Plate: 7 × 5 in. (17.8 × 12.7 cm)

Schorr Collection

Provenance:
Paul-Émile Pissarro, the artist's son; Colnaghi, London, sold to Schorr Collection, 1977.

Selected References:
None.

Fig. 112

86. *Bathers*, c. 1894

Color monotype on paper

Image: 7 × 4 ¾ in. (17.8 × 12.1 cm); sheet: 8 3/16 × 6 ½ in. (20.8 × 16.5 cm)

Museum of Fine Arts, Boston, Gift of Mr. and Mrs. Peter A. Wick, 58.1382

Provenance:
Mr. and Mrs. Peter A. Wick, given to Museum of Fine Arts, Boston, 1958.

Selected References:
Shapiro and Melot 1975, no. 7.

Fig. 107

87. *The Market at Gisors; Rue Cappeville*, c. 1894

Etching in black, with watercolor, on ivory laid paper, iii/vii

Image: 6 11/16 × 4 ¾ in. (17 × 12 cm); sheet: 11 11/16 × 8 ⅛ in. (29.7 × 20.7 cm)

Art Institute of Chicago, Restricted gift of Suzanne Searle Dixon, 1990.496

Provenance:
Margo Schab, sold to Art Institute of Chicago, 1990.

Selected References:
Delteil 1999, no. 112, iii/vii.

Fig. 101

88. *The Market at Gisors; Rue Cappeville*, 1894–95

Etching in color on paper, vii/vii

Plate: 8 × 5 ½ in. (20.3 × 14 cm); sheet: 12 ⅝ × 7 ½ in. (32.1 × 19.1 cm)

Private collection, courtesy of Harris Schrank, New York

Provenance:
Sale, Galerie Kornfeld, Bern, 13 June 2013, lot 566; Harris Schrank, New York; private collection.

Selected References:
Delteil 1999, no. 112, vii/vii.

Fig. 102

89. *A Young Woman Washing Her Feet at the Edge of a Stream*, c. 1894–95

Monotype on wove paper

Plate: 5 × 6 15/16 in. (12.7 × 17.6 cm); sheet: 6 × 8 1/16 in. (15.3 × 20.4 cm)

The Metropolitan Museum of Art, New York, Harris Brisbane Dick Fund, 1947, 47.90.3

Provenance:
John Rewald; purchased by The Metropolitan Museum of Art, 1947.

Selected References:
Shapiro 1973, checklist no. 90; Shapiro and Melot 1975, no. 4; Thomson 1990, pp. 88, 126, cat. 72, fig. 105.

Fig. 108

90. *Church and Farm at Éragny*, 1895

Etching on paper, vi/vi, color state v

Plate: 6 3/16 × 9 ⅝ in. (15.7 × 24.5 cm); sheet: 9 ⅞ × 11 13/16 in. (25.1 × 30 cm)

Harvard Art Museums/Fogg Museum, Cambridge, Massachusetts, Gift of Robert Walker in honor of Jakob Rosenberg, M19867

Provenance:
Robert Walker, given to Fogg, 1988.

Selected References:
Delteil 1999, no. 96, vi/vi.

Fig. 103

91. *Bathers*, 1895–96

Monotype, pencil, and gouache on laid paper

Image: 4 ½ × 6 ¼ in. (11.4 × 15.9 cm)

Dallas Museum of Art, The Wendy and Emery Reves Collection, 1985.R.46

Provenance:
Wendy and Emery Reves, Roquebrune, France, given to Dallas Museum of Art, 1985.

Selected References:
Brettell 1995, pp. 116–17.

Fig. 109

92. *Quai de Rouen (Grand Pont)*, 1896

Lithograph on laid blue Ingres paper

Image: 8¼ × 11½ in. (21 × 29.2 cm)

The Nelson-Atkins Museum of Art, Kansas City, Missouri, Purchase: acquired through the Richard Shields Fund, F75-15

Provenance:
Dr. Heinrich Stinnes, Cologne (d. 1932; his sale, C. G. Boerner, Leipzig, 10–11 Nov. 1932, lot 332, sold to Galerie Aktuaryus); Galerie Aktuaryus, Zürich (from 1932); Dr. Sigmund Pollag, Zürich (until 1973; his sale, Galerie Wolfgang Ketterer, Munich, 27 Nov. 1973, lot 2289); Angus Whyte Gallery, Boston, sold to The Nelson-Atkins Museum of Art, 20 June 1975.

Selected References:
Delteil 1999, no. 172.

Fig. 115

93. *Haymakers of Éragny*, 1897

Etching and drypoint printed in black on ivory wove paper, iii/iii

Plate: 8 × 6 in. (20.3 × 15.2 cm); sheet: 12¾ × 9½ in. (32.4 × 24.1 cm)

Smith College Museum of Art, Northampton, Massachusetts, Purchased, SC 1931:4-14

Provenance:
J. B. Neumann, New York, sold to Smith College Museum of Art, 1931.

Selected References:
Delteil 1999, no. 124, iii/iii.

Fig. 114

94. *Line of Women Bathing*, 1897

Lithograph on blue-gray paper

Image: 5¼ × 7⅞ in. (13.3 × 20 cm); sheet: 10¹¹⁄₁₆ × 14⅜ in. (27.2 × 36.5 cm)

Minneapolis Institute of Art, The Winton Jones Endowment for Prints and Drawings, 2007.69

Provenance:
Henri M. Petiet, Paris (d. 1980); estate of Petiet (sale, Piasa, Paris, 7 Dec. 2006, lot 148, sold to Johnson); Jan Johnson, Montreal (2006–7, sold to Minneapolis Institute of Art).

Selected References:
Delteil 1999, no. 181.

Fig. 113

PAUL-ADOLPHE RAJON
French, 1843–1888

95. *Félix Bracquemond in 1852*, c. 1870

After Félix Bracquemond (French, 1833–1914)

Etching on paper

Plate: 9¹³⁄₁₆ × 7⁷⁄₁₆ in. (25 × 18.9 cm); sheet: 12½ × 9 in. (31.8 × 22 .8 cm)

Harvard Art Museums/Fogg Museum, Gift of Benjamin Allen Rowland, M10164

Provenance:
Benjamin Allen Rowland, given to Fogg, 1942.

Selected References:
Béraldi 1891, no. 147.

Fig. 5

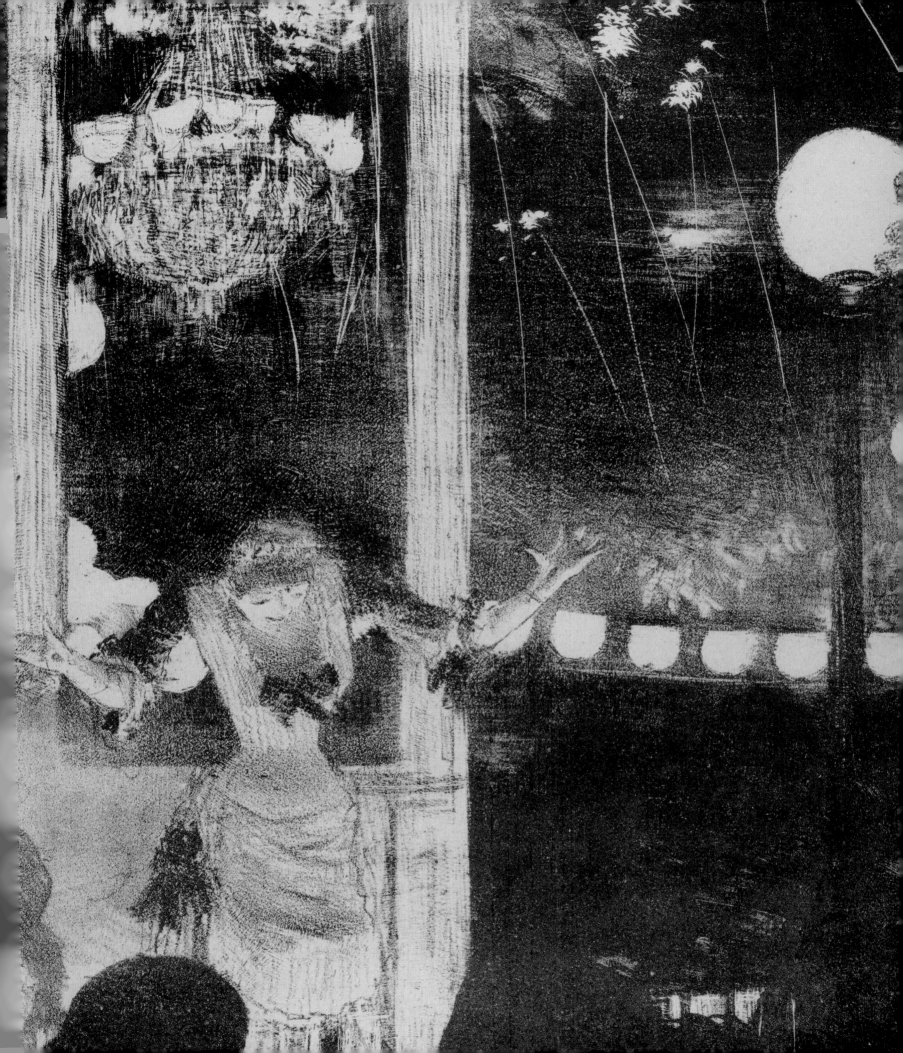

Notes

Throughout the notes, references to catalogues raisonnés have been abbreviated as follows:

AC Jean Adhémar and Françoise Cachin, *Degas: The Complete Etchings, Lithographs, and Monotypes* (New York: The Viking Press, 1975)

B Adelyn Dohme Breeskin, *Mary Cassatt: A Catalogue Raisonné of the Graphic Work* (Washington, DC: Smithsonian Institution Press, 1979)

D Loys Delteil, *Camille Pissarro: l'oeuvre gravé et lithographié; The Etchings and Lithographs*, supplemented by Jean Cailac, edited by Alan Hyman (San Francisco: Alan Wofsy Fine Arts, 1999)

MS Nancy Mowll Mathews and Barbara Stern Shapiro, *Mary Cassatt: The Color Prints*, exh. cat. (Williamstown, MA: Williams College Museum of Art; New York: Harry N. Abrams, 1989)

PDR Joachim Pissarro and Claire Durand-Ruel Snollaerts, *Pissarro: Critical Catalogue of Paintings*, 3 vols. (Paris: Wildenstein Institute; Milan: Skira, 2005)

RS Sue Welsh Reed and Barbara Stern Shapiro, *Edgar Degas: The Painter as Printmaker*, exh. cat. (Boston: Museum of Fine Arts, 1984)

ARTISTIC COLLABORATION: A BRIEF HISTORY

1 On the Le Nain brothers, see Dickerson and Bell 2016. For the Carracci, see Robertson 2008.

2 Three books deal with the phenomenon of summer artist colonies in ways diverse enough that each is worth reading. The earliest is Jacobs 1985. Of particular importance here is chapter 3, "A Second Arcadia: Pont-Aven and Concarneau (France)," pp. 42–87. Lübbren 2001 takes a nongeographical approach and deals with comparative issues, the most relevant of which is the concept of "creative sociability" (see pp. 17–36). The most recent is Barrett 2010.

3 See Luthi and Israël 2014 on Bernard, and Solana 2004 on Gauguin.

4 White 1996.

5 Pissarro 2006.

6 The study of intersubjectivity and interaction has so often been reduced to pairs of artists, musicians, or writers that larger groups often elude scholarly scrutiny. We have had Rubens versus Rembrandt by Simon Schama, Van Gogh versus Gauguin by Douglas Druick and Peter Zegers, Degas and Picasso by Elizabeth Cowling and Richard Kendall, Degas and Cassatt by Kimberly Jones, and the now canonical Braque and Picasso by William Rubin. Even the trio of this current project only begins to address these larger issues. See Schama 1999, Druick and Zegers 2001, Cowling and Kendall 2010, Jones 2014, and Rubin 1989.

7 A similar exhibition was organized once before with the same group of artists in 1992 by the St. John's Museum of Art in Wilmington, North Carolina. See Brennan and Furst 1992. Unfortunately, that exhibition and its small, if wonderful, catalogue included only thirty-three works, which is not enough to actually measure the extent of interaction of the three artists as they worked together.

8 Meyers 2005. Because this book was written by a biographer and literary critic, few art historians have taken it seriously. It is not only beautifully written and well researched, it contains both insights and facts missing in many of the studies of the oeuvres of the four artists.

9 The most comprehensive exploration of the cliché-verre remains Glassman and Symmes 1980. For the artists discussed here, see Elizabeth Glassman's chapter titled "Cliché-verre in the 19th Century," pp. 27–44. See also Paviot 1994, particularly pp. 9–19, and Matthias 2007, especially "'Eine besondere graphische Technik': Zur Rezeptionsgeschichte des Cliché-verre," pp. 7–22. The latter publication supersedes much in Glassman's essay, but is more difficult to find in American art libraries.

10 See Glassman and Symmes 1980, p. 88.

11 For the paintings, see Horbez 2004.

12 The primary reference for this is Bailly-Herzberg 1972. The most recent rehearsal of this material in English is an essay by Anna Arnar titled "Seduced by the Etcher's Needle: French Writers and the Graphic Arts in Nineteenth-Century France," in Helsinger 2008, pp. 39–53.

13 On the significance of gesture for the Impressionists, see Brettell 2000, p. 17.

14 Though Berson 1996 offers much of the data necessary for an investigation of the collective aspect of Impression, such a study has yet to be undertaken.

15 Rewald 1946.

16 Exhibitions such as *In the Light of Italy* and *A Brush with Nature*, both based largely on the Gere Collection of oil sketches at the National Gallery, London, bring together representative samples of such works, but the accompanying essays stress the artists' segregation by nationality, as well as their interactions with nature more than with each other. See Conisbee, Faunce, and Strick 1996 and Riopelle and Bray 1999.

INNOVATIVE IMPRESSIONS: CASSATT, DEGAS, AND PISSARRO AS PAINTER-PRINTMAKERS

1 "Il y a donc aujourd'hui deux espèces d'eaux-fortes: celles de tout le monde qui se ressemblent par le sujet, par la facture, par la couleur, et surtout par l'absence d'idée; le titre dit ce qu'elles voudraient être; et celles qui s'expliquent toutes seules. Celles-là sont imparfaites. Comme la jeunesse, elles ont des défauts et leur caractère est d'en avoir. . . . Les bords ne sont pas égaux, certaines parties sont négligées, d'autres peu faites, d'autres d'un fini et d'un esprit charmants; vous êtes devant une vraie eau-forte, une œuvre d'artiste, et l'esprit qu'il a mis dans sa plaque réveille le vôtre et vient causer avec lui. . . . Elles sentent l'imprévu, elles en ont l'inachevé et l'indéfini; c'est le caractère propre de l'eau-forte qui est tout à la fois soudaine et finie." Lepic 1876, p. 9.

2 Degas did eventually break off relations with Pissarro when Degas's increasing anti-Semitism emerged in the 1890s during the Dreyfus affair.

3 The Cézanne-Pissarro relationship has been extensively analyzed by Joachim Pissarro. See Pissarro 2005 and Pissarro 2006.

4 See Fredericksen 2002.

5 "Combattre la photographie, la lithographie, l'aqua-tinte, la gravure dont les hachures recroisées ont un point au milieu . . . le travail régulier, automatique, sans inspiration qui dénature l'idée même de l'artiste." Gautier 1863, n.p.

6 "Autant le burin, avec ses allures compassés, avec son élégance prévue et méthodique, convient aux compositions solennelles, aux figures et aux nudités idéales, autant l'eau-forte, dans sa marche capricieuse, va bien aux choses familières ou champêtre, au fouillis des paysages agrestes, au pittoresque des ruines et aux épisodes toujours nouveau du combat que se livrent sous nos yeux la lumière et l'ombre. . . . Le burin, en un mot, répond à la majesté de l'art et à la sévère éloquence du dessin: l'eau-forte représente l'improvisation, la liberté et la couleur." Blanc 1867, p. 636.

7 An engraving by Étienne Achille Réveil (1800–1851) of Ingres's self-portrait had been published in 1851.

8 Bouillon 1987, p. 77, gives Bracquemond's son as the source of this story.

9 While the final state may have initially been Bracquemond's primary goal, by 1884 the value of the incomplete first state was recognized, as demonstrated by its reproduction in the *Gazette des Beaux-Arts* in a biographical article on the artist. See Lostalot 1884, p. 423.

10 Melot 1996, pp. 69–70.

11 A print of this photograph, dated c. 1865, is in the Metropolitan Museum of Art, New York (1983.1084.2).

12 It is fascinating to note that although Manet chose not to participate in the upstart exhibition, his work was nonetheless represented in it by Bracquemond's copy, of which Manet must have been aware.

13 The only other identified etchings in the exhibition were two untitled works by Henri Stanislas Rouart (1833–1912), an engineer and occasional artist better known as a collector. See Berson 1996, vol. 1, p. 7.

14 Buchanan 1997, p. 54. This article provides a very detailed study of the two artists' relationship.

15 In his brief essay "Comment je devins graveur à l'eau-forte" (How I became an etcher), Lepic notes that he began his efforts in etching about sixteen years earlier, thus in about 1860. Lepic 1876, p. 3.

16 For Lepic on Rembrandt, see Lepic 1876, pp. 7–8. In Lepic's own time, as Bailly-Herzberg notes, the printer Auguste Delâtre (1822–1907), who produced the *Eaux-fortes modernes* volumes as well as other sheets, was widely known for leaving a considerable amount of ink on the plates he printed for artists, although sometimes this was against the artists' wishes. Bailly-Herzberg 1972, p. 6.

17 Lepic 1876, p. 11. Six impressions in the Baltimore Museum of Art are illustrated in Hauptman 2016, pp. 70–71, cat. 16.

18 See Reed and Shapiro 1984, pp. 47, 51, for the two seated portrait drawings. They cite a third that is similar but not as closely related to the bust-length portrait.

19 RS 17 and 18.

20 D 1 and 2.

21 D 3.

22 Corot had already produced a number of etchings as well working in the related technique of cliché-verre (see Rick Brettell's essay in this volume), and it seems possible that he provided some guidance to Pissarro—like Joseph Gabriel Tourny (1817–1880) had done for Degas—as the younger artist began to take up etching.

23 These include Reff 1967; Pissarro 2006; and Brettell 2011, pp. 53–54, 120–22.

24 Segard 1913, p. 8, cited and translated in Breeskin 1979, p. 13.

25 B 8.

26 B 9.

27 "Voilà quelqu'un qui sent comme moi." Segard 1913, p. 35. As George T. M. Shackelford notes, however, this account, recollected by Cassatt decades after the fact, seems an uncharacteristically sentimental statement for Degas. George T. M. Shackelford, "*Pas de deux*: Mary Cassatt and Edgar Degas," in Barter 1998, p. 109.

28 *Rehearsal of the Ballet* is a work Cassatt particularly appreciated, recommending that her friend Louisine Havemeyer purchase it.

29 Marcellin Desboutin, letter to Guiseppe de Nittis, 17 July 1876, quoted in Reed and Shapiro 1984, p. xxix.

30 Reed and Shapiro 1984, p. 62.

31 RS 22.

32 Reed and Shapiro 1984 lists several other prints that used this ink; see p. 12 and cats. 5, 12, 15, 19, and 24.

33 Isaacson 1994, pp. 438–42.

34 "Les grains marchent, même sans vous (qui devriez nous apprendre au lieu de nous laisser aller d'un côté et de l'autre." Edgar Degas, letter to Félix Bracquemond, undated [late 1879 or early 1880], in Guérin 1945, pp. 48–49.

35 See Bouillon 1989, where the drawing, which is in a private collection, is illustrated.

36 Studies include Douglas Druick and Peter Zegers's "Degas and the Printed Image, 1854–1914," in Reed and Shapiro 1984, pp. xv–lxxii; Bouillon 1989; Melot 1996; Barbara Stern Shapiro, "A Printmaking Encounter," in Dumas et al. 1997, pp. 235–45; Minder 1998; and Amanda T. Zehnder's "Forty Years of Artistic Exchange," in Jones 2014, pp. 2–19.

37 Tout-Paris 1880, p. 2.

38 Katherine Cassatt, letter to Alexander Cassatt, 9 Apr. [1880], in Mathews 1984, p. 151.

39 See Druick and Zegers in Reed and Shapiro 1984, pp. xlv–xlvi. They note that Degas wrote to Pissarro that "our issues *avant la lettre* [before captioning] will cover our costs," presumably referring to the edition of fifty with original prints. Edgar Degas, letter to Camille Pissarro, undated [1880], in Guérin 1945, p. 55; translation from Reed and Shapiro 1984, p. xlv.

40 Reed and Shapiro 1984, p. 174, document twenty impressions.

41 See Barbara Stern Shapiro, "A Printmaking Encounter," in Dumas et al. 1997, p. 239.

42 Edgar Degas, letter to Camille Pissarro, undated [1880], in Guérin 1945, p. 53.

43 B 20.

44 B 21. See Tedeschi 2013 for a discussion of this progression.

45 Breeskin 1979, pp. 45–46, lists only four states, but the Museum of Fine Arts, Boston, holds six impressions of this work from the collection of Henri Petiet, a collector and dealer who acquired all of the prints that dealer Ambroise Vollard had purchased from Cassatt herself. Three of the states in Boston are unrecorded, probably made prior to Breeskin's final state. Thanks go to Patrick Murphy for supplying this information.

46 Museum of Fine Arts, Boston, 2001.690.

47 The progression of these states is discussed in Shapiro 1973, under cats. 6–11.

48 Jones 2014, pp. 86–92.

49 This drawing is illustrated in Jones 2014, p. 88.

50 In the pastel *At the Louvre (Miss Cassatt)* (private collection) that Kimberly Jones suggests followed the *Etruscan Gallery* etching (Jones 2014, p. 90), the figures are returned to a slightly more sharply angled position with respect to each other, and placed among paintings rather than ancient sculpture.

51 See Jones 2014, pp. 87–88, and Berson 1996, vol. 2, p. 148, no. V-44, which both note the uncertainty about this work's inclusion.

52 "I will leave aside the printed work of M. Pissarro, encircled by the violet of his frames surrounding a yellow paper." (Je laisserai de côté l'oeuvre gravé de M. Pissarro, cernée par le violet de ses cadres entourant un papier jaune.) Huysmans 1880; reprinted in Berson 1996, vol. 1, p. 286.

53 Hollis Clayson identified the lamp in this etching and proposed this reading of Cassatt's image in the exhibition *Electric Paris*, Sterling and Francine Clark Art Institute, Williamstown, Massachusetts, 2013. She also extensively explored the links between technological and artistic innovation in Cassatt's prints of lamps in Clayson 2017.

54 Hollis Clayson studied Degas's prints of these types of lighting in "Darkness and the Light of Lamps," in Hauptman 2016, pp. 85–87.

55 See Mathews and Shapiro 1989, p. 59.

56 AC 116.

57 Barter 1998, pp. 67–68, and Zehnder in Jones et al. 2014, pp. 8–9. Note that neither print was intended to be included in the journal.

58 D 17.

59 D 20.

60 "Imprimé par E. Degas; aquatinte coulée par Pizarro [sic], 2e état reprise au pinceau métallique sur vernis mou." Cited in *Pissarro* 1980, p. 207.

61 Reed and Shapiro 1984, p. 126.

62 "Je n'ai fait tirer qu'hier ce petit essai avec le crayon de charbon. Vous voyez comme c'est d'un joli gris. Il faudrait des crayons à émeri. . . . Merci de la pierre que vous m'avez envoyée. Elle raye le cuivre d'une façon délicieuse." Edgar Degas, letter to Alexis Rouart, undated (dated by Guérin to 1882, but now believed to date to around 1880), in Guérin 1945, pp. 61–62. Guérin identified

the "crayon de charbon" as coming from an electric lamp, and this tool is described in further detail in Reed and Shapiro 1984, p. 126.

63 "On voit venir l'orage." Duvivier and Melot 2017, p. 11.

64 Jay Clarke discussed this issue in the context of Impressionist prints in Clarke 2013, p. 40.

65 "Je vous ferai tirer avec une encre de couleur votre prochain envoi. J'ai aussi d'autres idées pour les planches en couleur. . . . Je vous enverrai bientôt des essais de moi en ce genre." Edgar Degas, letter to Camille Pissarro, undated [1880], in Guérin 1945, pp. 53–54.

66 The other sheets are in brown (Bibliothèque nationale de France, Paris), blue-gray, crimson (both Ashmolean Museum, Oxford), red-brown, and green (both National Gallery of Canada, Ottawa).

67 See Minder 1998, p. 68, for a discussion of the color impression of *The Old Cottage*. Melot 1996, pp. 231–32, discusses some of the critical and artistic biases against color prints in the period.

68 Mary Cassatt to Louisine Havemeyer, in Havemeyer 1961, p. 244.

69 PDR 735.

70 Brettell and Lloyd 1984, p. 196, no. 284.

71 D 48.

72 PDR 725 and 726.

73 For a map of these Rouen locations, see Pissarro and Durand-Ruel Snollaerts 2005, vol. 2, p. 480.

74 Brettell and Lloyd 1980, pp. 49–50, outline the complex sequencing of these works. Duvivier and Melot 2017, p. 31, suggests that the etching *L'Île Lacroix, Rouen* (D 69) may date to 1883.

75 In 1891 he wrote to his son Lucien, "I need a good press to make my prints; I've managed to make color prints with Titi [his son Félix] . . . who is beginning to print pretty well with our bad press." (Il me faudrait pour mes gravures une bonne presse; avec Titi j'arriverais à faire des gravures en couleurs . . . Titi qui commence à tirer pas mal avec notre mauvaise presse.) Camille Pissarro, letter to Lucien Pissarro, 3 Apr. 1891, in Bailly-Herzberg 1980–91, vol. 3, p. 56, letter 650.

76 D 29. Shapiro and Melot 1975 is the only study of Pissarro's monotypes. They date all of the nineteen works they catalogue to c. 1894–95, based partly on the only known dated monotype, *A Bather* (fig. 99). They note, however, that Pissarro seems often to have worked on related subjects in different media at the same time, and it is on these grounds that the *Field of Cabbages* monotype is dated to the same period as the *Cabbage Field* etching.

77 "Ça serait ravissant de voir des contours de choux très suivi. . . . Pas besoin de vous complimenter sur la qualité d'art de vos potagers." Edgar Degas, letter to Camille Pissarro, 1880, in Guérin 1945, p. 54.

78 There is another monotype in a private collection of a similar subject, *Sunset* (*Le coucher de soleil*), showing a figure and two cows casting long shadows. Minder 1998, p. 145, dates it "c. 1879–80 (?)," while Duvivier and Melot 2017, p. 18, dates it 1894/1896.

79 Breeskin 1979, p. 20. This idea is also reflected in Achille Segard's account of Cassatt taking up drypoint. "To impose on herself an almost absolute precision in drawing from the living model, Miss Cassatt adopted a working process that excluded all cheating or inexactitude. She was not content to draw with a pencil. She wanted to engrave the copper with a steel point so that the plate would retain the trace of her errors or corrections." (Pour s'imposer à elle-même une précision quasi absolue dans le dessin d'après le modèle vivant, Miss Cassatt s'imposa un procédé de travail qui exclue toute tricherie ou toute inexactitude. Elle ne se contenta point de dessiner avec le crayon. Elle voulut graver sur le cuivre, avec la pointe de fer, afin que la plaque gardât la trace de ses erreurs ou de ses repentirs.) Segard 1913, p. 86.

80 See Mathews and Shapiro 1989, pp. 40–41, for an illustrated list of the series of twelve drypoints.

81 Judith Barter, in her study of childhood and maternity in Cassatt's work, notes that the pastel of a mother and child Cassatt exhibited in the Impressionist exhibition of 1881, along with several other works that featured children, were well received. Barter 1998, p. 69.

82 Mathews and Shapiro 1989, pp. 35, 54n29, suggest several prints that might have been in this series.

83 George T. M. Shackelford, in Barter 1998, p. 123, suggests that this print may date closer to 1880.

84 See Druick and Zeghers in Reed and Shapiro 1984, pp. xxxiv–xxxviii, for a description of this process.

85 AC 95.

86 Janis 1968, no. 178.

87 AC 132.

88 A number of these are discussed and reproduced in Hauptman 2016.

89 It is also fascinating to note in this context that one instance of a direct exchange between Cassatt and Degas centered on images of women at their toilette, when, at the end of the Impressionist exhibition of 1886, she acquired his pastel *Woman in a Shallow Tub* (1885; The Metropolitan Museum of Art, New York) and gave him her painting *Girl Arranging Her Hair* (1886; National Gallery of Art, Washington, DC) in return.

90 Mary Cassatt, letter to Berthe Morisot, Apr. 1890, in Mathews 1984, p. 214. Morisot, who made only a small number of prints in her career, had been planning for the previous two years to produce an album of color lithographs. See Melot 1996, p. 212.

91 Mary Cassatt, letter to Frank Weitenkampf, 18 May 1906, cited in Mathews and Shapiro 1989, p. 37.

92 See especially Nancy Mowll Mathews's essay "The Color Prints in the Context of Mary Cassatt's Art," in Mathews and Shapiro 1989, pp. 36–48, and Marc Rosen and Susan Pinsky's essay "The Medium as Muse: Innovations and Intersections in Printmaking," in Jones 2014, pp. 105–11.

93 Stéphane Mallarmé, letter to the publisher Deman, 1 Nov. 1888, cited and translated in Melot 1996, pp. 211–12.

94 As Rosen and Pinsky suggest, she may have tested these unexpected colors in alternate sheets, but chose more subdued combinations for the edition. Rosen and Pinsky in Jones 2014, p. 109.

95 The Brooklyn Museum currently describes their sheet as an uncatalogued state before the final version, although Mathews and Shapiro catalogue it as a final state. See Matthews and Shapiro 1989, pp. 145–49.

96 This exhibition that had come about because, despite having shown with the group the previous year, both Cassatt and Pissarro were excluded from the Société des Peintres-Graveurs by a new requirement that its members be French-born. The two artists then reached an agreement with Durand-Ruel to hold their own exhibitions adjacent to that of the printmakers.

97 "Ce dos, vous l'avez modelé?" Segard 1913, p. 104.

98 "Mon cher Lucien, je pense qu'il est nécessaire pendant que je suis bien

imprégné de ce que j'ai vu chez miss Cassatt où je suis allé hier, que je te parle des gravures en couleurs qu'elle compte exposer chez Durand-Ruel en même temps que moi. . . . Tu te rappelles les essais que tu as faits à Eragny, eh bien! Mlle Cassatt l'a réalisé admirablement; le ton mat, fin délicat . . . du bleu adorable, des roses frais, etc. . . . mais le résultat est admirable, c'est aussi beau que les Japonais." Camille Pissarro, letter to Lucien Pissarro, 3 Apr. 1891, in Bailly-Herzberg 1980–91, vol. 3, p. 55, no. 650.

99 "Il a été charmé par le coté noble de cet art, tout en faisant de petites réserves qui ne touchent en rien le fond." Camille Pissarro, letter to Lucien Pissarro, 8 Apr. 1891, in Bailly-Herzberg 1980–91, vol. 3, pp. 57–58, no. 651.

100 "Dîner chez les Fleury Samedi avec Mlle Cassatt. Exposition japonaise aux Beaux-Arts. Le casque d'un pompier sur une grenouille. Hélas! Hélas! Le goût partout!" Edgar Degas, letter to Albert Bartholomé, Apr. 1890, in Guérin 1945, p. 152.

101 Barter 1998, p. 82 states that Cassatt started the project that summer at her country house, while Mathews suggests Cassatt started in fall 1890 (Mathews and Shapiro 1989, p. 36).

102 An account of this visit by Degas to his friend Georges Jeanniot was given some years later in Jeanniot 1933. This narrative is cited and analyzed along with the monotypes in Kendall 1993, pp. 145–75.

103 Kendall 1993, p. 145.

104 Richard Kendall proposed grouping Degas's roughly fifty color landscape monotypes into three subgroups based on size, suggesting that about thirty were made during the Burgundy trip. Kendall 1993, pp. 172–74, 273–74, appendix 1.

105 Kendall 1993, p. 188.

106 Mary Cassatt, letter to Rose Lamb, 30 Nov. 1892, in Mathews 1984, p. 240.

107 "Des pochades au pastel. Cela ressemble à des impressions en couleurs; c'est très curieux, un peu déhanché, mais rudement délicat de ton." Camille Pissarro, letter to Lucien Pissarro, 2 Oct. 1892, in Bailly-Herzberg 1980–91, vol. 3, p. 262, no. 819.

108 The complicated process Degas used for this series is described in Reed and Shapiro 1984, pp. 220–52, and also discussed by Druick and Zegers in Reed and Shapiro 1984, pp. lxii–lxix, who reproduce twenty-two related drawings Degas made at different stages of the process.

109 RS 63.

110 "C'est convenu avec Mlle Cassatt de faire ensemble avec elle des séries, je ferai des marchés, des paysannes dans les champs, et, chose épatante, je pourrai tenter de mettre en pratique quelques-uns des principes du néo-impressionnisme. . . . Si nous pouvions faire de belles gravures ce serait un grand point." Camille Pissarro, letter to Lucien Pissarro, 3 Apr. 1891, in Bailly-Herzberg 1980–91, vol. 3, p. 55, no. 650.

111 Camille and Lucien did produce a portfolio, Les travaux des champs, with drawings by Camille that were executed as woodcuts by Lucien, some of them printed in color. This portfolio of six prints was probably completed in 1893 and published by Vale Press in 1895. See Pissarro 1980, pp. 230–31, and Brettell and Lloyd 1980, pp. 75–85. An extensive group of works related to this project are illustrated in Brettell and Pissarro 2017, pp. 119–49.

112 "J'attends l'encre pour tirer. Nous avons essayé avec de la couleur à l'huile, ce sera épatant. Cela va me mettre en goût." Camille Pissarro, letter to Lucien Pissarro, 3 Jan. 1894, in Bailly-Herzberg 1980–91, vol. 3, p. 416, no. 975.

113 This monotype relates to a painting completed in 1893, Haymakers, Evening, Éragny (Joslyn Art Museum, Omaha), which may suggest a slightly earlier date for the print.

114 "Je me suis mis à la gravure à l'eau-forte en couleurs, j'attends toujours mes plaques de chez Miss Cassatt, quinze jours pour faire les points de repères, j'aurais déjà fini ma gravure si j'avais eu mes planches. Je vais les faire au papier à l'émeri, je ne veux pas employer le même moyen que Miss Cassatt, je ne ferai que des rehauts; j'ai commencé un Marché. . . . Je voudrais que ce soit souple, simple, très simple de couleur et d'un aspect fort." Camille Pissarro, letter to Lucien Pissarro, 26 May 1894, in Bailly-Herzberg 1980–91, vol. 3, p. 454, no. 1008.

115 The five are Church and Farm at Éragny (D 96); Beggar Women (D 110); Peasant Women Weeding the Grass (D 111); The Market at Gisors (D 112); and Women Bathing While Tending the Geese (D 119).

116 Like many of his prints, Church and Farm at Éragny also relates to a painting, Landscape at Éragny (Musée d'Orsay, Paris), which may well have been made after the print. See Pissarro 1980, p. 218. Note also that the Musée d'Orsay currently dates the painting to 1897, which supports the suggestion that the print preceded the painting.

117 "Depuis que j'ai la presse je me suis mis à faire des Baigneuses." Camille Pissarro, letter to Lucien Pissarro, 14 Jan. 1894, in Bailly-Herzberg 1980–91, vol. 3, p. 418, no. 978. "Je viens de faire tirer deux planches de Baigneuses à l'eau-forte, épatantes, tu verras cela, c'est peut-être trop nature, ce sont des paysannes en chair . . . mais je crois que c'est ce que j'ai fait de mieux." Camille Pissarro, letter to Lucien Pissarro, 21 Jan. 1894, in Bailly-Herzberg 1980–91, vol. 3, p. 420, no. 979. Bailly-Herzberg identified the two prints as D 116 and 117, while Minder 1998, p. 119, proposed D 114 and D 116.

118 "J'ai fait toute une série de dessins imprimés romantiques, qui m'ont paru avoir un aspect assez amusant, des Baigneuses en quantité dans toutes espèces de poses en des paysages paradisiaques, des intérieurs aussi, Paysannes à leur toilette, etc. ce sont des motifs que je me mets à peindre quand je ne puis sortir. C'est très amusants à cause des valeurs—les noirs et blancs—qui donnent le ton pour les tableaux. J'en ai fait rehaussés de couleurs." Camille Pissarro, letter to Lucien Pissarro, 19 Apr. 1894. Bailly-Herzberg 1980–91, vol. 3, p. 445, no. 1001.

119 AC 168.

120 This last is illustrated in Minder 1998, p. 144. The bent-over figure of one bather in the Boston sheet recalls some of Degas's at times indecorous interior bather monotypes.

121 Shapiro and Melot 1975, no. 5.

122 PDR 1060.

123 PDR 1061 and 1062.

124 PDR 1103.

125 In addition to the two Young Woman Washing Her Feet, the Dallas and Bergquist Bathers, and the Boston and Schorr collection pairs discussed here, there are also two versions of The Hearth—one in the Bibliothèque nationale de France, Paris, and the other in the Graphische Sammlung, Städelschen Kunstinstitut, Frankfurt. These are illustrated in Duvivier and Melot 2017, p. 29.

126 D 161.

127 MS 15.

128 MS 19.

129 MS 22.

130 D 194.

Adhémar and Cachin 1975
Adhémar, Jean, and Françoise Cachin. *Degas: The Complete Etchings, Lithographs, and Monotypes.* New York: The Viking Press, 1975.

Amic et al. 2007
Amic, Sylvain, et al. *L'impressionnisme, de France et d'Amérique: Monet, Renoir, Sisley, Degas.* Exh. cat. Versailles: Éditions Artlys, 2007; Montpellier: Musée Fabre; Grenoble: Musée Grenoble.

Bailly-Herzberg 1972
Bailly-Herzberg, Janine. *L'Eau-forte de peintre au dix-neuvième siècle: La Société des aquafortistes, 1862–1867.* 2 vols. Paris: Léonce Laget, 1972.

Bailly-Herzberg 1980–91
Bailly-Herzberg, Janine. *Correspondance de Camille Pissarro.* 5 vols. Paris: Presses universitaires de France; Paris: Editions du Valhermeil, 1980–91.

Barrett 2010
Barrett, Brian Dudley. *Artists on the Edge: The Rise of Coastal Artists' Colonies, 1880–1920.* Amsterdam: Amsterdam University Press, 2010.

Barter 1998
Barter, Judith A., et al. *Mary Cassatt, Modern Woman.* Exh. cat. Chicago: Art Institute of Chicago; New York: Abrams, 1998.

Béraldi 1885
Béraldi, Henri. *Les graveurs du XIXe siècle.* Vol. 3, *Bracquemond.* Paris: Librairie L. Conquet, 1885.

Béraldi 1891
Béraldi, Henri. *Les graveurs du XIX siècle.* Vol. 11, *Pillement–Saint-Èvre.* Paris: Librairie L. Conquet, 1891.

Berson 1996
Berson, Ruth, ed. *The New Painting: Impressionism, 1874–1886; Documentation.* 2 vols. San Francisco: Fine Arts Museums of San Francisco, 1996.

Blanc 1867
Blanc, Charles. *Grammaire des arts du dessin: Architecture, sculpture, peinture.* 3rd ed. Paris: Ve J. Renouard, 1867.

Boggs 1988
Boggs, Jean Sutherland, et al. *Degas.* Exh. cat. New York: The Metropolitan Museum of Art; Ottawa: National Gallery of Canada, 1988.

Bouillon 1987
Bouillon, Jean-Paul. *Félix Bracquemond, le réalisme absolu: Œuvre gravé, 1849–1859, catalogue raisonné.* Geneva: Skira, 1987.

Bouillon 1989
Bouillon, Jean-Paul. "Bracquemond, Le Jour et la Nuit." In *Degas inédit: Actes du colloque Degas, Musée d'Orsay, 18–21 avril 1988,* 251–59. Paris: La Documentation française, 1989.

Breeskin 1970
Breeskin, Adelyn Dohme. *Mary Cassatt: A Catalogue Raisonné of the Oils, Pastels, Watercolors, and Drawings.* Washington, DC: Smithsonian Institution Press, 1970.

Breeskin 1979
Breeskin, Adelyn Dohme. *Mary Cassatt: A Catalogue Raisonné of the Graphic Work.* Washington, DC: Smithsonian Institution Press, 1979.

Brennan and Furst 1992
Brennan, Anne G., and Donald Furst. *Cassatt, Degas and Pissarro: A State of Revolution.* Exh. cat. Wilmington, NC: St. John's Museum of Art, 1992.

Brettell 1990
Brettell, Richard R. *Pissarro and Pontoise: The Painter in a Landscape*. New Haven, CT: Yale University Press, 1990.

Brettell 1995
Brettell, Richard R. *Impressionist Paintings, Drawings, and Sculpture from the Wendy and Emery Reves Collection*. Dallas: Dallas Museum of Art, 1995.

Brettell 2000
Brettell, Richard R. *Impression: Painting Quickly in France, 1860–1890*. Exh. cat. New Haven, CT: Yale University Press; Williamstown, MA: Sterling and Francine Clark Art Institute, 2000.

Brettell 2011
Brettell, Richard R. *Pissarro's People*. Exh. cat. San Francisco: Fine Arts Museums of San Francisco, 2011.

Brettell and Lloyd 1980
Brettell, Richard R., and Christopher Lloyd. *A Catalogue of the Drawings by Camille Pissarro in the Ashmolean Museum, Oxford*. Oxford: Clarendon Press; New York: Oxford University Press, 1980.

Brettell and Pissarro 2017
Brettell, Richard R., and Joachim Pissarro. *Pissarro à Éragny: La nature retrouvée*. Exh. cat. Paris: Réunion des musées nationaux-Grand Palais, 2017.

Buchanan 1997
Buchanan, Harvey. "Edgar Degas and Ludovic Lepic: An Impressionist Friendship." *Cleveland Studies in the History of Art* 2 (1997): 32–121.

Childs 2017
Childs, Elizabeth C., ed. *Spectacle and Leisure in Paris: Degas to Mucha*. Exh. cat. Saint Louis: Mildred Lane Kemper Art Museum, 2017.

Clarke 2013
Clarke, Jay, ed. *The Impressionist Line from Degas to Toulouse-Lautrec: Drawings and Prints at the Clark*. Exh. cat. Williamstown, MA: Sterling and Francine Clark Art Institute, 2013.

Clayson 2017
Clayson, Hollis. "Mary Cassatt's Lamp." In *Is Paris Still the Capital of the Nineteenth Century? Essays on Art and Modernity, 1850–1900*, edited by Hollis Clayson and André Dombrowski, 257–83. London and New York: Routledge, 2017.

Cohn and Boggs 2005
Cohn, Marjorie Benedict, and Jean Sutherland Boggs. *Degas at Harvard*. Exh. cat. Cambridge, MA: Harvard University Art Museums; New Haven, CT: Yale University Press, 2005.

Conisbee, Faunce, and Strick 1996
Conisbee, Philip, Sarah Faunce, and Jeremy Strick. *In the Light of Italy: Corot and Early Open-Air Painting*. Exh. cat. Washington, DC: National Gallery of Art, 1996.

Cowling and Kendall 2010
Cowling, Elizabeth, and Richard Kendall. *Picasso Looks at Degas*. Exh. cat. Williamstown, MA: Sterling and Francine Clark Art Institute; Barcelona: Museu Picasso, 2010.

Delteil 1919
Delteil, Loys. *Le peintre-graveur illustré (XIX et XX siècles)*. Vol. IX, *Edgar Degas*. Paris: Chez L'Auteur, 1919.

Delteil 1999
Delteil, Loys. *Camille Pissarro: l'oeuvre gravé et litho-graphié; The Etchings and Lithographs*. Supplemented by Jean Cailac, edited by Alan Hyman. San Francisco: Alan Wofsy Fine Arts, 1999.

Dickerson and Bell 2016
Dickerson, C. D., III, and Esther Bell. *The Brothers Le Nain: Painters of Seventeenth-Century France*. Exh. cat. San Francisco: Fine Arts Museums of San Francisco, 2016.

Druick and Zegers 2001
Druick, Douglas W., and Peter Kort Zegers. *Van Gogh and Gauguin: The Studio of the South*. Exh. cat. Chicago: Art Institute of Chicago; New York: Thames & Hudson, 2001.

Dumas et al. 1997
Dumas, Ann, et al. *The Private Collection of Edgar Degas*. Exh. cat. New York: The Metropolitan Museum of Art, 1997.

Durand-Ruel Snollaerts and Duvivier 2017
Durand-Ruel Snollaerts, Claire, and Christophe Duvivier. *Camille Pissarro: Le premier des impressionnistes / The First among the Impressionists*. Exh. cat. Paris: Musée Marmottan Monet; Vanves: Éditions Hazan, 2017.

Duvivier and Melot 2017
Duvivier, Christophe, and Michel Melot. *Camille Pissarro: Impressions gravées*. Exh. cat. Pontoise: Musée Tavet-Delacourt; Paris: Somogy éditions d'art, 2017.

Fredericksen 2002
Fredericksen, Andrea. "The Etching Club of London: A Taste for Painters' Etchings." *Philadelphia Museum of Art Bulletin* 92 (Summer 2002): 5–35.

Gautier 1863
Gautier, Théophile. "Un mot sur l'eau-forte." *Eaux-fortes modernes* 1 (1 Sept. 1863).

Glassman and Symmes 1980
Glassman, Elizabeth, and Marilyn F. Symmes. *Cliché-Verre: Hand-Drawn, Light-Printed; A Survey of the Medium from 1839 to the Present*. Exh. cat. Detroit: Detroit Institute of Arts, 1980.

Guérin 1945
Guérin, Marcel, ed. *Lettres de Degas*. Paris: Éditions Bernard Grasset, 1945.

Hauptman 2016
Hauptman, Jodi, et al. *Edgar Degas: A Strange New Beauty*. Exh. cat. New York: Museum of Modern Art, 2016.

Havemeyer 1961
Havemeyer, Louisine W. *Sixteen to Sixty: Memoirs of a Collector*. New York: Privately printed, 1961.

Helsinger 2008
Helsinger, Elizabeth K., et al. *The "Writing" of Modern Life: The Etching Revival in France, Britain, and the U.S., 1850–1940*. Exh. cat. Chicago: Smart Museum of Art, University of Chicago, 2008.

Horbez 2004

Horbez, Dominique. *Corot et les peintres de l'école d'Arras*. Tournai: Renaissance du livre, 2004.

Huysmans 1880

Huysmans, J[oris]-K[arl]. "L'Exposition des indépendants en 1880." Paris, 1880. Reprinted in Berson 1996, vol. 1, 285–93.

Isaacson 1979

Isaacson, Joel. *The Crisis of Impressionism, 1878–1882*. Exh. cat. Ann Arbor: University of Michigan Museum of Art, 1979.

Isaacson 1994

Isaacson, Joel. "Constable, Duranty, Mallarmé, Impressionism, Plein Air, and Forgetting." *Art Bulletin* 76, no. 3 (Sept. 1994): 427–50.

Ives et al. 1997

Ives, Colta, et al. *The Private Collection of Edgar Degas: A Summary Catalogue*. New York: The Metropolitan Museum of Art, 1997.

Jacobs 1985

Jacobs, Michael. *The Good and Simple Life: Artist Colonies in Europe and America*. Oxford: Phaidon Press, 1985.

Janis 1968

Janis, Eugenia Parry. *Degas Monotypes: Essay, Catalogue and Checklist*. Exh. cat. Cambridge, MA: Fogg Art Museum, Harvard University, 1968.

Jeanniot 1933

Jeanniot, Georges. "Souvenirs sur Degas," *Revue Universelle* 55, no. 14 (15 Oct. 1933): 152–74; no. 15 (1 Nov. 1933): 280–304.

Jones 2014

Jones, Kimberly A., et al. *Degas/Cassatt*. Exh cat. Washington, DC: National Gallery of Art, 2014.

Kahng 2007

Kahng, Eik. *The Repeating Image: Multiples in French Painting from David to Matisse*. Exh. cat. Baltimore: Walters Art Museum, 2007.

Kendall 1993

Kendall, Richard. *Degas Landscapes*. Exh. cat. New Haven, CT: Yale University Press in Association with the Metropolitan Museum of Art, New York, and the Museum of Fine Arts, Houston, 1993.

Lemoisne 1946–49

Lemoisne, P[aul].-A[ndré]. *Degas et son œuvre*. 4 vols. Paris: P. Brame et C. M. de Hauke, 1946–49.

Lepic 1876

Lepic, Ludovic. *Eaux-fortes de Lepic; Comment je devins graveur à l'eau-forte*. Paris: Vve. A. Cadart, 1876.

Lostalot 1884

Lostalot, Alfred de. "Les artistes contemporains: M. Félix Bracquemond, peintre-graveur." *Gazette des Beaux-Arts* 29 (May 1884): 420–26; (June 1884): 517–24; 30 (Aug. 1884): 155–61.

Loyrette 2016

Loyrette, Henri. *Degas: A New Vision*. Exh. cat. Melbourne: National Gallery of Victoria, 2016.

Lübbren 2001

Lübbren, Nina. *Rural Artists' Colonies in Europe, 1870–1910*. New Brunswick: Rutgers University Press, 2001.

Luthi and Israël 2014

Luthi, Jean-Jacques, and Armand Israël. *Émile Bernard: Instigateur de l'école de Pont-Aven; sa vie, son oeuvre, catalogue raisonné*. Paris: Editions des Catalogues raisonné, 2014.

Mathews 1984

Mathews, Nancy Mowll, ed. *Cassatt and Her Circle: Selected Letters*. New York: Abbeville Press, 1984.

Mathews 1994

Mathews, Nancy Mowll. *Mary Cassatt: A Life*. New Haven, CT: Yale University Press, 1994.

Mathews and Shapiro 1989

Mathews, Nancy Mowll, and Barbara Stern Shapiro. *Mary Cassatt: The Color Prints*. Exh. cat. Williamstown, MA: Williams College Museum of Art; New York: Harry N. Abrams, 1989.

Matthias 2007

Matthias, Agnes. *Zeichnungen des Lichts: Clichés-verre von Corot, Daubigny, und anderen aus deutschen Sammlungen*. Exh cat. Dresden: Staatliche Kunstsammlungen; Munich: Deutscher Kunstverlag, 2007.

Melot 1996

Melot, Michel. *The Impressionist Print*. Translated by Caroline Beamish. New Haven, CT: Yale University Press, 1996.

Meyers 2005

Meyers, Jeffrey. *Impressionist Quartet: The Intimate Genius of Manet and Morisot, Degas and Cassatt*. Orlando: Harcourt, 2005.

Minder 1998

Minder, Nicole, Richard Brettell, and Eric Gillis. *Degas & Pissarro: Alchimie d'une rencontre*. Exh. cat. Vevey: Musée Jenisch, 1998.

Paris 1880

5me exposition de peinture (Fifth Impressionist exhibition). Exh. cat. Paris, 1880.

Paviot 1994

Paviot, Alain. *Le cliché-verre: Corot-Delacroix-Millet-Rousseau-Daubigny*. Exh. cat. Paris: Musée de la vie Romantique; Paris: Éditions Paris-Musées/Paris Audiovisuel, 1994.

Pissarro 1980

Hayward Gallery. *Pissarro, 1830–1903*. Exh. cat. London: Hayward Gallery, 1980.

Pissarro 2005

Pissarro, Joachim. *Pioneering Modern Painting: Cézanne & Pissarro 1865–1885*. Exh. cat. New York: Museum of Modern Art, 2005.

Pissarro 2006

Pissarro, Joachim. *Cézanne/Pissarro, Johns/Rauschenberg: Comparative studies on Intersubjectivity in Modern Art*. Cambridge: Cambridge University Press, 2006.

Pissaro and Durand-Ruel Snollaerts 2005

Pissarro, Joachim, and Claire Durand-Ruel Snollaerts. *Pissarro: Critical Catalogue of Paintings*. 3 vols. Paris: Wildenstein Institute; Milan: Skira, 2005.

Pissarro and Venturi 1939

Pissarro, Ludovic-Rodo, and Lionello Venturi. *Camille Pissarro: Son art, Son Œuvre*. 2 vols. Paris: Paul Rosenberg, 1939.

Reed and Shapiro 1984

Reed, Sue Welsh, Barbara Stern Shapiro, et al. *Edgar Degas: The Painter as Printmaker*. Exh. cat. Boston: Museum of Fine Arts, 1984.

Reff 1967

Reff, Theodore. "Pissarro's Portrait of Cézanne." *Burlington Magazine* 109, no. 776 (Nov. 1967): 626–31, 633.

Rewald 1946

Rewald, John. *The History of Impressionism*. New York: Museum of Modern Art, 1946.

Riopelle and Bray 1999

Riopelle, Christopher, and Xavier Bray. *A Brush with Nature: The Gere Collection of Landscape Oil Sketches*. Exh. cat. London: National Gallery, 1999.

Robertson 2008

Robertson, Clare. *The Invention of Annibale Carracci*. Studi della Biblioteca Hertziana 4. Milan: Silvana Editorale, 2008.

Rubin 1989

Rubin, William. *Picasso and Braque: Pioneering Cubism*. New York: Museum of Modern Art, 1989.

Salomé 2010

Salomé, Laurent, ed. *A City for Impressionism: Monet, Pissarro, and Gauguin in Rouen*. Exh. cat. Rouen: Musée des Beaux-Arts de Rouen, 2010.

Schama 1999

Schama, Simon. *Rembrandt's Eyes*. New York: Alfred A. Knopf, 1999.

Segard 1913

Segard, Achille. *Mary Cassatt: Un peintre des enfants et des mères*. Paris: Librairie Paul Ollendorff, 1913.

Shapiro 1973

Shapiro, Barbara Stern. *Camille Pissarro, the Impressionist Printmaker*. Exh. cat. Boston: Museum of Fine Arts, 1973.

Shapiro and Melot 1975

Shapiro, Barbara Stern, and Michel Melot. "Les monotypes de Camille Pissarro." *Nouvelles de L'Estampe* 19 (1975): 16–23.

Shikes and Harper 1980

Shikes, Ralph E., and Paula Harper. *Pissarro: His Life and Work*. New York: Horizon Press, 1980.

Solana 2004

Solana, Guillermo, ed. *Gauguin and the Origins of Symbolism*. Exh. cat. Madrid: Fundación Collección Thyssen-Bornemisza, 2004.

Tedeschi 2013

Tedeschi, Martha. "Mirror Images: A Reflection on Mary Cassatt's Opera Box Prints." In *The Lunder Collection: A Gift of Art to Colby College*, 219–23. Exh. cat. Waterville, ME: Colby College Museum of Art, 2013.

Thomson 1990

Thomson, Richard. *Camille Pissarro: Impressionism, Landscape and Rural Labour*. Exh. cat. Birmingham: City Museum and Art Gallery; London: Herbert Press, 1990

Tout-Paris 1880

Tout-Paris [pseud.]. "La Journée Parisienne: Impressions d'un Impressionniste." *Le Gaulois,* 24 Jan. 1880, 2.

Viljoen 2013

Viljoen, Madeleine. *Daring Methods: The Prints of Mary Cassatt*. Exh cat. New York: New York Public Library, 2013.

White 1996

White, Barbara Ehrlich. *Impressionists Side by Side: Their Friendships, Rivalries, and Artistic Exchanges*. New York: Alfred A. Knopf, 1996.

Index

Photography Credits